HISTORIC PHOTOS OF
CHARLOTTE

TEXT AND CAPTIONS BY RYAN L. SUMNER

Turner®
Publishing Company
Nashville, Tennessee • Paducah, Kentucky

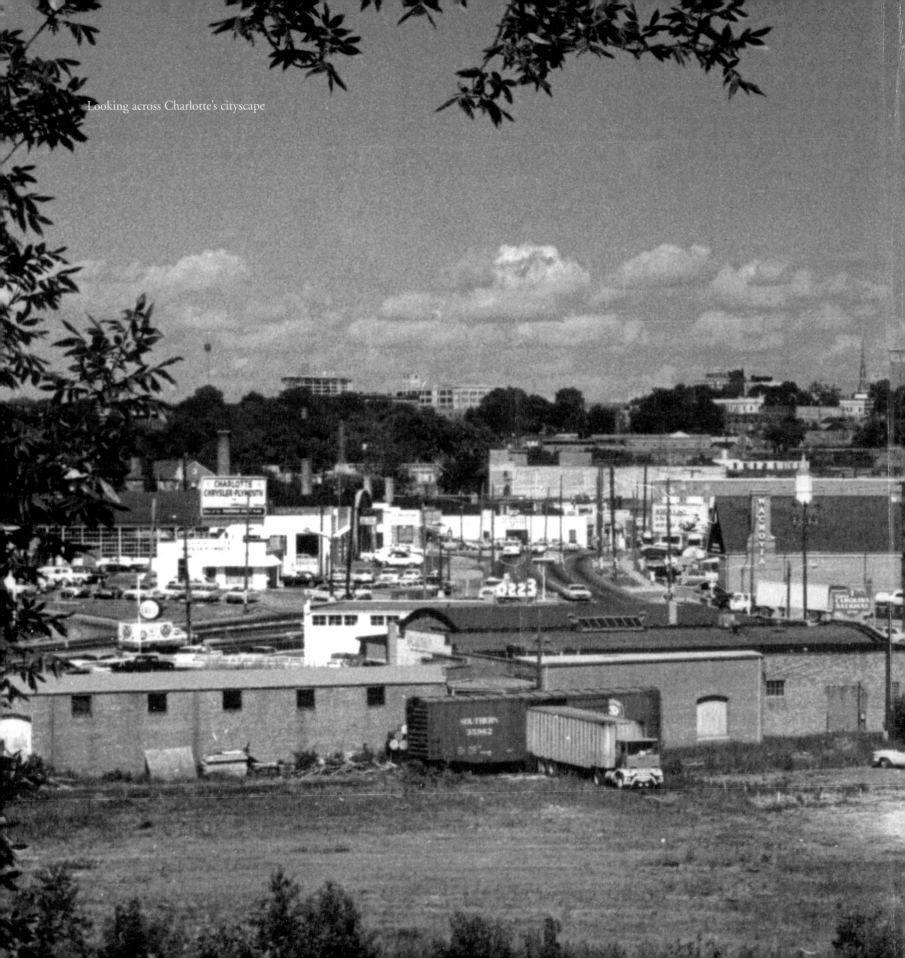

Looking across Charlotte's cityscape

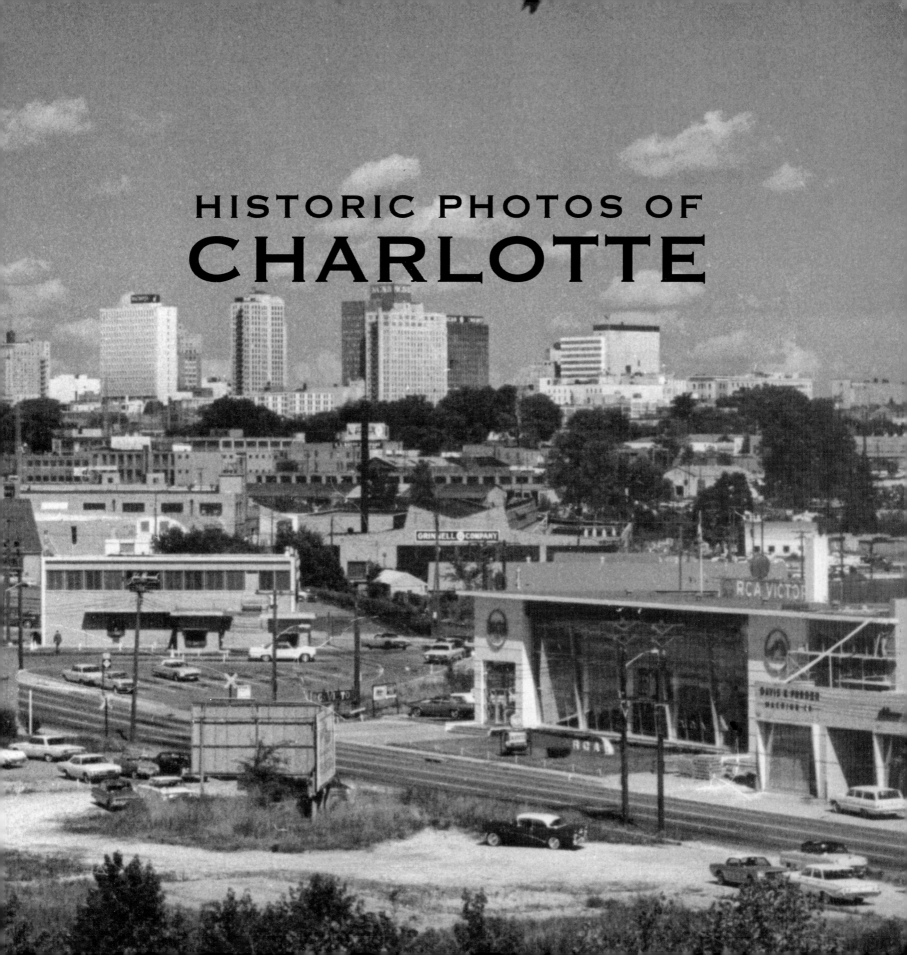

HISTORIC PHOTOS OF
CHARLOTTE

Turner Publishing Company
200 4th Avenue North • Suite 950 412 Broadway • P.O. Box 3101
Nashville, Tennessee 37219 Paducah, Kentucky 42002-3101
(615) 255-2665 (270) 443-0121

www.turnerpublishing.com

Library of Congress Control Number: 2006933649

ISBN: 1-59652-282-8

Printed in the United States of America

0 9 8 7 6 5 4 3 2 1

Contents

Cedric "Cornbread" Maxwell led the University of North Carolina Charlotte 49ers to victory in the NIT tournament in 1976 and to the Final Four in 1977. Maxwell was the number 12 pick in the '77 NBA draft by the Boston Celtics, for whom he played for eight of his eleven professional years.

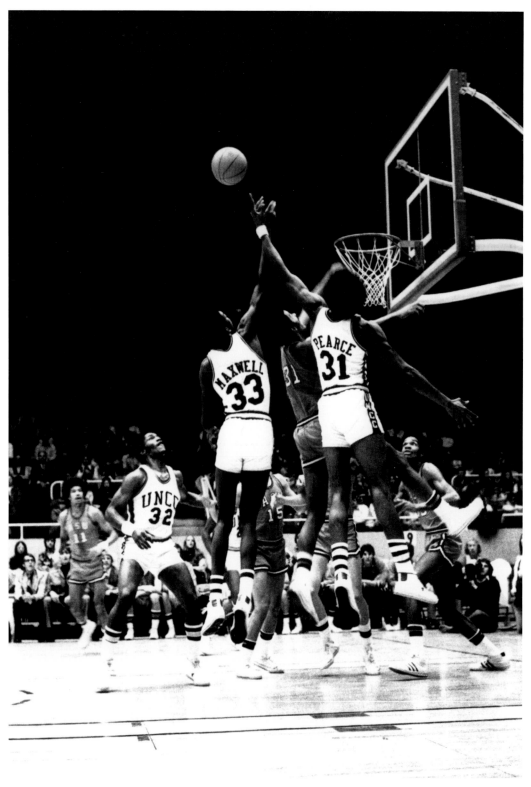

Acknowledgments

This volume, *Historic Photos of Charlotte,* is the result of the cooperation and efforts of many individuals, organizations, institutions, and corporations. It is with great thanks that we acknowledge the valuable contribution of the following for their generous support:

Mary Boyer
Carolinas Aviation Commission
Duke Energy
Federal Reserve
J. Murrey Atkins Library
Levine Museum of the New South
North Carolina State Archives
Public Library of Charlotte in Mecklenburg
University of North Carolina Charlotte Archives

We would also like to thank Robin Brabham
for valuable contributions and assistance in making this work possible.

PREFACE

Charlotte has thousands of historic photographs that reside in archives, both locally and nationally. This book began with the observation that, while those photographs are of great interest to many, they are not easily accessible. During a time when Charlotte is looking ahead and evaluating its future course, many people are asking, "How do we treat the past?" These decisions affect every aspect of the city—architecture, public spaces, commerce, infrastructure—and these, in turn, affect the way that people live their lives. This book seeks to provide easy access to a valuable, objective look into the history of Charlotte.

The power of photographs is that they are less subjective than words in their treatment of history. Although the photographer can make decisions regarding subject matter and how to capture and present it, photographs do not provide the breadth of interpretation that text does. For this reason, they offer an original, untainted perspective that allows the viewer to interpret and observe.

This project represents countless hours of review and research. The researchers and writer have reviewed thousands of photographs in numerous archives. We greatly appreciate the generous assistance of the individuals and organizations listed in the acknowledgments of this work, without whom this project could not have been completed.

The goal in publishing this work is to provide broader access to this set of extraordinary photographs that seek to inspire, provide perspective, and evoke insight that might assist people who are responsible for determining Charlotte's future. In addition, the book seeks to preserve the past with adequate respect and reverence.

With the exception of touching up imperfections caused by the damage of time, no other changes have been made. The focus and clarity of many images is limited to the technology and the ability of the photographer at the time they were taken.

The work is divided into eras. Beginning with some of the earliest known photographs of Charlotte, the first section

records photographs through the end of the nineteenth century. The second section spans the beginning of the twentieth century through the 1920s. Section Three moves from the 1920s to the 1950s. The last section covers recent times.

In each of these sections we have made an effort to capture various aspects of life through our selection of photographs. People, commerce, transportation, infrastructure, religious institutions, and educational institutions have been included to provide a broad perspective.

We encourage readers to reflect as they go walking in Charlotte, strolling through the city, its parks, and its neighborhoods. It is the publisher's hope that in utilizing this work, longtime residents will learn something new and that new residents will gain a perspective on where Charlotte has been, so that each can contribute to its future.

Todd Bottorff, Publisher

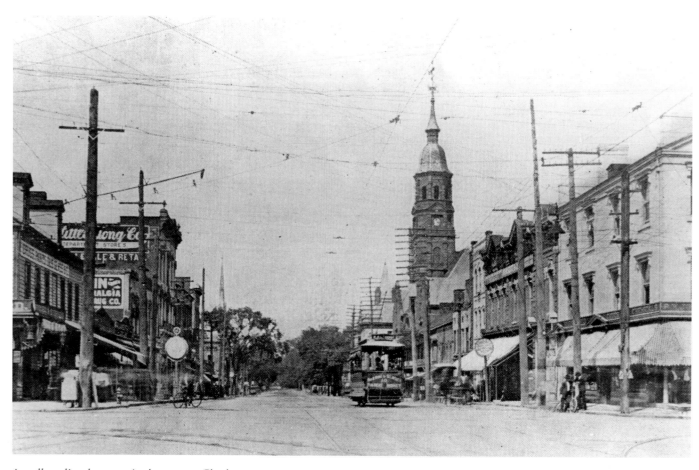

A trolley plies the route in downtown Charlotte.

THE BIRTH OF A TEXTILE TYCOON

Charlotte is the quintessential "New South" city and has always been a place obsessed with growth, change, and reinvention—moving from field, to factory, to finance.

Named in honor of British King George III's wife, Charlotte was a place of little importance before the American Civil War. Rocky rivers made it hard to get crops to market, so plantations stayed small compared with the Deep South. In the early 1860s, only one Mecklenburg family owned fifty slaves; however, nearly a quarter of Mecklenburg residents were slave holders, with more than 800 households owning between one and twenty persons in forced servitude. The railroads had just come to Charlotte and other "back country" towns in the decade before America divided itself into two nations locked in a death grip with each other.

With the coastal plantations destroyed, this region came into its own. Cotton farmers brought their crops to Charlotte and other towns that sprang up along the rail line. Area leaders began to re-envision their land of cotton farms as a land of cotton manufacturing. Charlotte became the hub of this new textile-mill economy.

Other industries and businesses followed and Charlotte began to grow at a meteoric rate, quickly becoming the "Capital of the Carolinas." People came from all around to shop at downtown department stores. Henry Ford's automobiles—made on Statesville Avenue—emancipated workers from their farms and mill villages. Radio broadcasts from Charlotte's WBT—one of the country's first radio stations—connected the region to the wider world and let Southerners share their culture, mostly through music, with the nation at large. James Duke dammed the Catawba River to build power plants, which supplied the region with electricity and Charlotteans with the power to prosper.

The greatest changes were still to come. The South had long been the country's poorest region and Charlotte was hard hit by the Stock Market Crash of 1929 and subsequent Great Depression. Federal investment through Roosevelt's New Deal created new infrastructure and modernization, which along with the Civil Rights Movement of the 1960s, let the South join the rest of the nation in the modern era. By the 1970s and 1980s, Charlotte began to emerge as a banking center and is today the second largest financial center in the United States—trailing only New York City.

Once little more than a courthouse village, the "Queen City" is today a powerful economic magnet boasting numerous Fortune 500 companies, professional sports teams, and drawing newcomers from all over the nation and globe.

Looking east on Trade Street ca. 1890. R. M. White's wholesale and retail grocery is visible in the background.

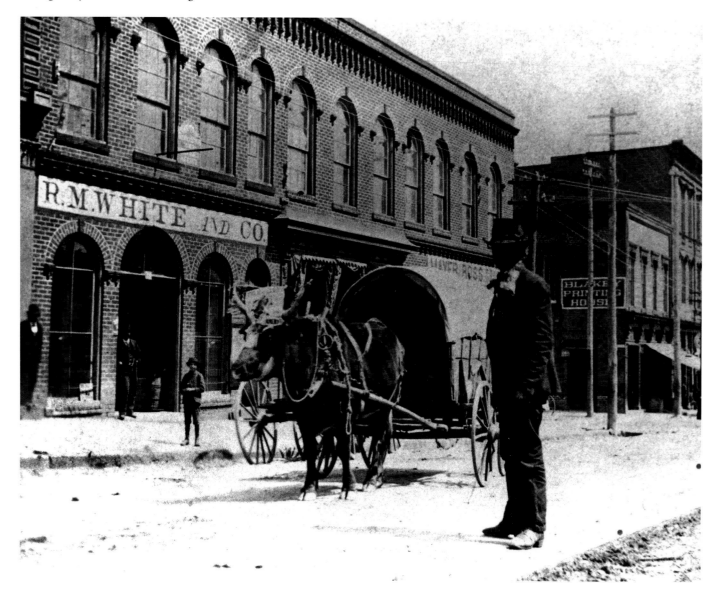

Hezekiah Alexander was a prominent farmer and one of Mecklenburg County's foremost patriots during the Revolution. Alexander held several offices in the Revolutionary government and is said to have been one of the signers of the Mecklenburg Declaration of Independence. Alexander's house, built in 1774, still stands off Shamrock Road and is cared for by the Charlotte Museum of History.

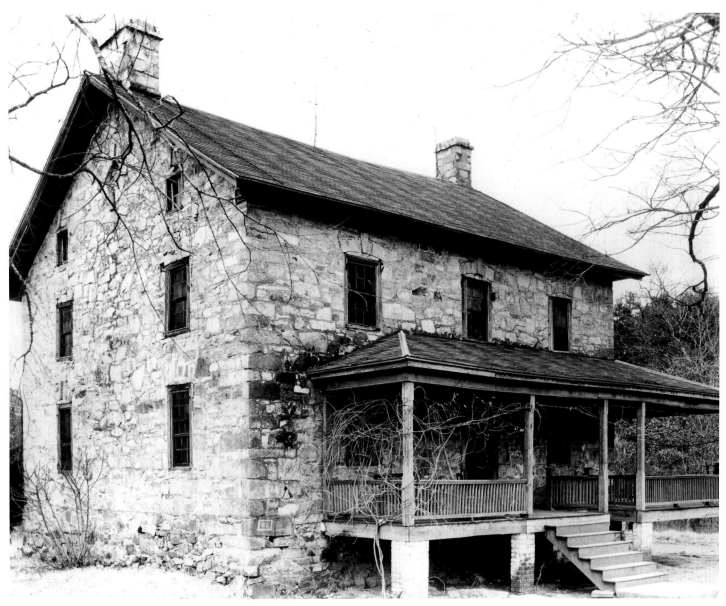

South Tryon Street (ca. 1890)

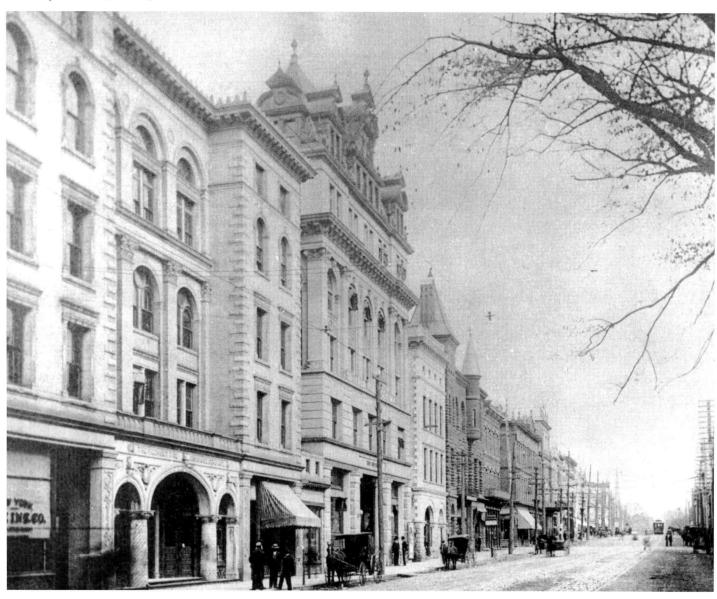

A doctor's daughter raised just north of Charlotte near Cornelius, Annie Alexander studied medicine in Philadelphia and New York. As the only woman among the 100 physicians certified by the Maryland Board of Medical Examiners in 1885, hers were the highest scores. The first woman licensed to practice medicine in the South, Dr. Alexander opened her office in Charlotte two years later. At first people scoffed and she earned just $2 her first year. She persevered and quickly gained acclaim, serving at both Presbyterian and Saint Peter's hospitals, physician for Presbyterian College, and at Camp Greene as acting assistant surgeon. Later Dr. Alexander won election to the presidency of the Mecklenburg Medical Association.

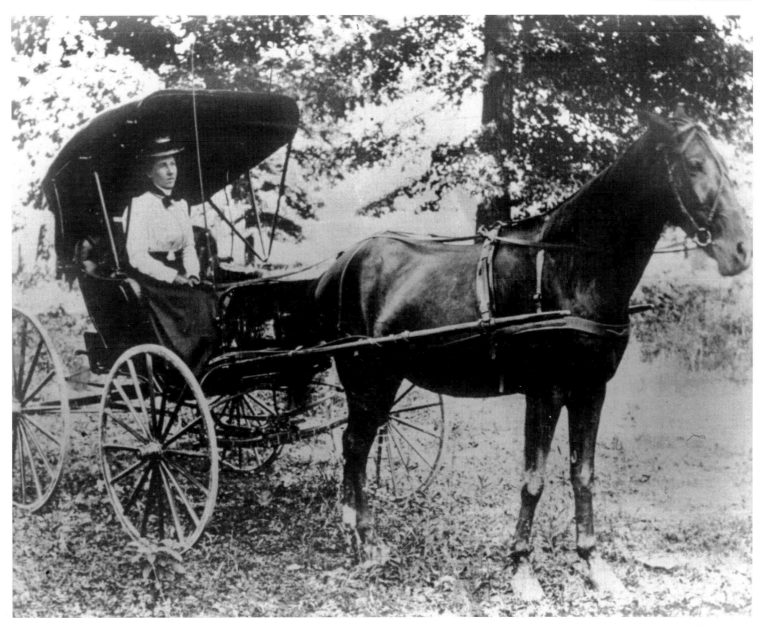

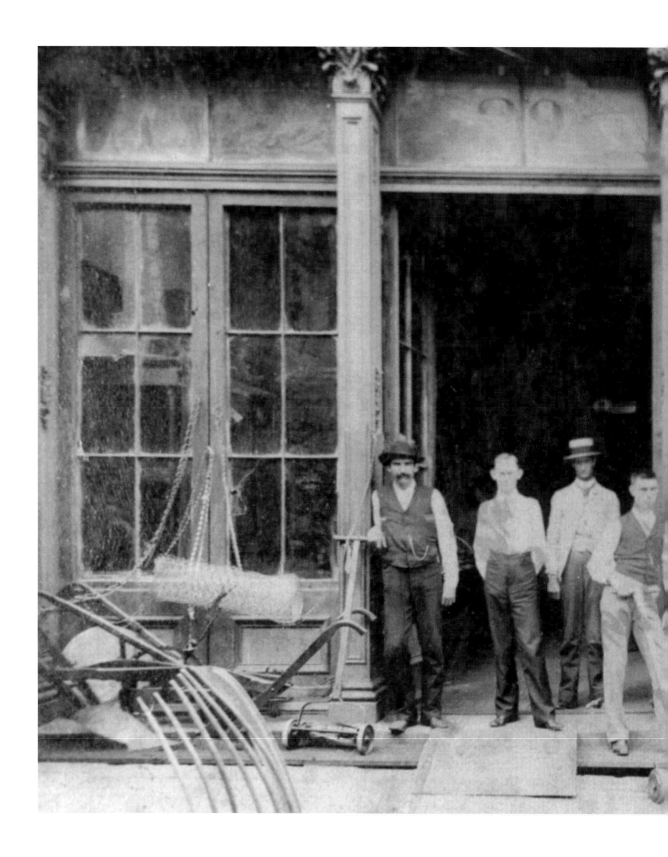

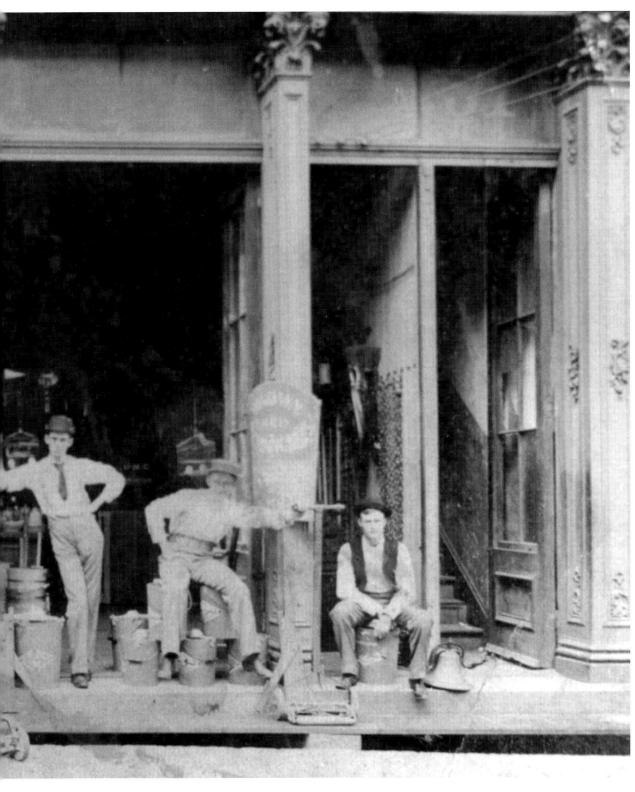

Established in 1883, the Brown and Weddington Hardware store stood on Trade Street, between College and Tryon Streets.

First Presbyterian Church

Established in 1834, Saint Peter's is the oldest Episcopal Church in Charlotte. The current sanctuary, located at the corner of Tryon and Seventh streets, was erected in 1892.

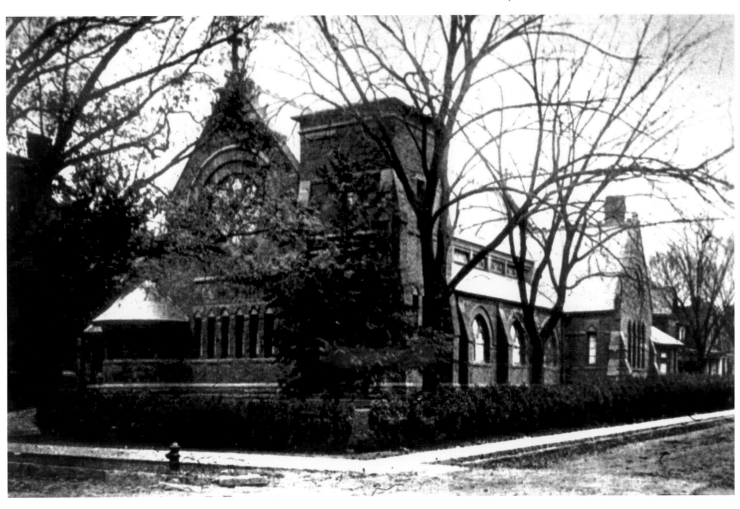

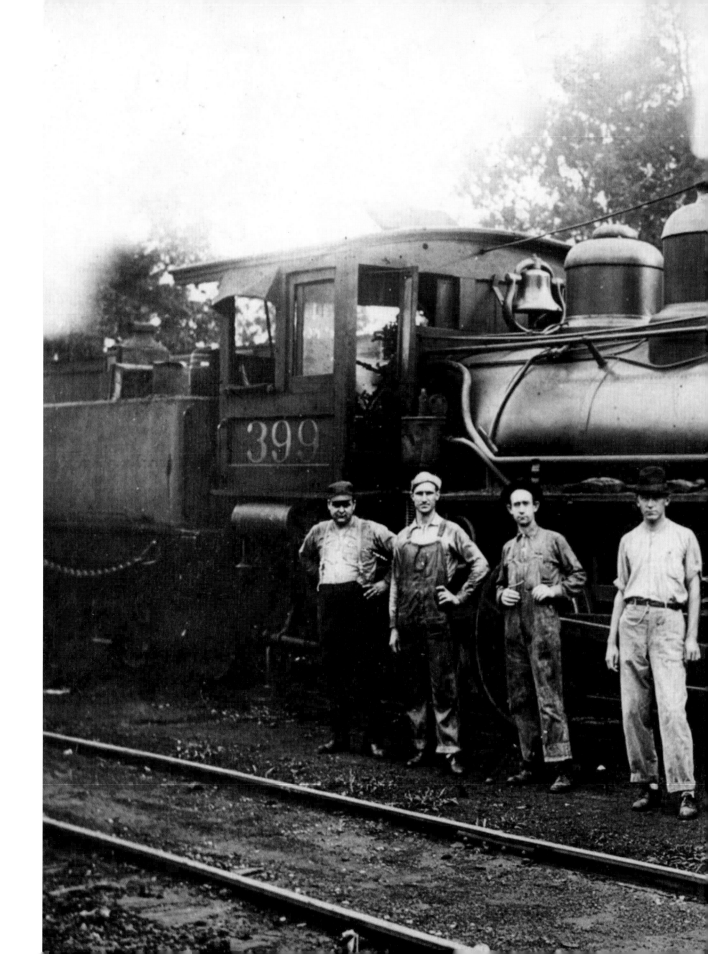

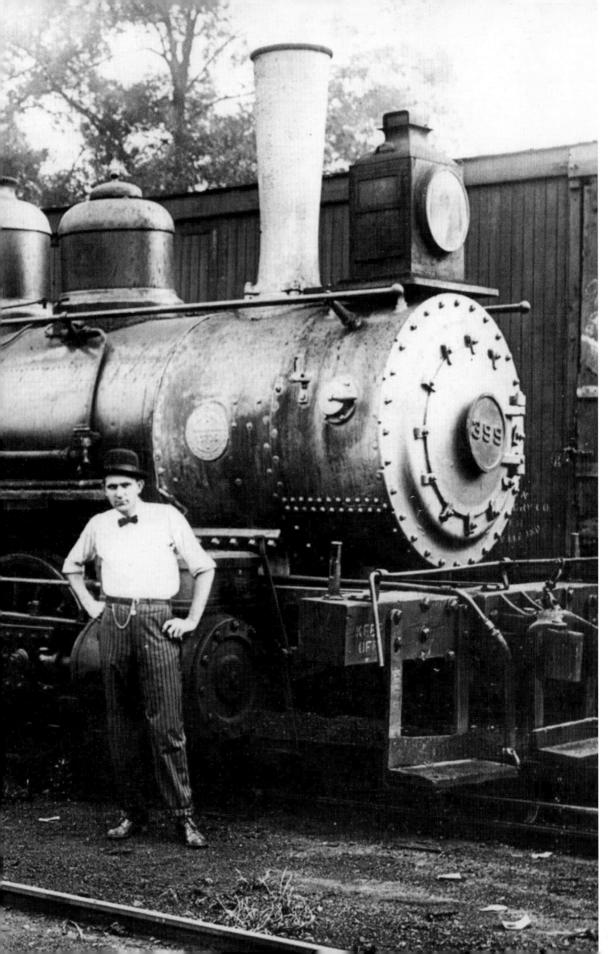

Railroad connections transformed Charlotte from just another backcountry town to a city of regional importance. In 1852, local merchants and planters built the very first railroad into the Carolina piedmont: the Charlotte and South Carolina Railroad. Rail lines continued to grow, and in 1884 several small companies joined together to form the Southern Railway—connecting Washington, D.C., to New Orleans, with Charlotte poised right in the center. (Pictured is the Charlotte railroad yard, ca. 1895)

The stately home of Zebulon B. Vance, the governor of North
Carolina during the Civil War and later a United States senator

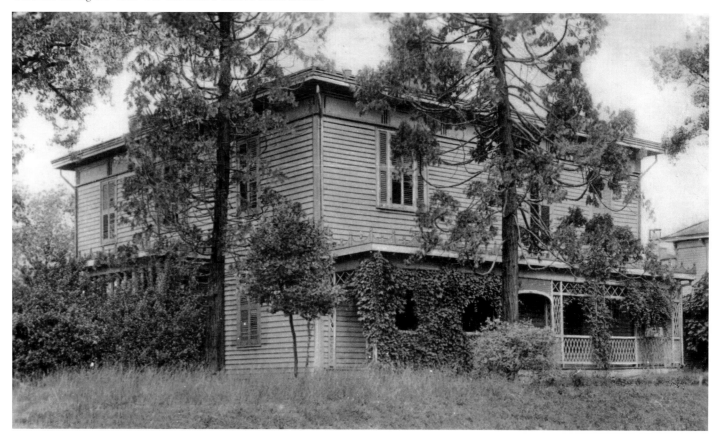

The Charlotte police department, 1885–1890

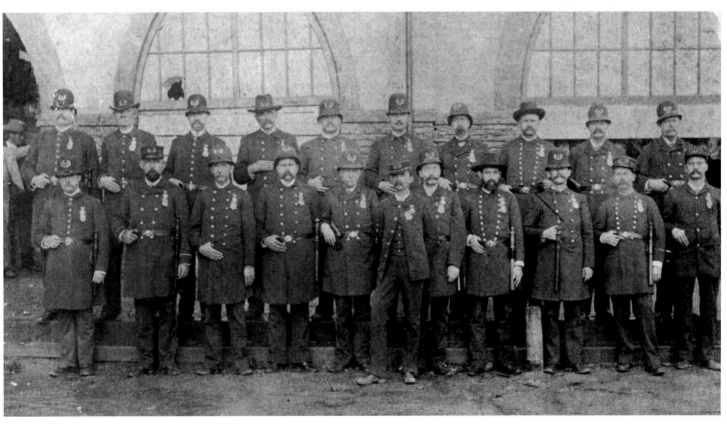

The steam fire engine of Charlotte's
Company Number Seven

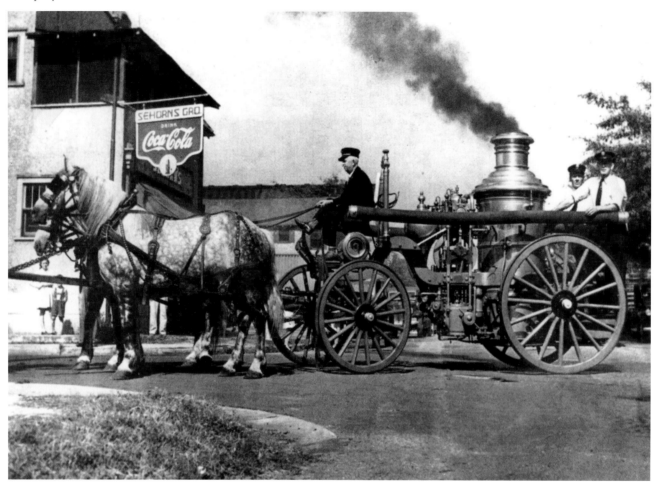

Cotton remained the chief crop and the basis of the local economy well into the early 1900s. D. A. Tompkins widely circulated this 1898 photo, to show the strength of Charlotte's macadam roadways.

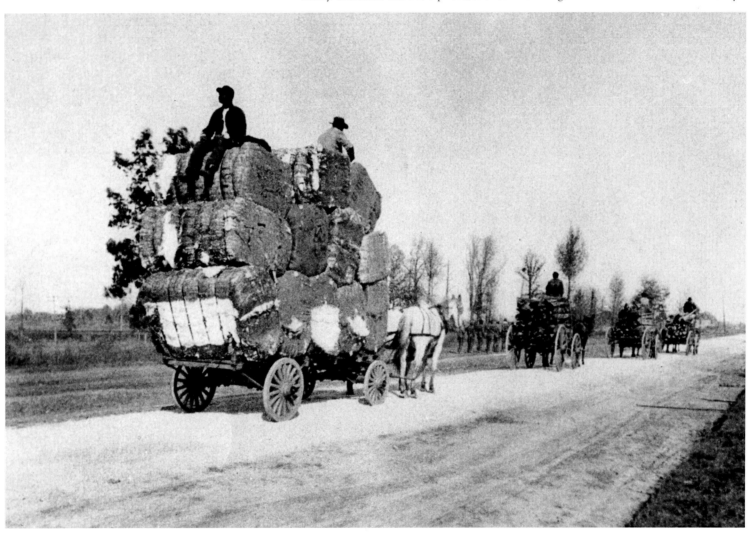

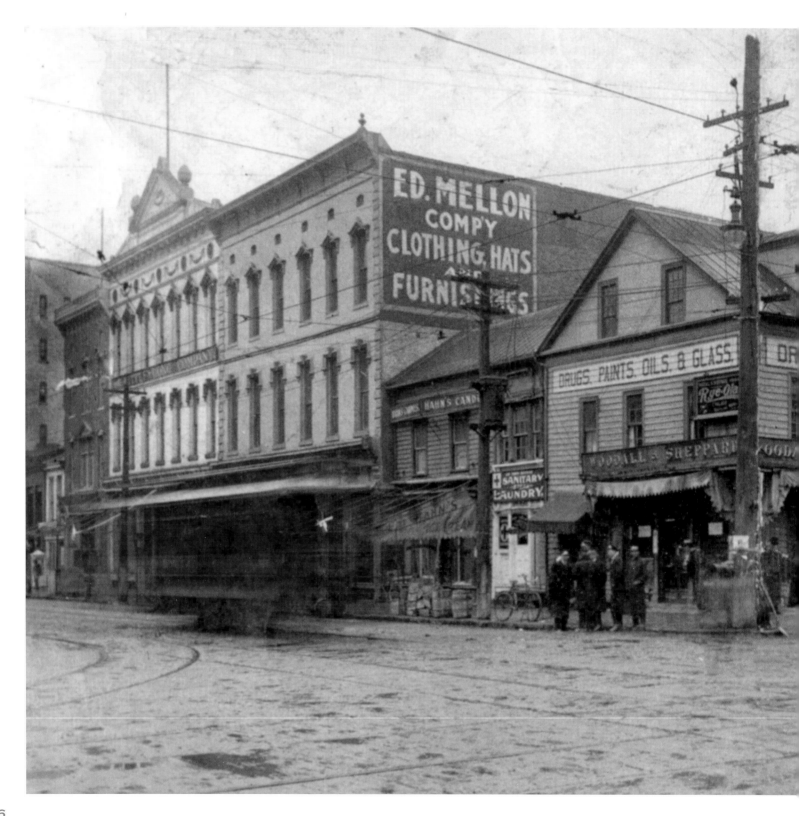

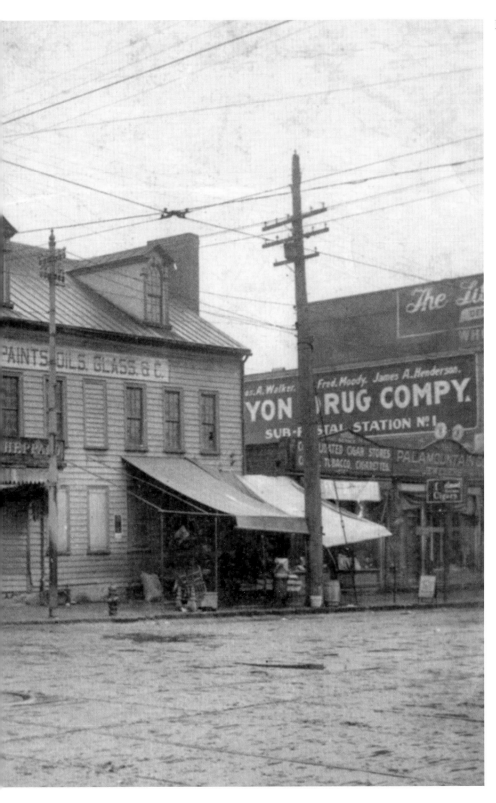

Independence Square looking northwest

Mecklenburg County's third courthouse—used from 1847 to 1898—
stood at the corner of West Trade and North Church streets.

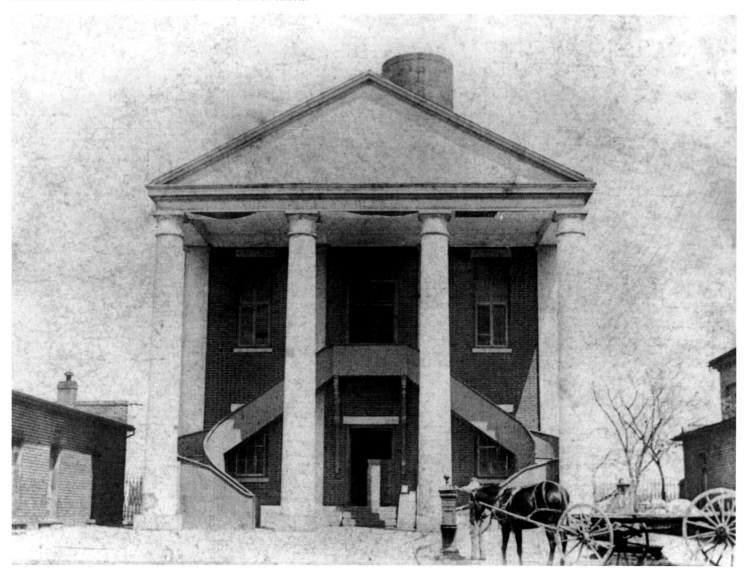

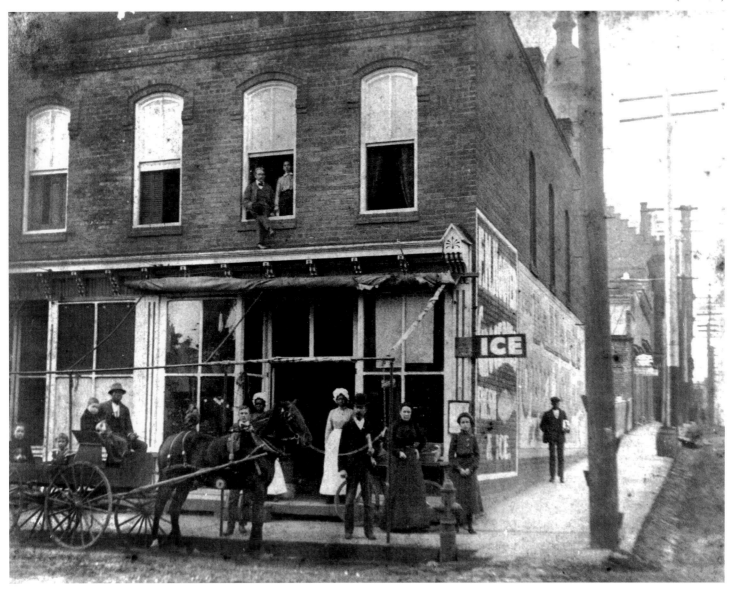

A small store at the corner of East
Trade and Brevard streets (ca. 1890)

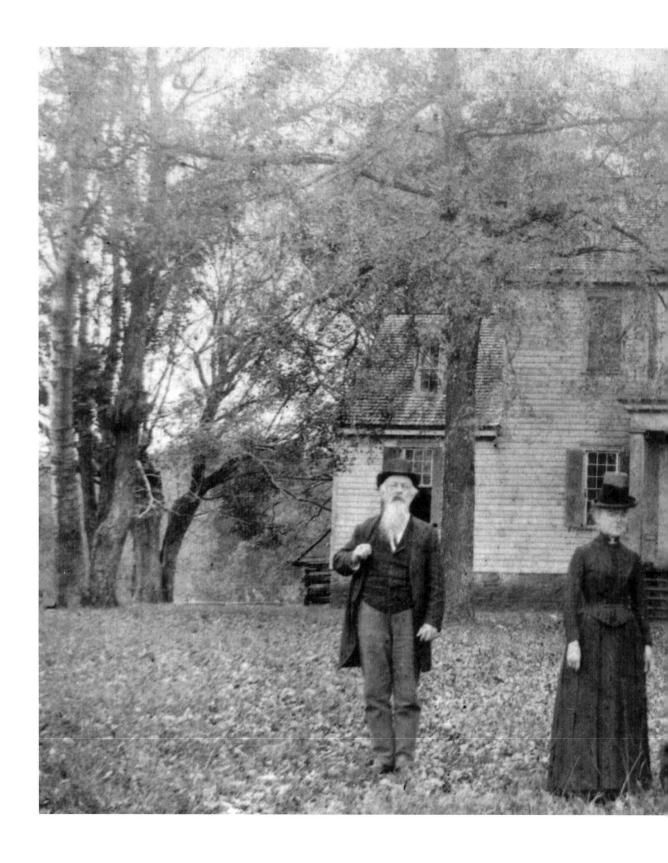

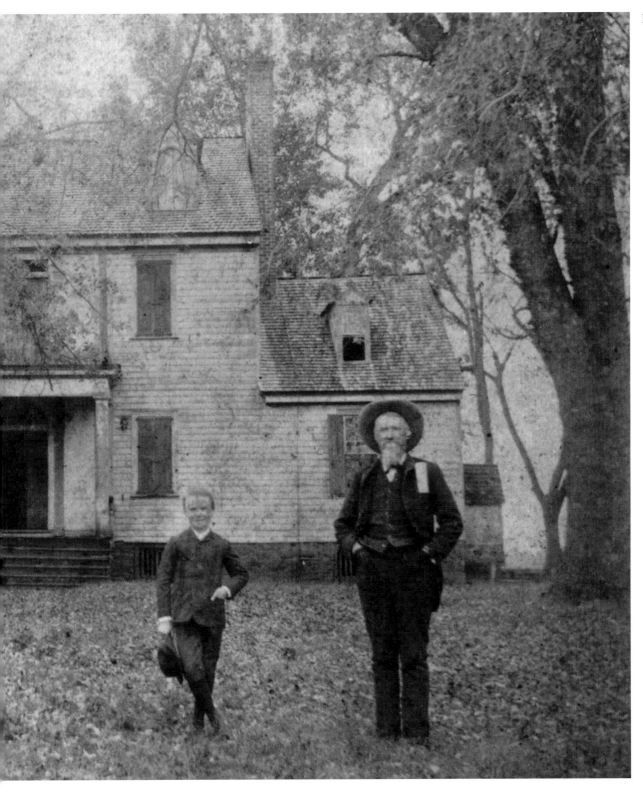

The Buford Hotel, at 4th and South Tryon streets, was undoubtedly the finest of Charlotte's early hotels. It served as home to industrialist D. A. Tompkins, hosted prominent visitors such as Thomas Edison, and was one of the swankiest places to eat in town. In 1908, the hotel became the first headquarters of Union National Bank—which later evolved into First Union and eventually Wachovia.

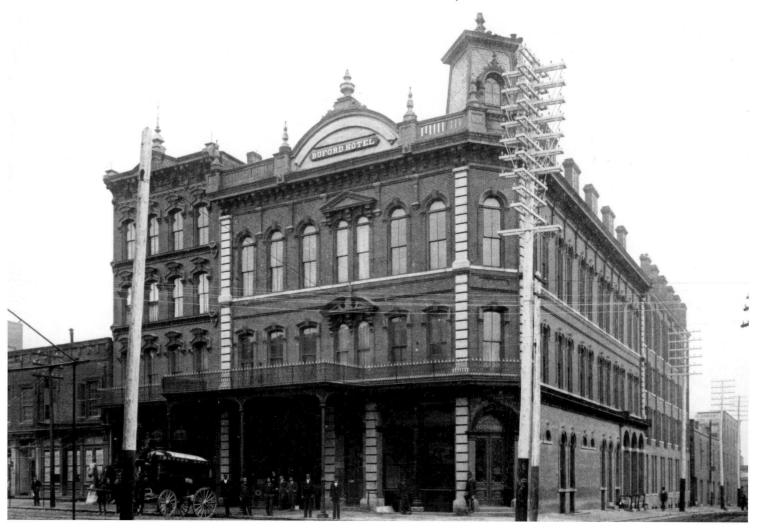

Built in the 1840s at the southeast corner of Trade and Tryon streets, the Mansion was Charlotte's first stately hotel. Later called the Central Hotel, the establishment's grand ballroom hosted many lavish occasions and town dances. The grand four-story yellow-brick structure fell to the wrecking ball in the 1930s.

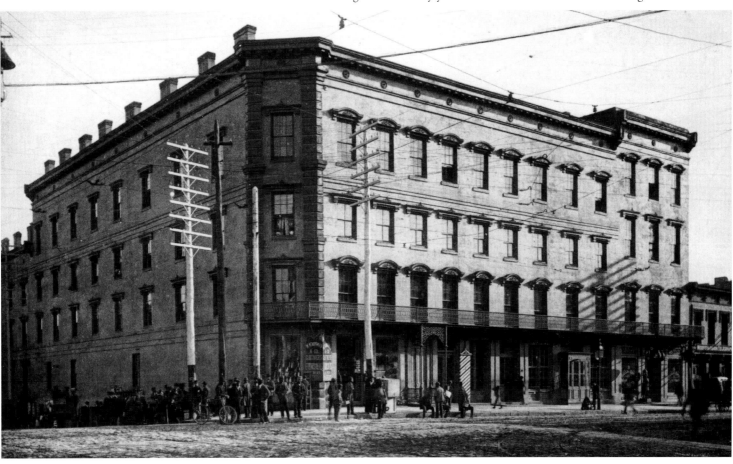

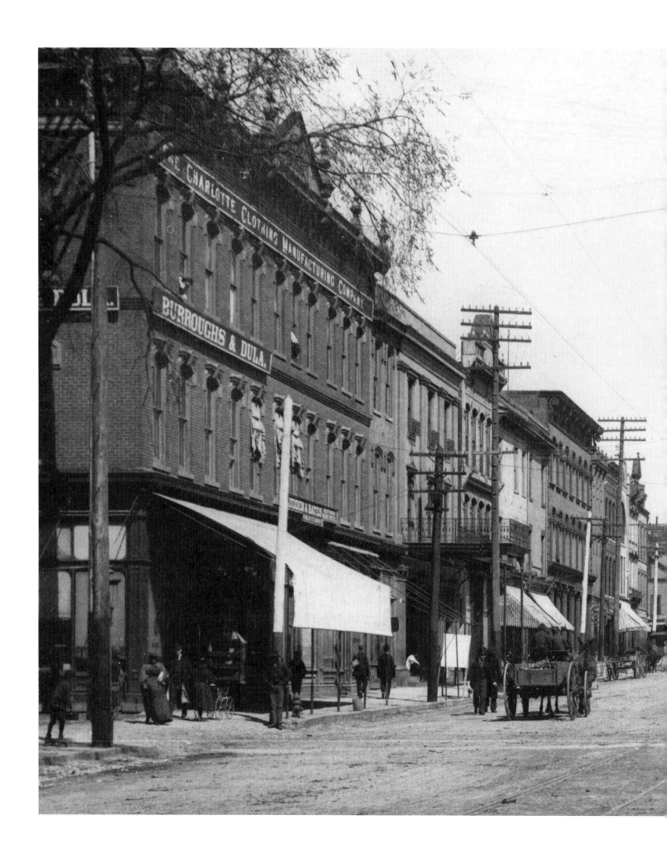

24

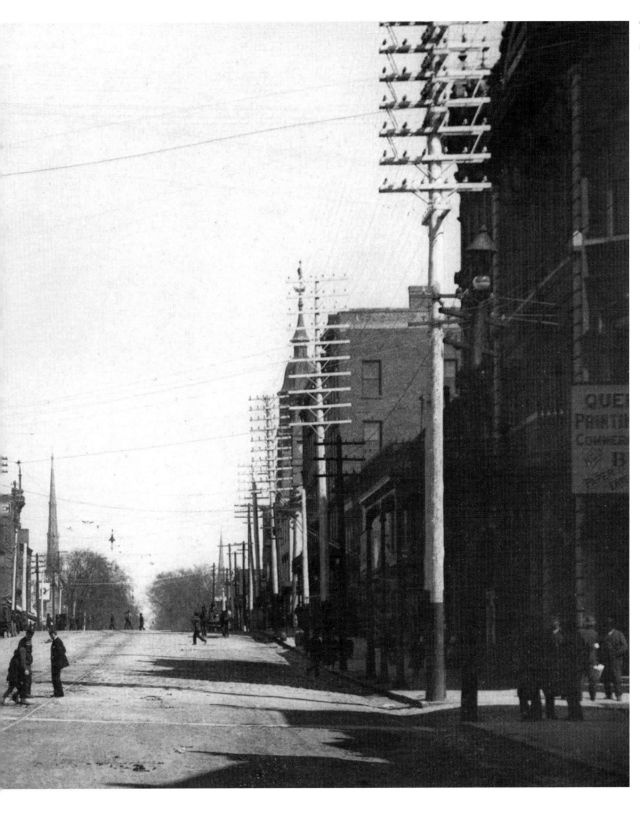

Tryon Street facing north, around 1900

The northwest corner of Trade and Tryon streets. Visible are Samuel
Wittowsky's Dry Good Store and the A. B. Reese Company, a pharmacy.

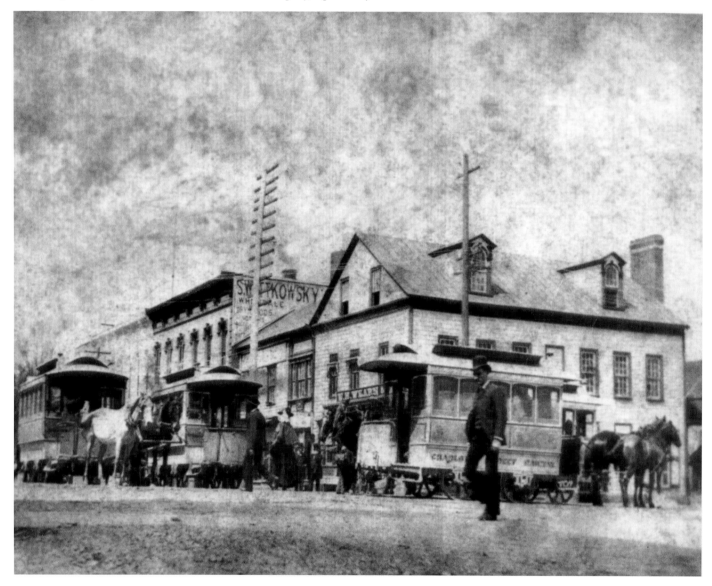

Big Business Takes the Stage

Realizing that northern industrialists were making relatively high profits turning southern cotton into cloth, merchants in and around Charlotte began to construct textile mills, reshaping the Carolina piedmont from a land of isolated farms into a region of factories and drastically altering the way thousands of people lived.

The railroad proved instrumental in converting the region to manufacturing. Because the factories required rail connections to bring in baled cotton and machinery, as well as move their finished products out, most of the cotton mills in the Southeast clustered along the Southern Railway. Charlotte's central location on the rail line gave the city a strategic advantage.

No single individual did more to industrialize the Carolinas than Daniel Augustus Tompkins. A native of South Carolina, Tompkins studied engineering in New York before coming to Charlotte in 1883 and establishing the D. A. Tompkins Company. He designed and built over 100 textile factories across the South, wrote books on cotton manufacturing and finance, set up textile training programs at Clemson and North Carolina State University, and invented the technology to turn cotton seeds into cooking oil. Tompkins even purchased the *Charlotte Observer* to spread his gospel of southern industrialization.

By the early 1900s, Charlotte's cotton tycoons gleefully reported that "half the looms and spindles in the South are within one hundred miles of this city." This transformation occurred with amazing speed and by the 1920s the South passed New England to become the largest textile producing region in the country.

Life in Charlotte's factory-owned mill villages represented numerous new challenges—not the least of which was how to redefine work and family roles. Although some positions were open only to men, both genders worked side-by-side at jobs like spinning and weaving, causing the Carolinas to lead the nation throughout the twentieth century in the percentage of women working outside the home. Tompkins and other textile manufacturers required a worker be supplied for every room in a family's house. As a result, the number of children—as young as six or seven—toiling up to 12 hours a day, 6 days a week in the state's mills, swelled to over 25 percent before a 1903 law forbade employment of persons under twelve years of age. Mill owners did not stand for organized labor and quickly put down attempts at unionization—even violently at times.

The 1911 graduating class of Charlotte University School—a college preparatory academy for boys founded in 1907 and owned and operated by Professor Hiram W. Glasgow. The institution closed in 1930.

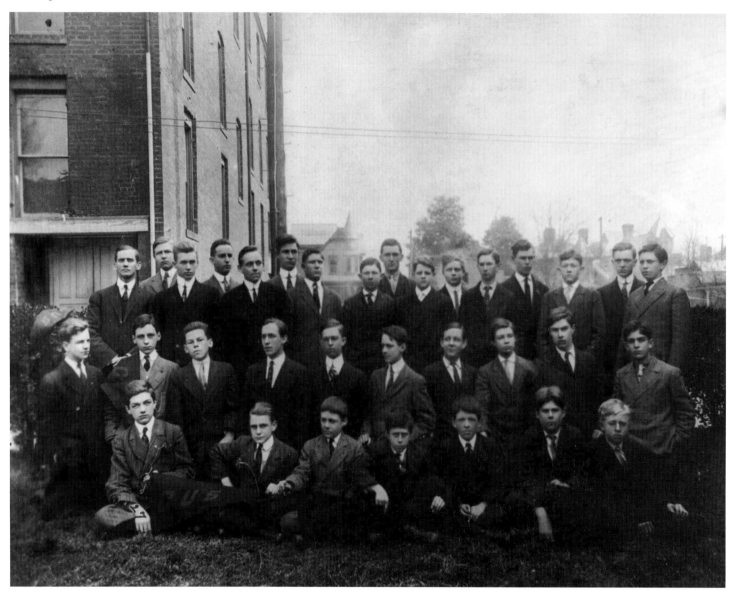

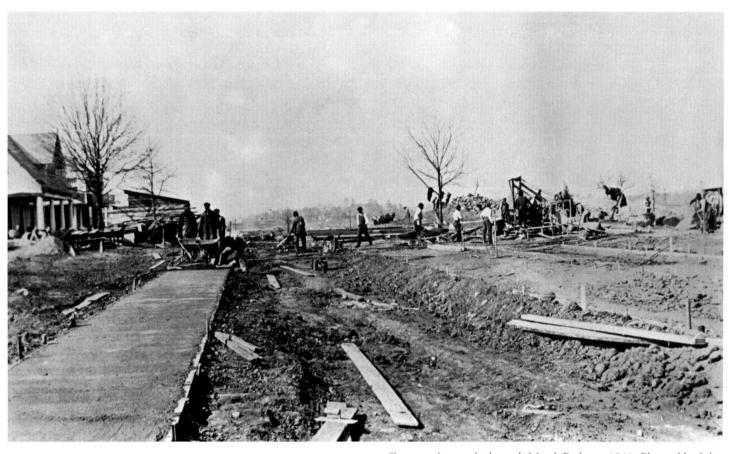

Constructing roads through Myer's Park, ca. 1911. Planned by John Nolen—one of the country's best planners—this stately Charlotte neighborhood was formerly the farm of Jack S. Myers.

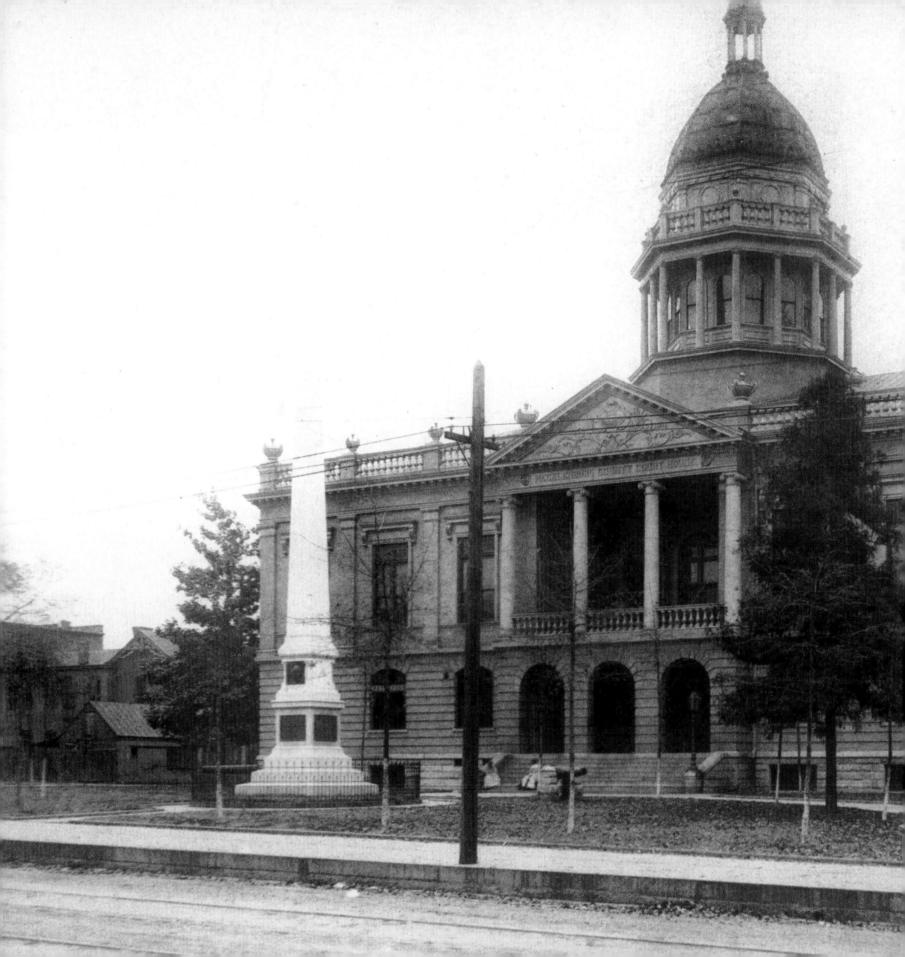

In 1896, Mecklenburg County erected a new courthouse at the southeast corner of Tryon and Third streets on the former site of Liberty Hall, a Revolutionary War–era academy.

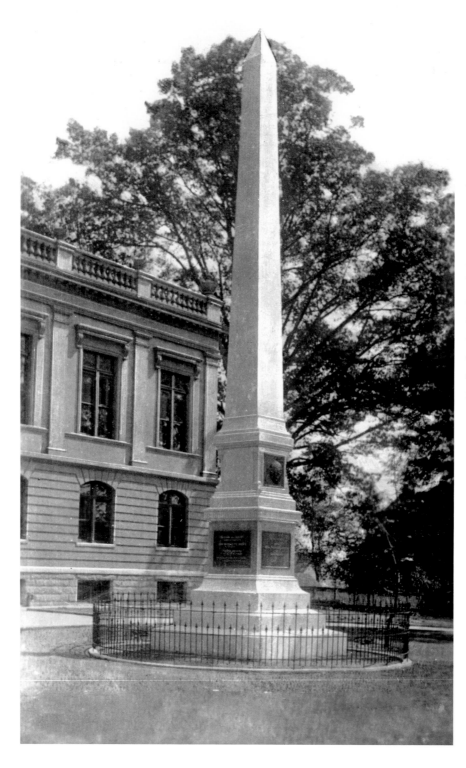

The 1898 annual celebration of "Meck Dec Day," commemorating the alleged signing of the Mecklenburg Declaration of Independence on May 20, 1775, was one of the grandest in the history of the city—eclipsing even the Centennial Celebration. The day's ceremonies included the dedication of this monument, erected in front of the courthouse on South Tryon and East Third streets. When the county constructed a new courthouse on East Trade Street 25 years later, the obelisk was moved to the esplanade in front of the new building.

Mary Anna Morrison grew up near Charlotte. She married Thomas (later called "Stonewall") Jackson in 1857. Two of Anna's sisters also married Confederate generals. Mrs. Jackson spent the war in Charlotte, living at her West Trade Street home after her husband's death at Chancellorsville. As a widow representing the "Lost Cause," she became an iconic figure of near religious adoration in the city.

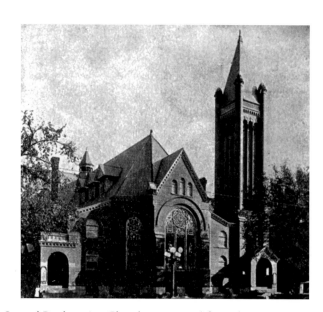

The Second Presbyterian Church was created from the congregation at
First Presbyterian (previously known as simply the Presbyterian Church)
when they outgrew their building in 1873. The daughter congregation
met for a while in the courthouse and even built a small church on
North Tryon Street in 1875. In 1894, the group built this commanding
sanctuary, seen here about 1910.

Two Charlotte women enjoy a drive in an early automobile, ca. 1905.

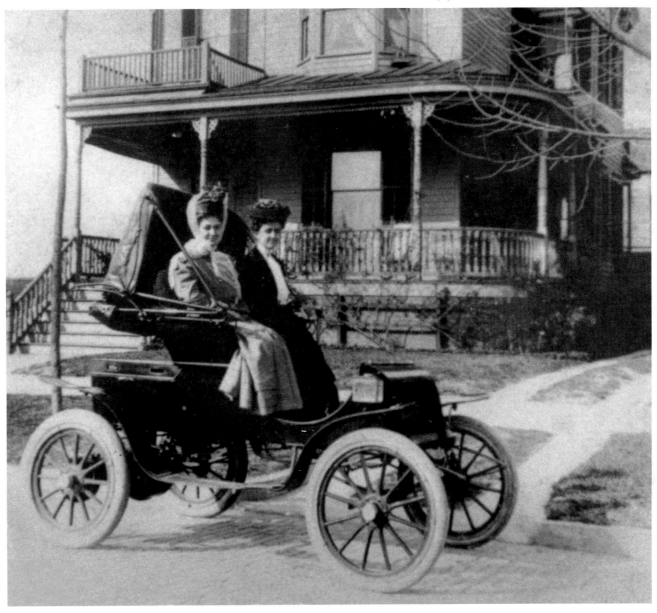

Elizabeth College, located at the intersection of Elizabeth Avenue and Hawthorne Lane, opened in 1897—one of many women's colleges that sprang up in the South concurrent with the growth of a white-collar class that did not need to put their daughters to work on the farm or in the textile mill. In addition to academic courses, Elizabeth offered conservatory training in art, voice, piano, and violin. The school moved to Salem, Virginia, and the grounds were acquired by Presbyterian Hospital in 1918.

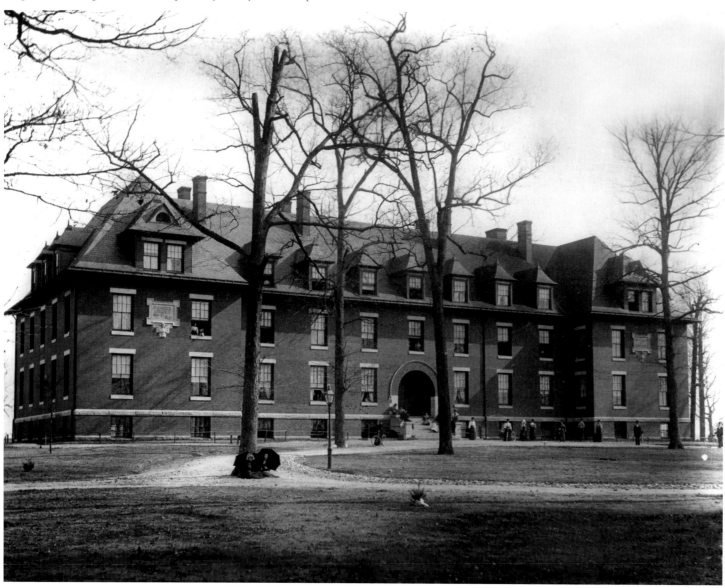

Elizabeth College was renowned for its Gerard Conservatory of Music.

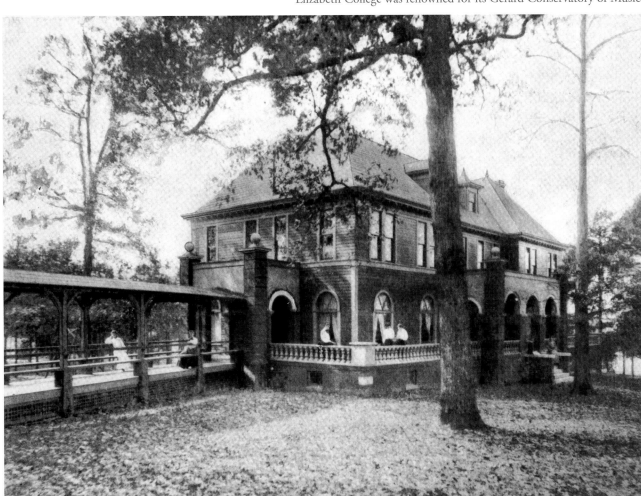

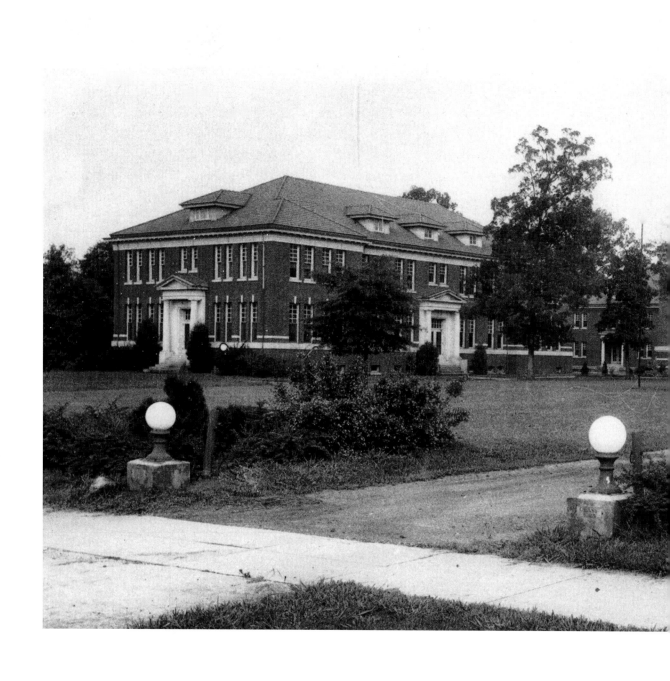

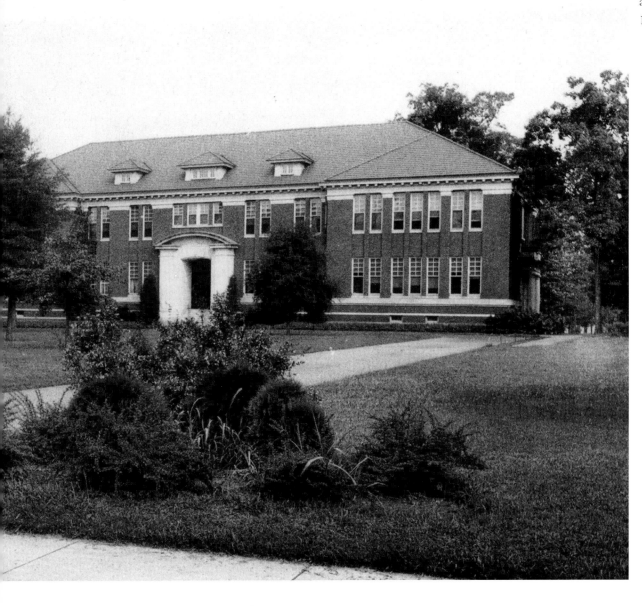

The grounds of Queens College
as they appeared in the early
1920s

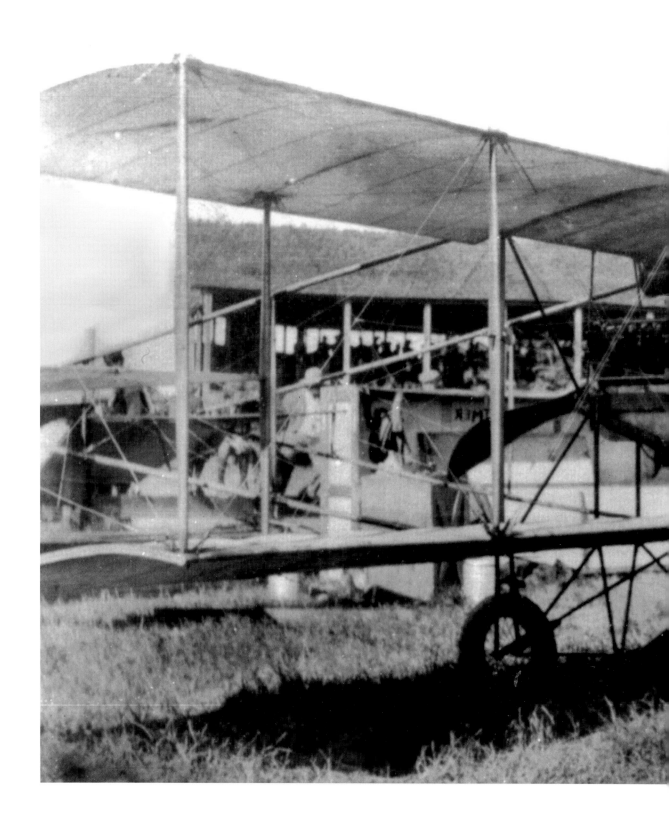

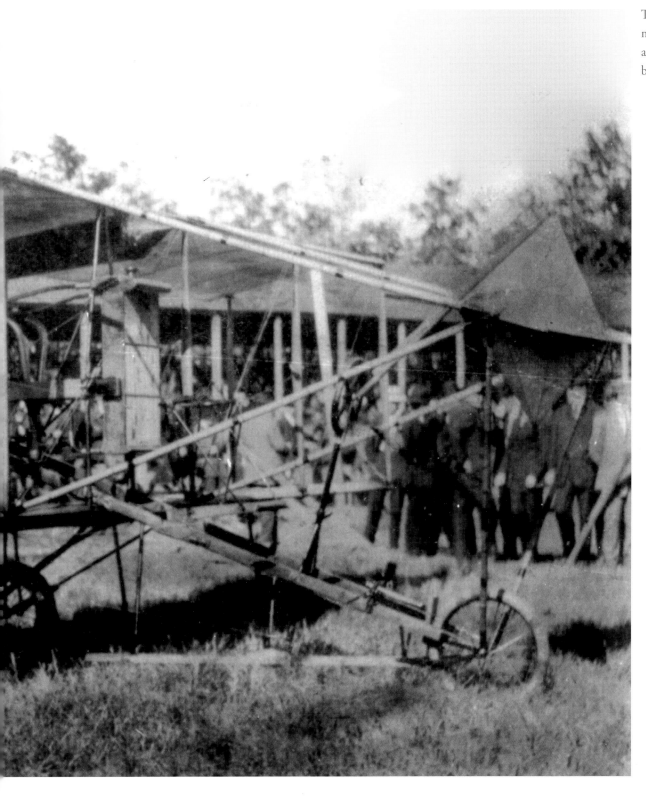

This early airplane
must have been quite
a curiosity in the days
before World War I.

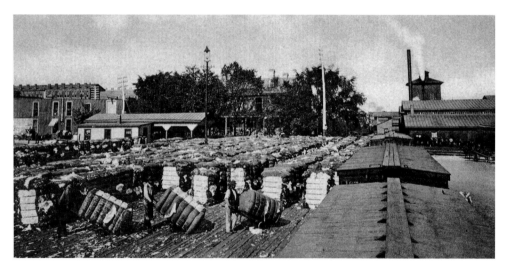

Trucking cotton on the old city platform (1906)

Thomas B. Hoover sits in one of his horse-drawn buggies in 1905. His livery stable stood in the 200 block of East Trade Street.

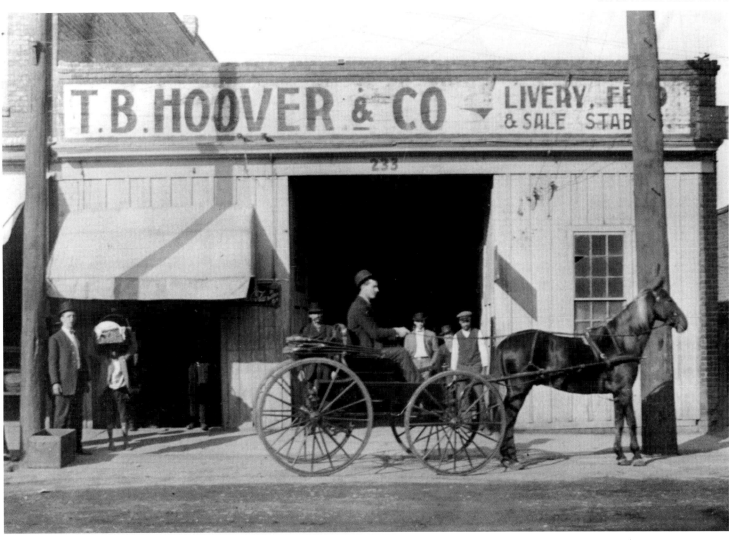

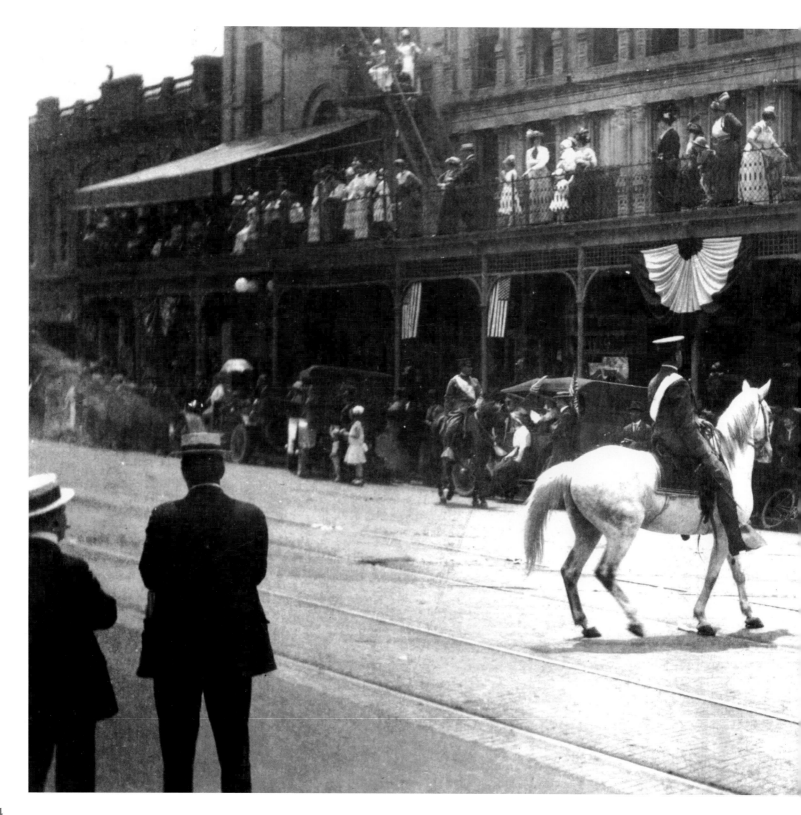

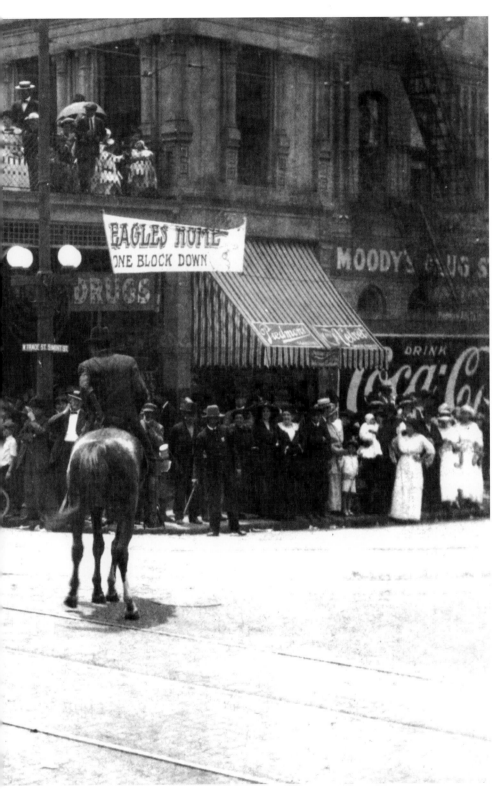

The second floor of this building served as Presbyterian Hospital's first home—notice the patients and nurses standing on the balcony to watch the annual Mecklenburg Declaration Day parade. Seen here ca. 1900, it stood on the corner of Church and Trade streets across from the Selwyn Hotel.

Looking north up College from Fourth Street, ca. 1904, reveals a bustle of activity. Philip Carey Manufacturing at left sold cement, roofing materials, and pipe coverings. The Klueppelberg Grocery is visible at right.

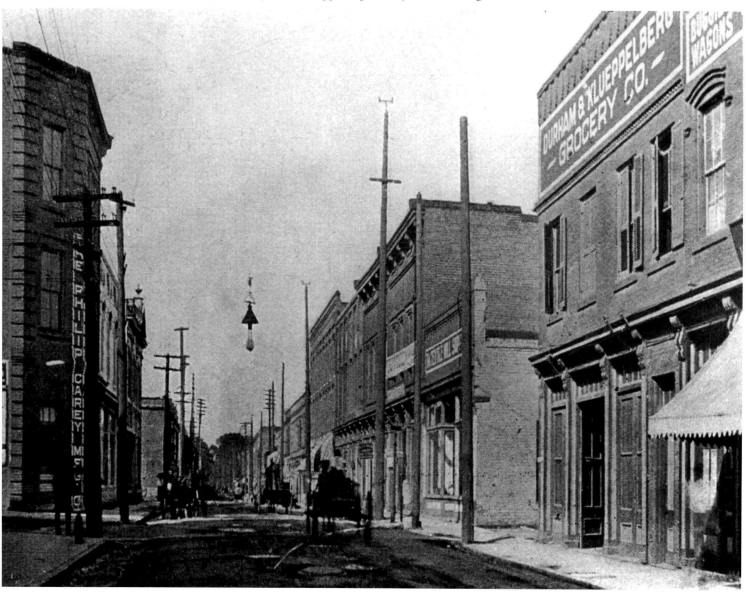

Located at Tryon and Fifth streets, the J. B. Ivey Company opened in May 1924. The building, designed by William Peeps at a cost of $1,250,000, is today used for shops and condominiums.

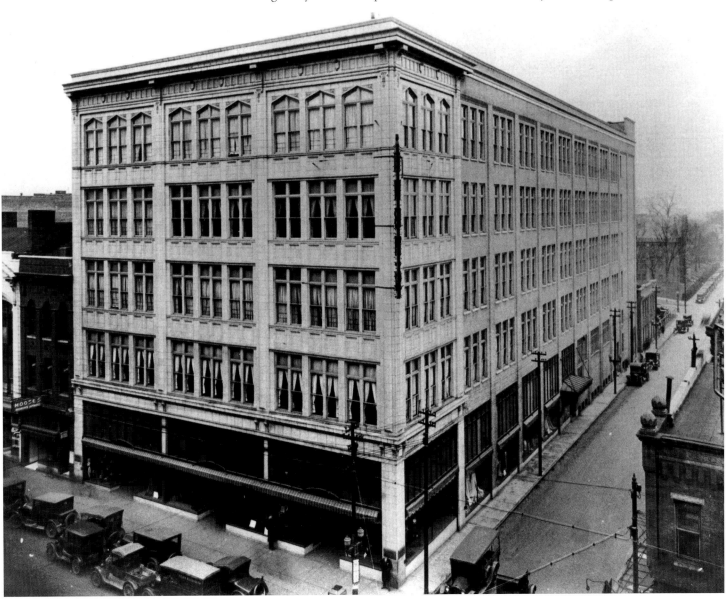

A devout Methodist, J. B. Ivey insisted that his window displays—seen here—be curtained off on Sundays, in order that pedestrians not be tempted by worldly concerns.

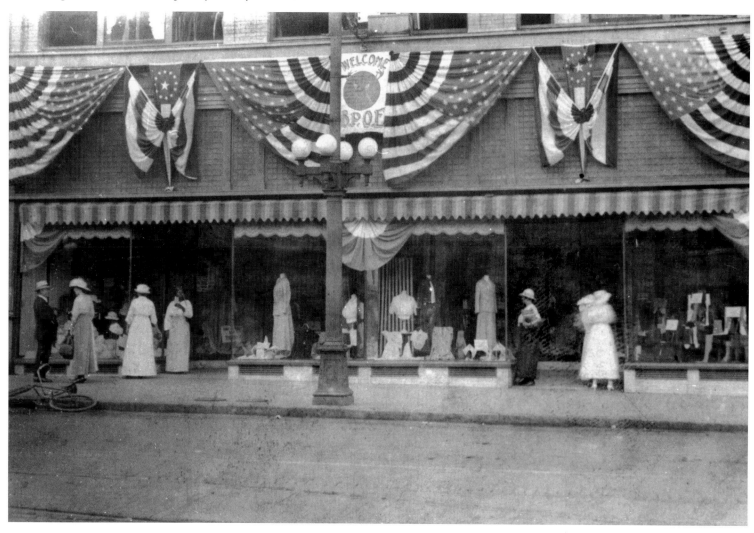

The Bee Hive—a posh dry goods, clothing, shoes, and millinery store—stood at the intersection of College and East Trade streets (ca. 1904).

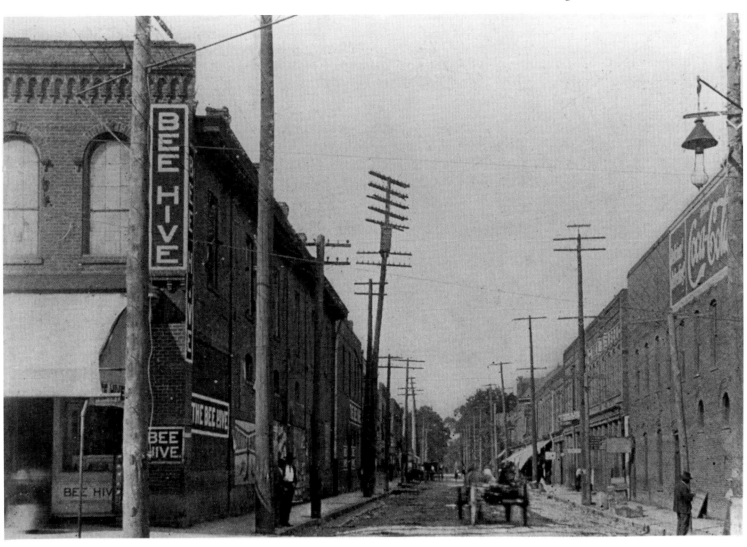

Facing east down turn of the century Trade Street, with the Belk Brother's department store at the left.

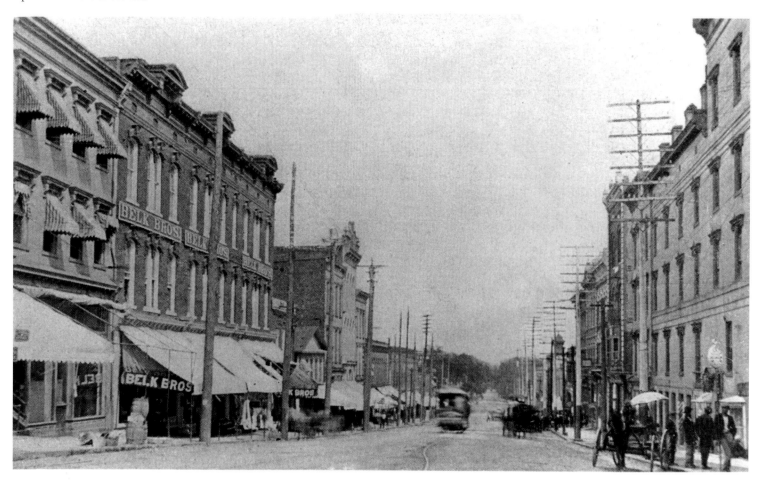

Formed by the merger of two smaller congregations, the First Methodist Church opened its doors in 1927. Times got tough quickly and the new congregation barely held on to its new $900,000 sanctuary during the Depression, finally clearing its indebtedness in 1944.

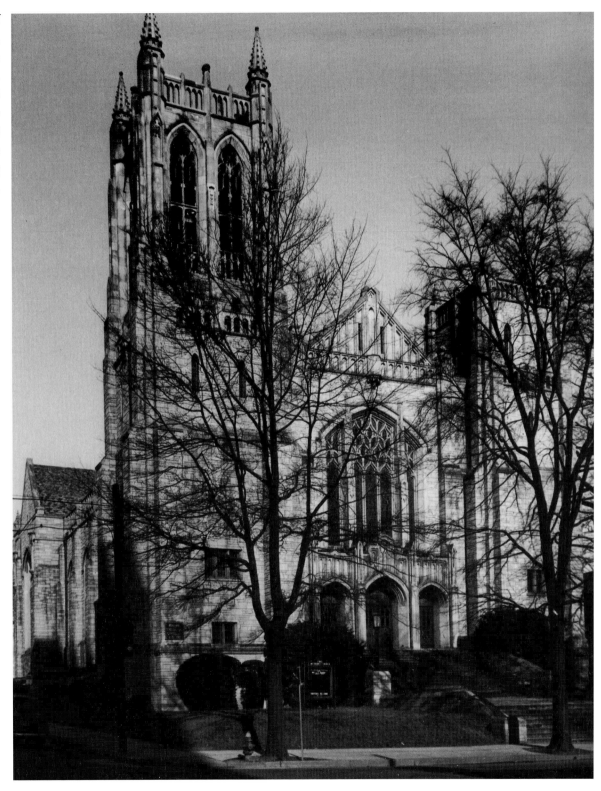

Mayor Kirkpatrick and Governor Locke Craig (ca. 1916)

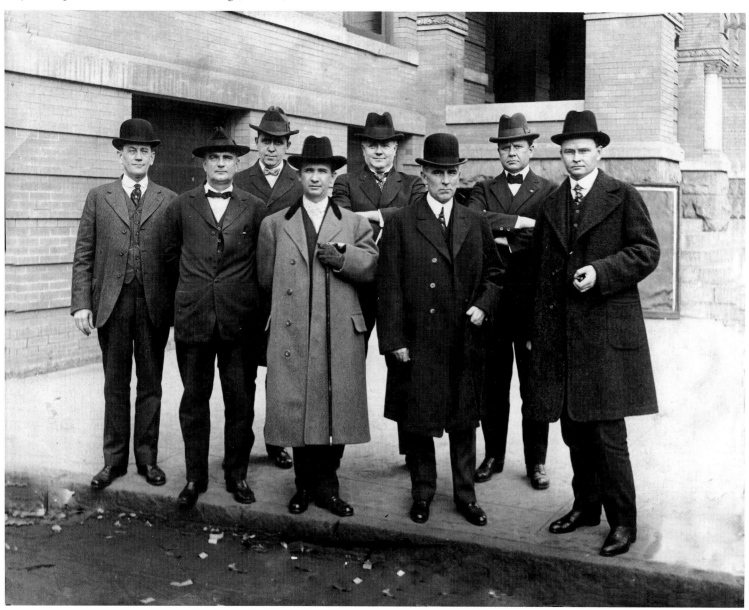

President Woodrow Wilson was the guest of honor at the 1916 annual celebration of the Mecklenburg Declaration of Independence—"Meck Dec Day."

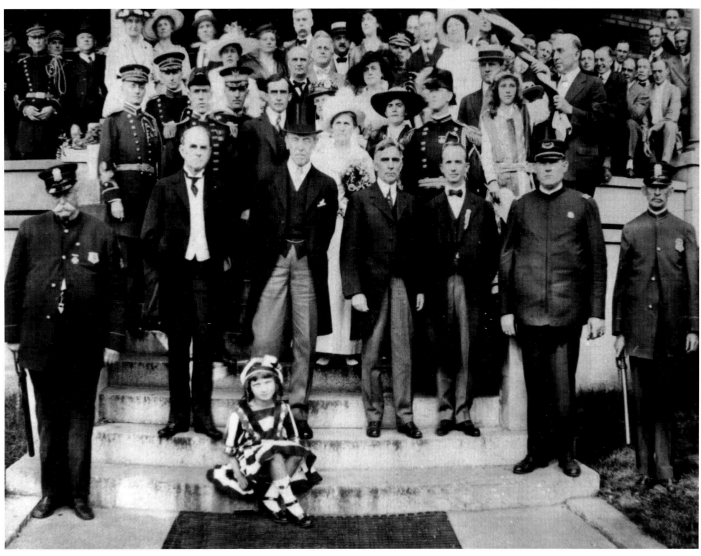

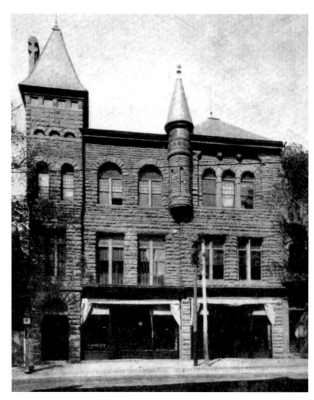

Built between 1887 and 1889, this brownstone building housed one of the first YMCAs in Charlotte. Standing on South Tryon Street between Third and Fourth streets, the building was sold to the American Trust Company in 1905.

Still smarting from the loss of the Civil War and struggling against persistent poverty, business leaders organized the Charlotte Chamber of Commerce in 1877. They published "booster booklets" and advertised in magazines—anything to attract businesses to the city. Their motto, adopted in 1905, "Watch Charlotte Grow," is emblazoned on this parade drum of the Charlotte Drum Corps.

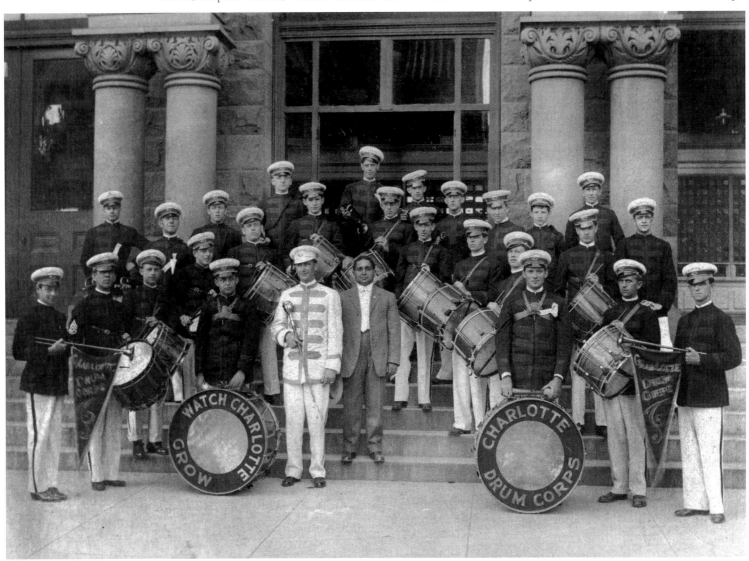

Campsite in Camp Greene

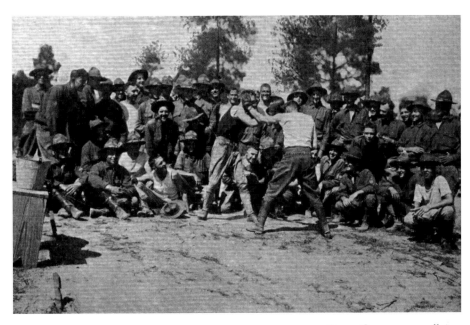

Camp Greene men rallying
around a match of boxing

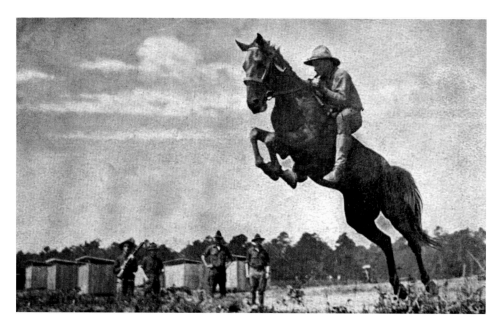

Horsemanship at Camp Greene

Two women park their horse and buggy in front of the Selwyn Hotel's Church Street entrance, ca. 1905.

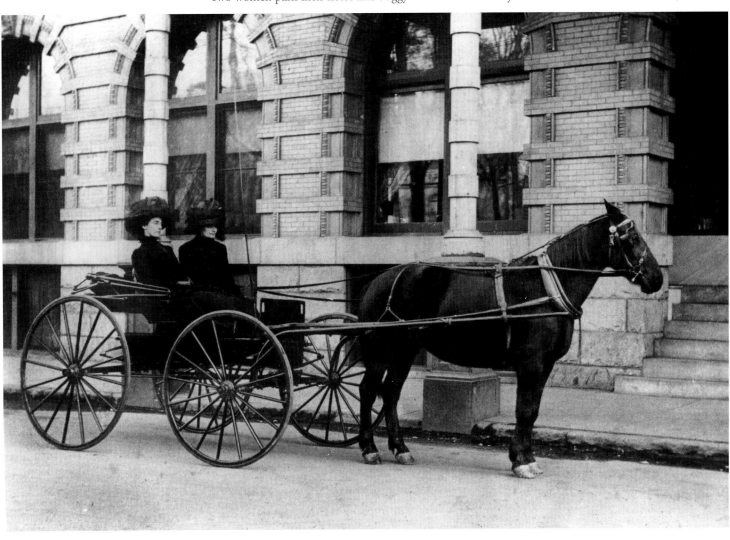

Fourth Street facing west from College Street (ca. 1904)

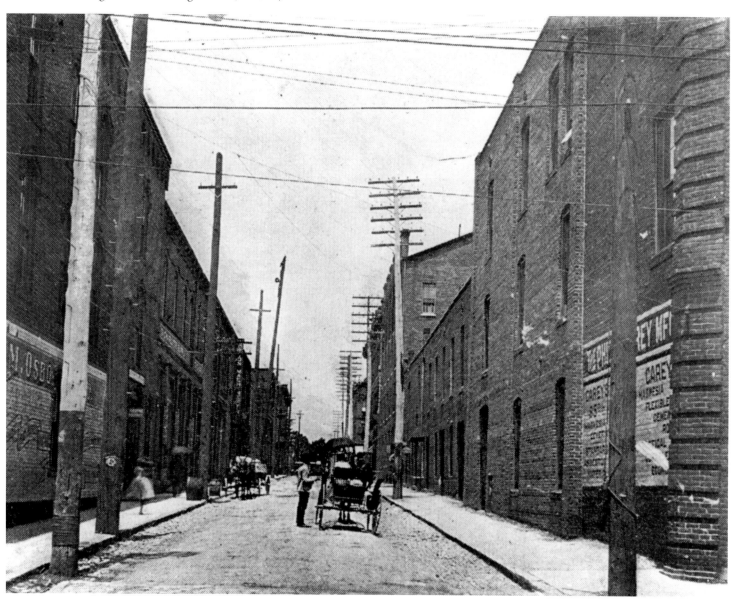

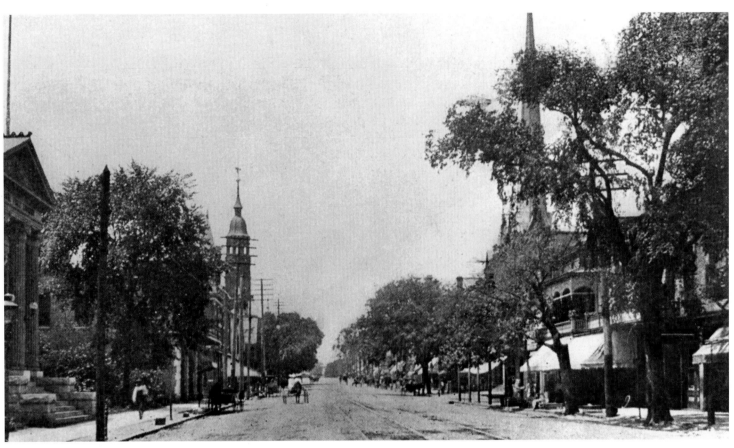

North Tryon Street in the early years of the twentieth century. City Hall and the new Carnegie Library are at left. The steeple of First Presbyterian is visible through the trees at right.

The Atherton—located on South Boulevard—was one of Charlotte's most productive textile mills. The structures have been adapted for re-use as lofts, restaurants, and other businesses.

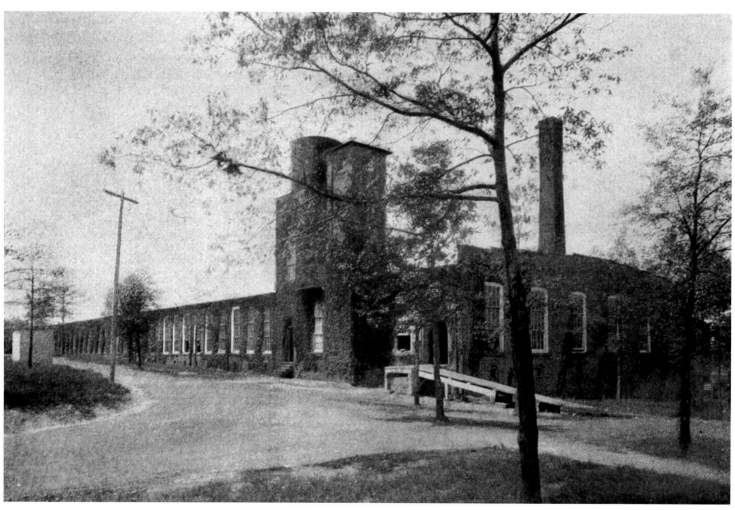

Charlotte industrialist D. A. Tompkins knew that cotton seed had many uses, not the least of which was its manufacture into cooking oil. Tompkins and Fred Oliver established the Southern Cotton Oil Company on South Tryon and Worthington Avenue—the first of many "oil mills" they would build all over the South. The pair also experimented with using cotton hulls for fertilizer and livestock feed.

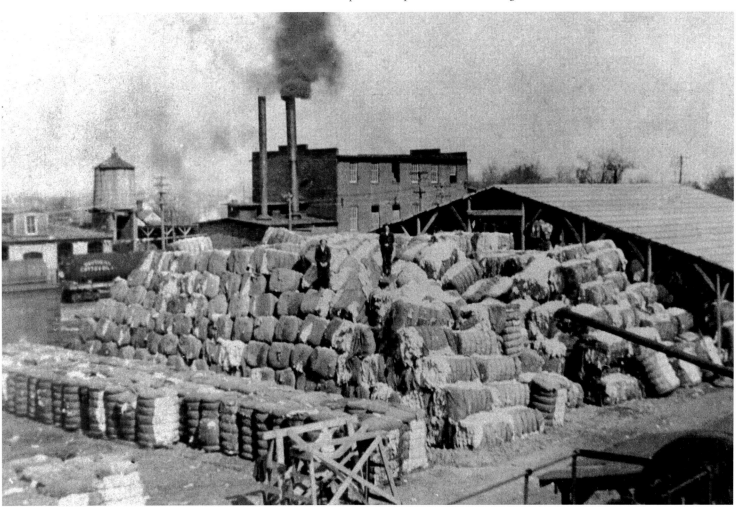

Charlotte's U.S. Post Office when it stood on Mint Street in the early 1910s

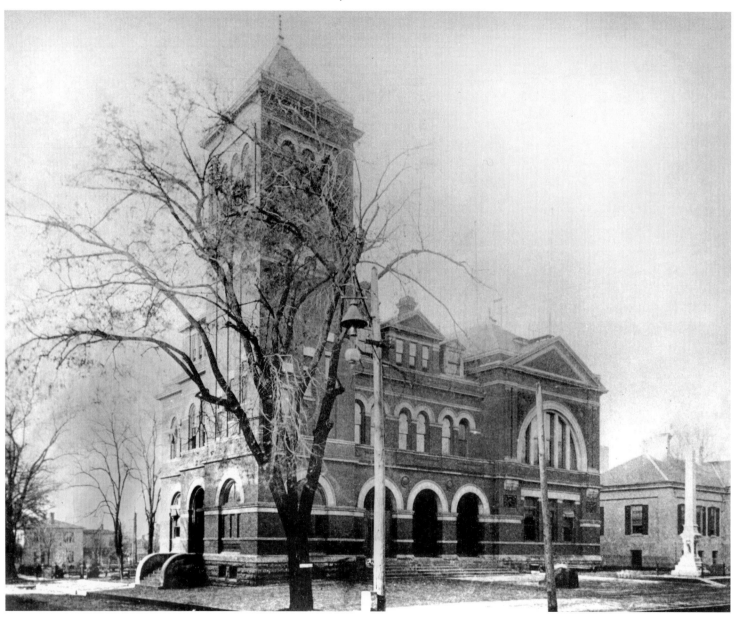

The Queen City Hotel—seen here at the turn of the twentieth century—stood at the northeast corner of College and Fifth streets.

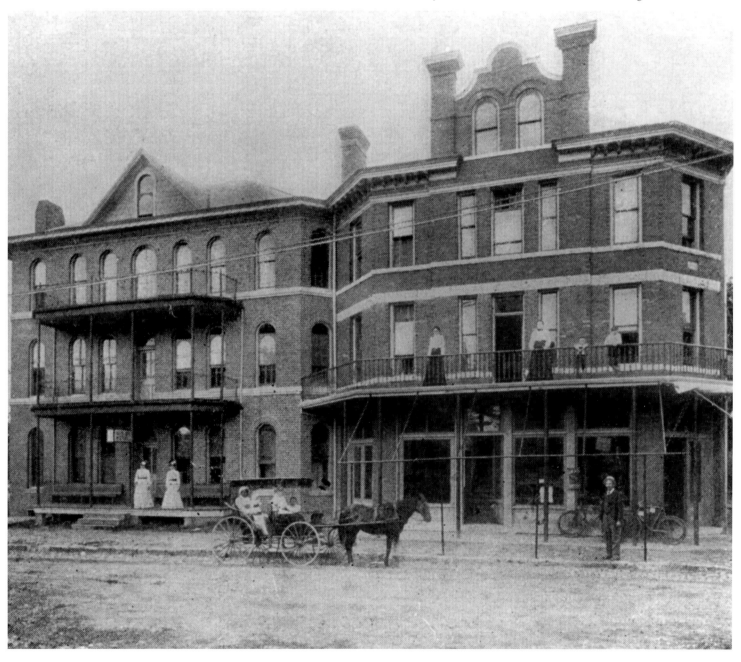

South Tryon Street, seen from its intersection at Trade Street (ca. 1904)

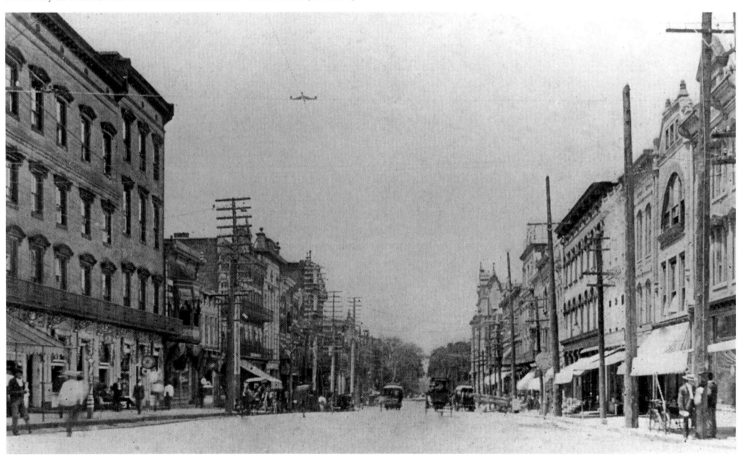

West Trade Street, seen from its intersection at Tryon Street (ca. 1904)

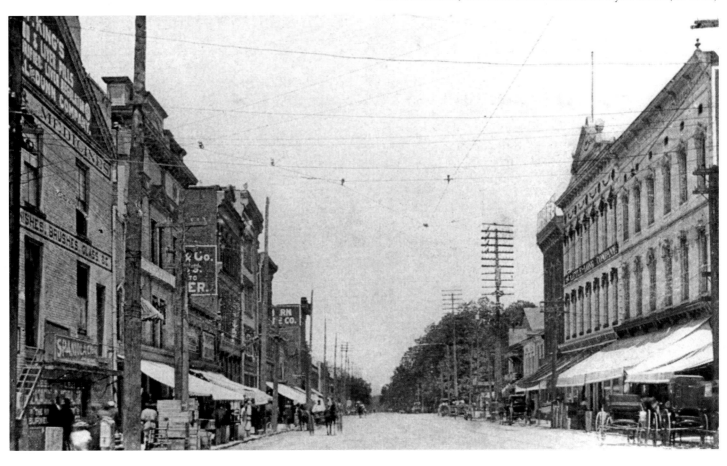

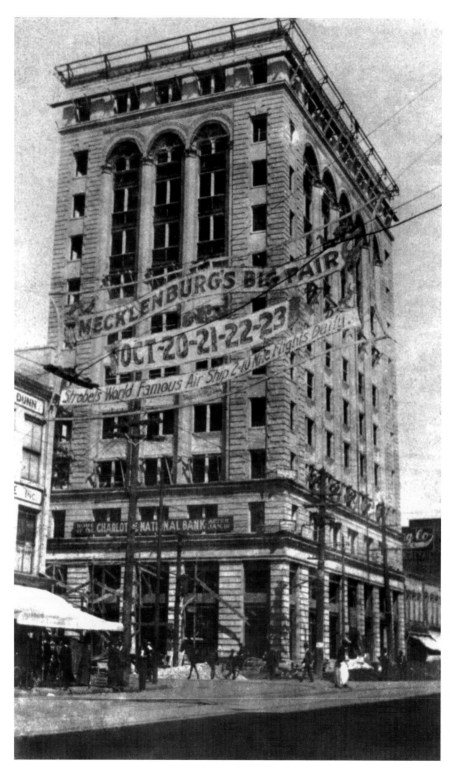

The Independence Building—designed by architect Frank Pierce Milburn—stood at the northwest corner of Trade and Tryon streets. Completed in 1908, it was the tallest building in the state and the first skyscraper built in the Carolinas using steel-frame construction.

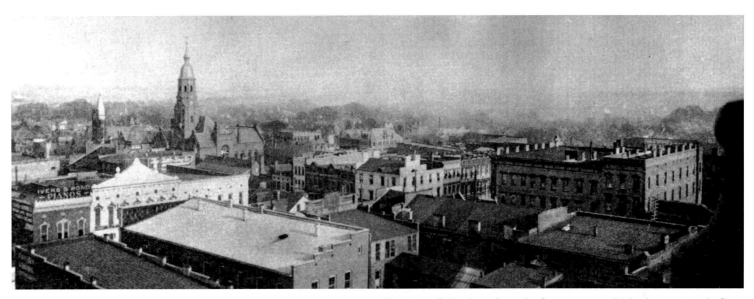

The view of Charlotte from the fourteen-story-high observation platform at the Tompkins Tower was unparalleled. This north-facing image shows Church Street to the left, the courthouse at center, and Fourth Ward to the upper left.

Local farmers bring their crop to market. (ca. 1900)

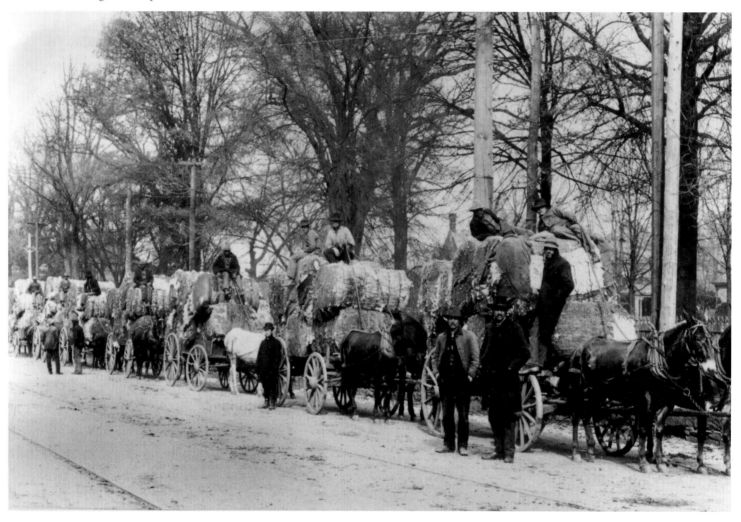

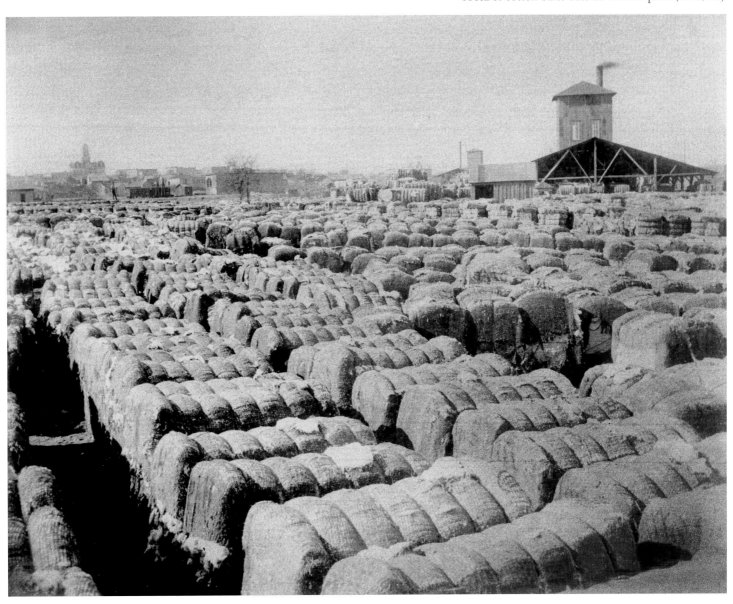

A sea of cotton bales outside the compress (ca. 1900)

W. A. Frye and Dock Crowell opened Charlotte's first Ford garage at
221 North College Street, seen here ca. 1913.

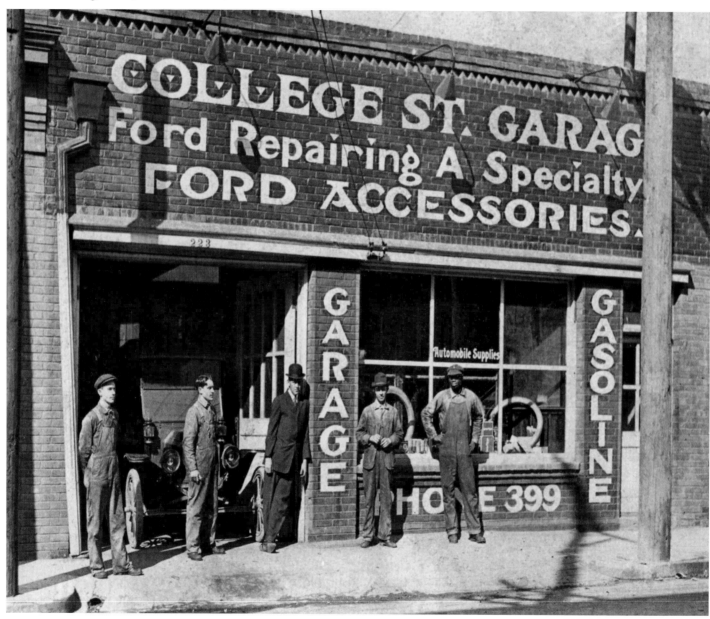

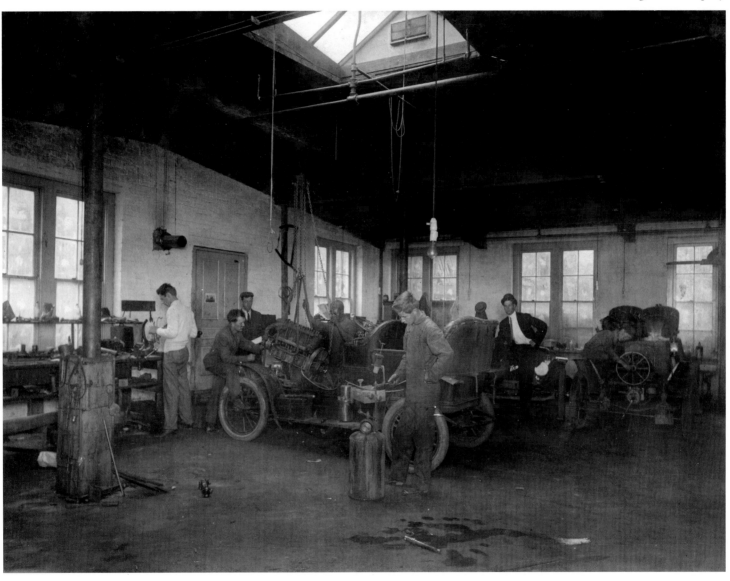

Interior of the Mecklenburg Auto Company

The Mecklenburg Auto Company at 211 South Church Street, ca.
1911. T. E. James was the president.

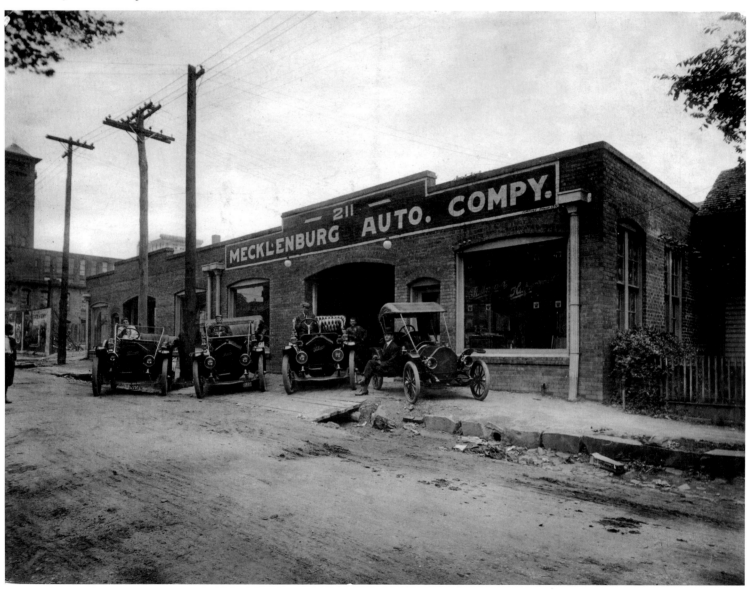

The new Shriner's Band premiered in this February 1916 parade along West Trade Street. Visible along the 200 block of West Trade are Smith's Bookstore, Climax Barbershop and Pool Room, Fites Cash Grocer, Carolina Pawn and Loan, and the Star Café.

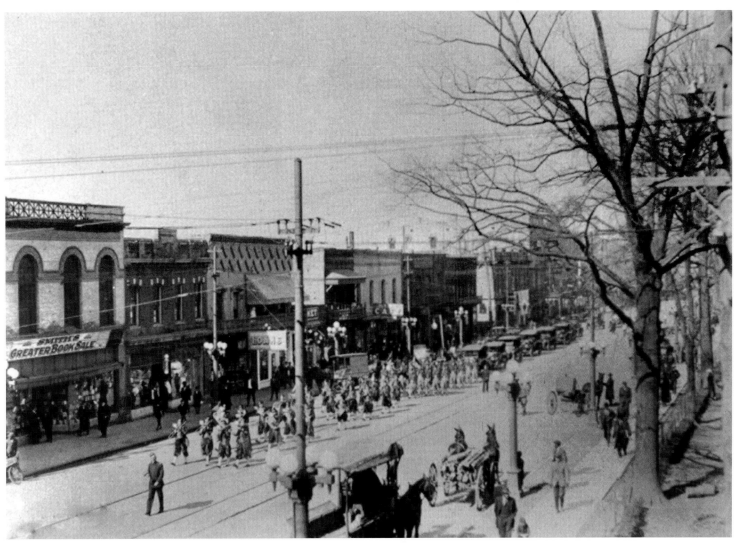

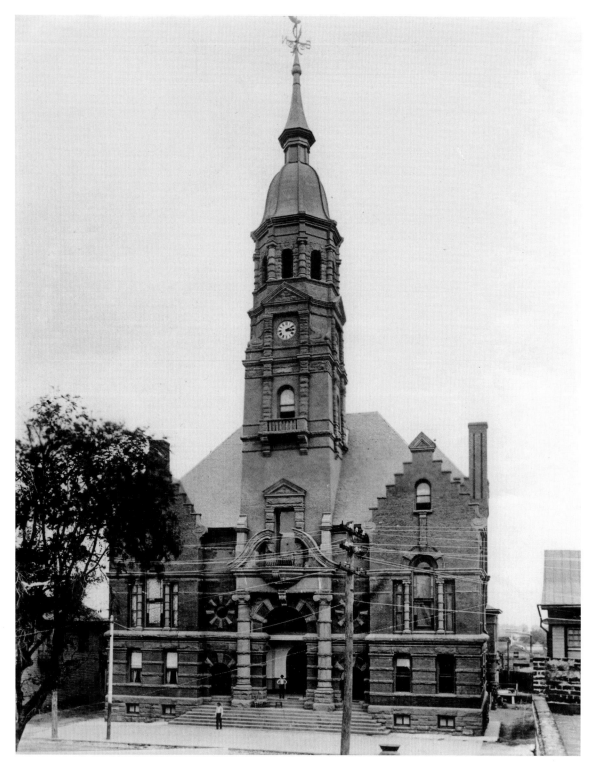

The city erected this new City Hall in 1891 on the southeast corner of Tryon and Fifth streets.

Cotton wagons coming into town (ca. 1900)

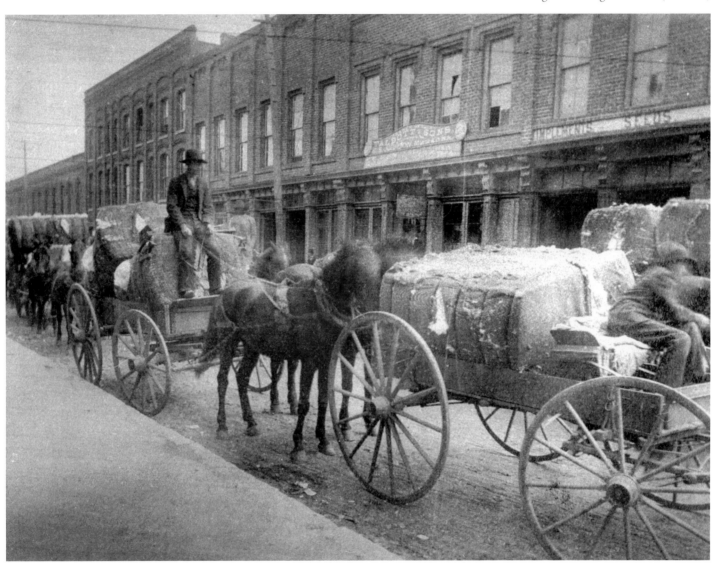

The Charlotte Fire Department located behind Charlotte's City Hall (January 1916)

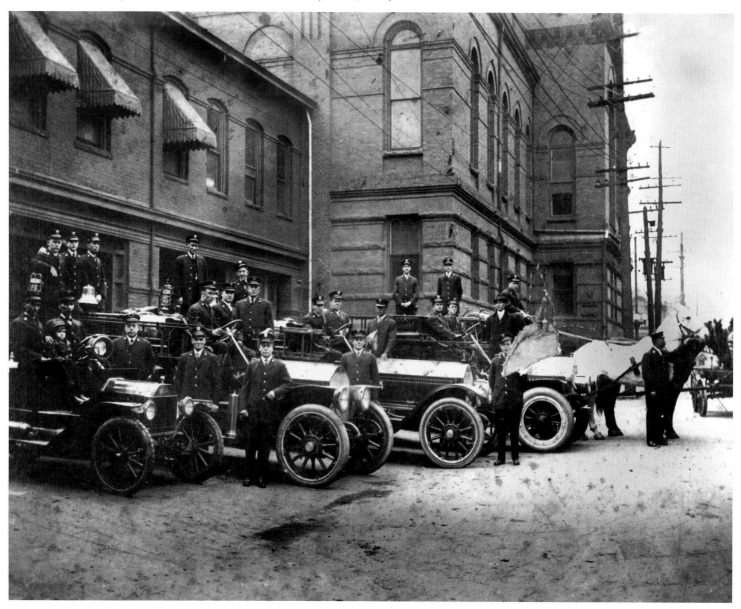

In Charlotte, as in other southern cities, a "Black Main Street" developed near the heart of town but was set off from the official Main Street. Black businesses here clustered along East Second and spilled onto South Boulevard and McDowell streets. This area, known as "Brooklyn," became the largest of the city's half-dozen or so African American neighborhoods. Shown here are pedestrians in the vicinity of Sanders Drugstore. (ca. 1908)

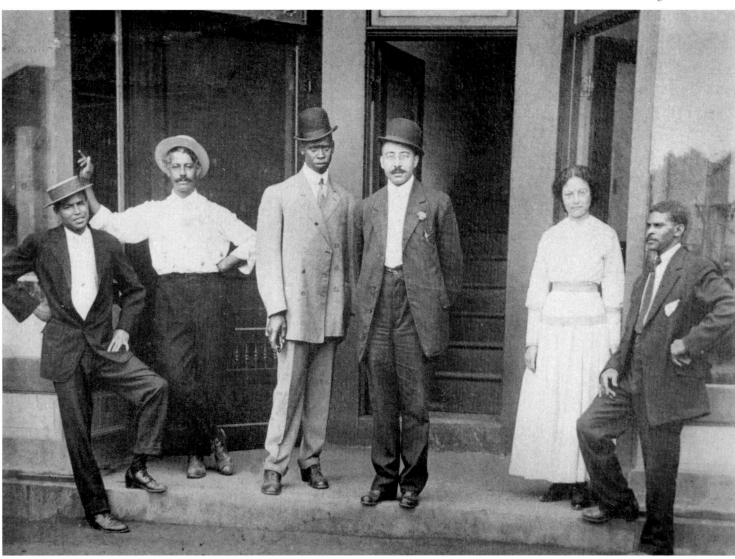

Area cotton farmers bring their crop to downtown. (1900)

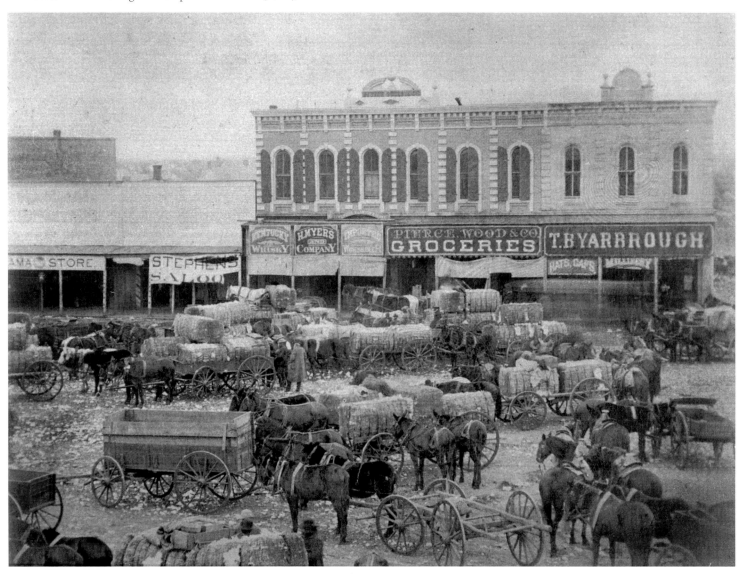

The small building with the "shoes" sign was Belk's first Charlotte store, which opened in 1885. Here employees pose for a photo outside the greatly expanded store on East Trade Street, ca. 1915. The store was demolished in the 1980s to make way for the Founder's Hall complex.

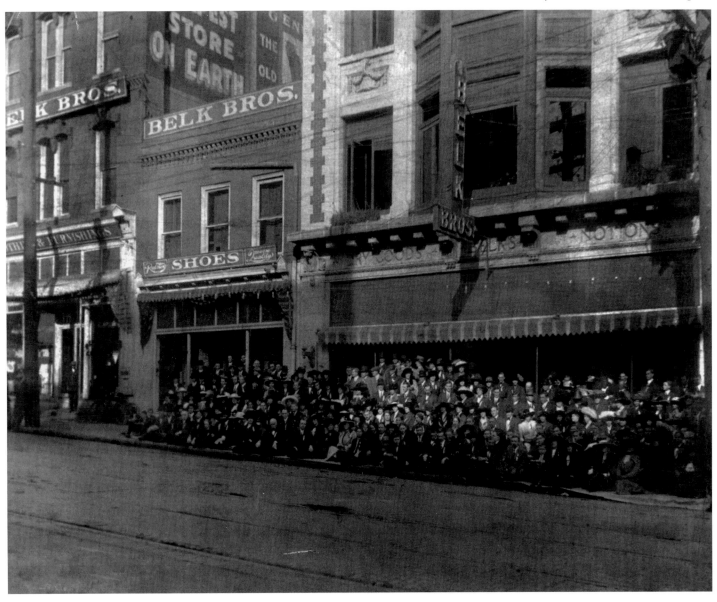

A horse and buggy pause for this 1905 photograph on Central Avenue in front of the home of Charles Parker—the operator of the Parker-Gardner Music Store.

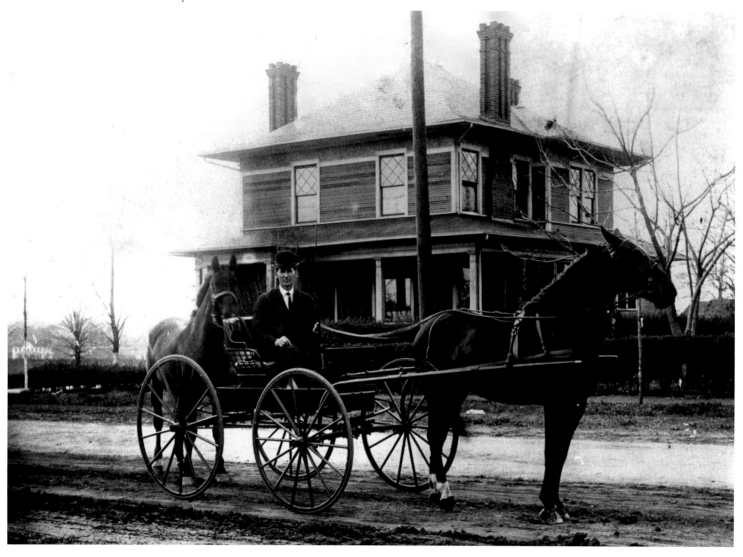

South Tryon's Trust Building was the home of Catawba Power and Light as well as Charlotte's Academy of Music. Fire consumed the structure on December 17, 1922.

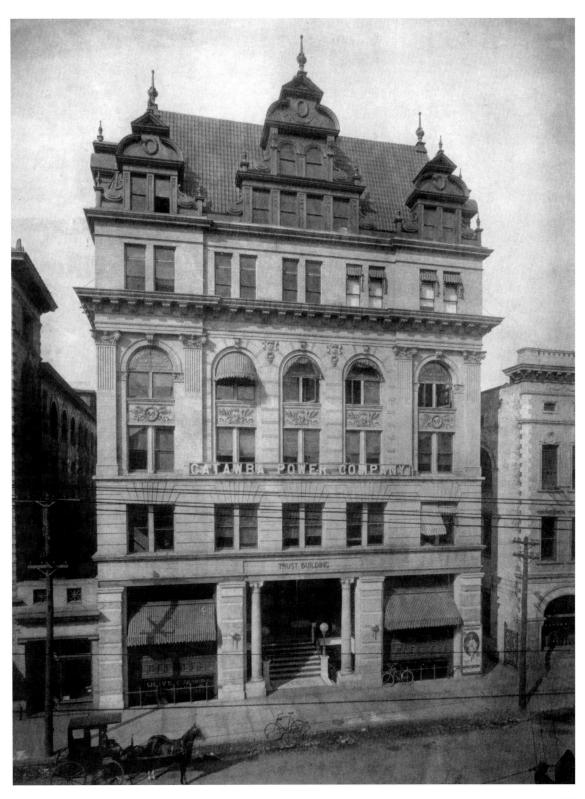

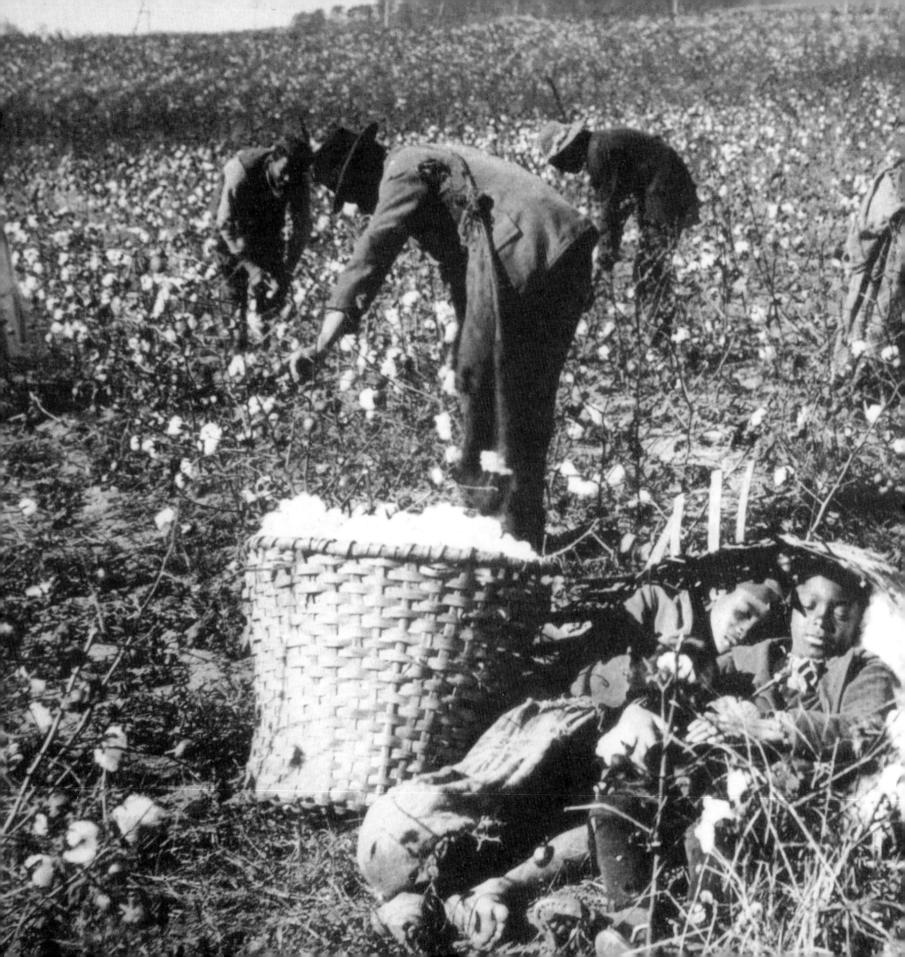

Picking cotton outside Charlotte

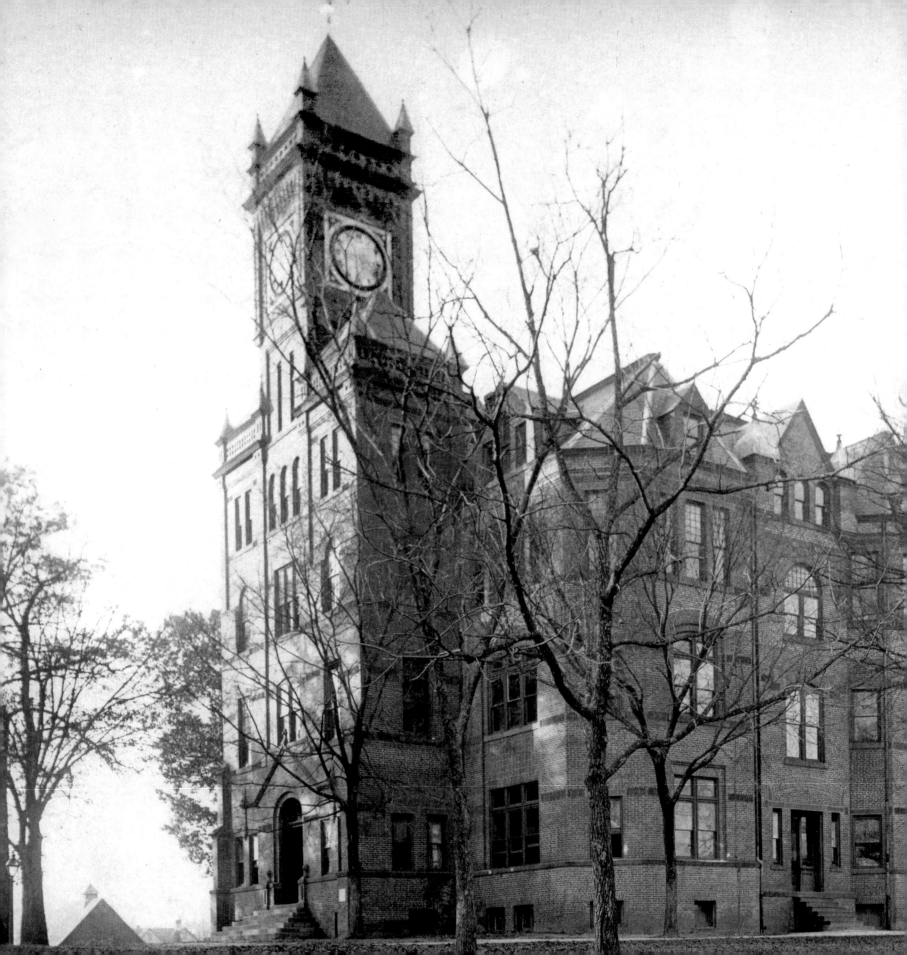

Biddle Hall

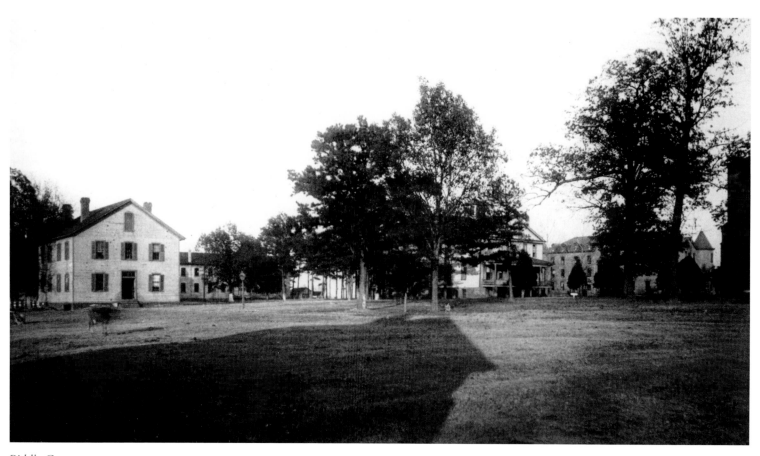

Biddle Campus

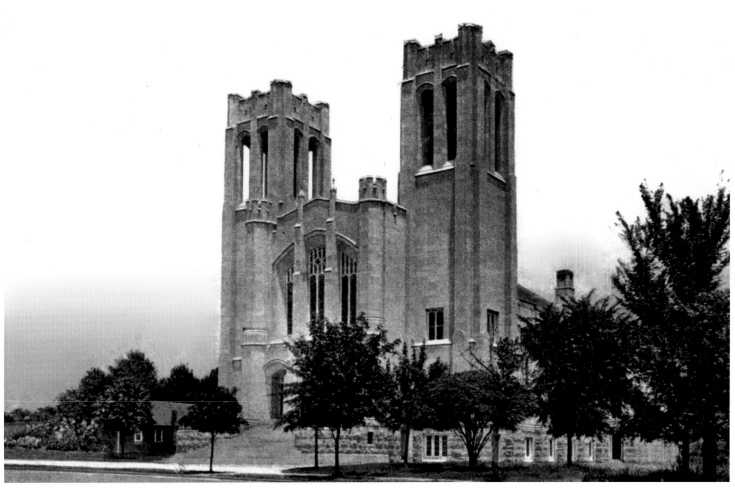

Dilworth Methodist Church

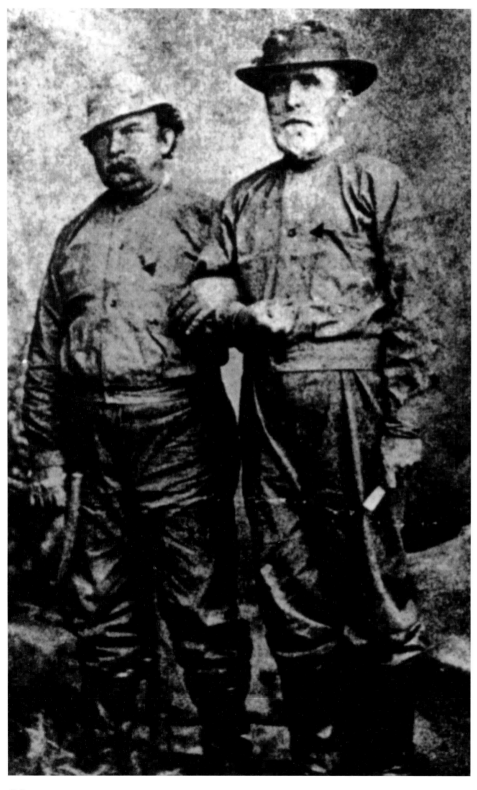

With the first documented discovery of gold in the United States occurring near Charlotte in 1799, gold mines quickly sprang up all over the region. Two of the most successful operations in Charlotte—the Saint Catherine and Rudisill mines—along with several others were consolidated into the Mecklenburg Gold Mining Company in 1830. These two miners worked in the Rudisill during the 1880s.

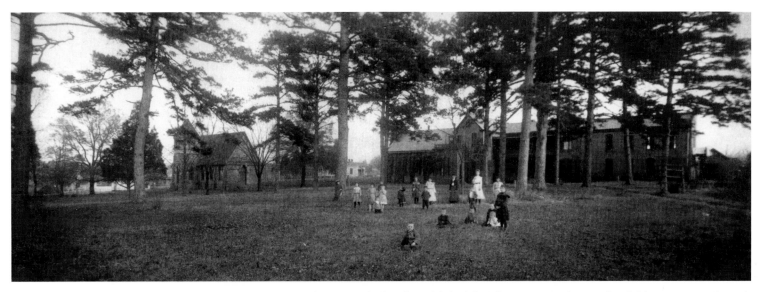

In 1887 Saint Peter's Episcopal Church established the Thompson Orphanage for children ages two through eighteen, becoming the first orphanage in the state supported by a religious body. The orphanage consisted of cottages, a chapel (erected in 1892), and a farm where the children and teachers milked cows. The organization moved in 1970. Only the chapel stands today, near Central Piedmont Community College.

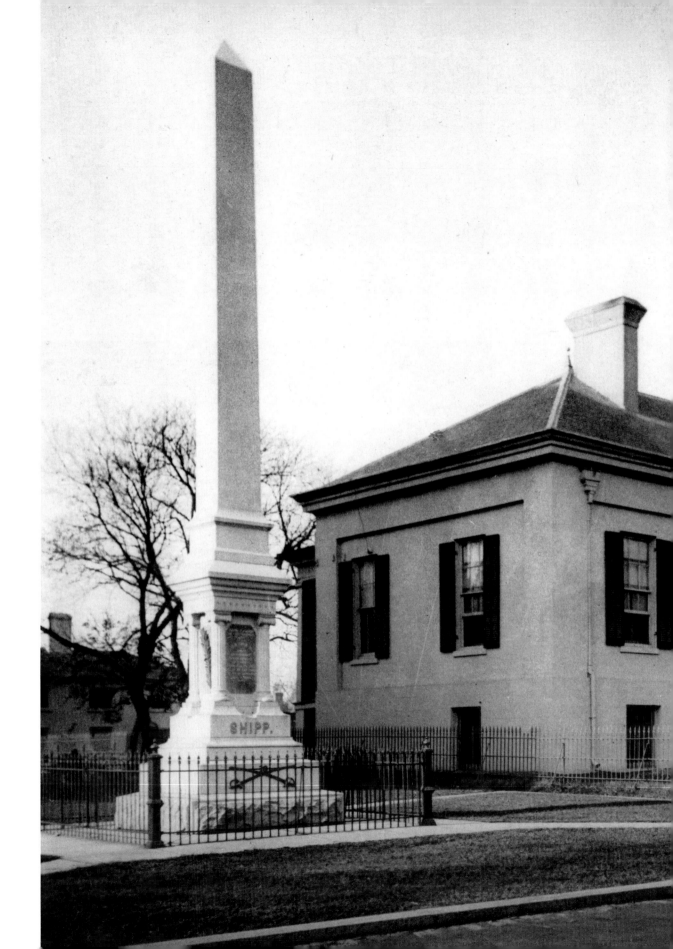

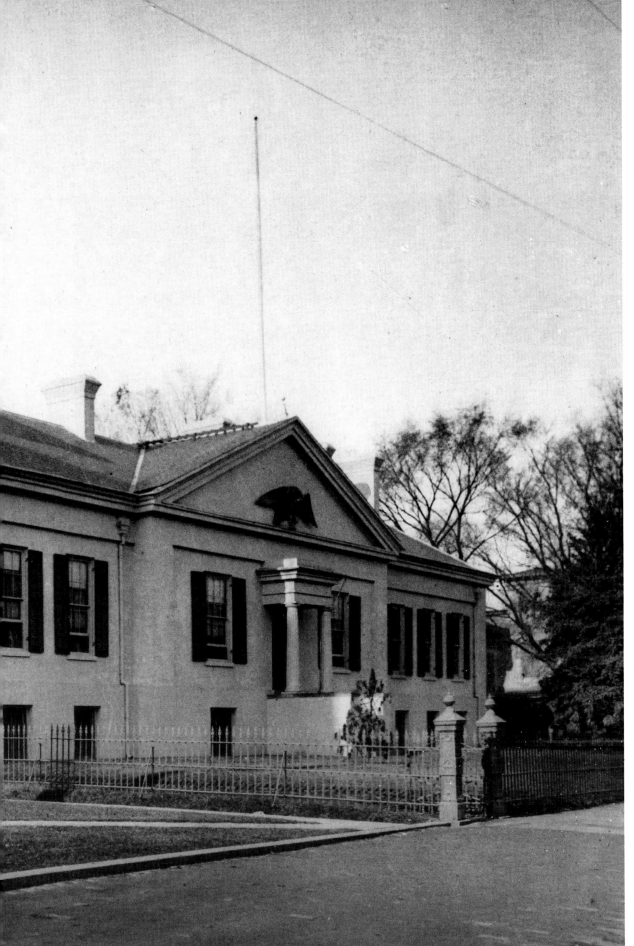

Charlotte became the gold trading center for the region. In March 1835, Congress approved the construction of a U.S. Mint in Charlotte to strike the Carolina gold into coins. The building stood at the corner of Mint and West Trade streets until the 1930s, when it was taken down and reconstructed in the suburbs as the Mint Museum of Art—the state's first art museum.

World War I soldiers march down Tryon Street.

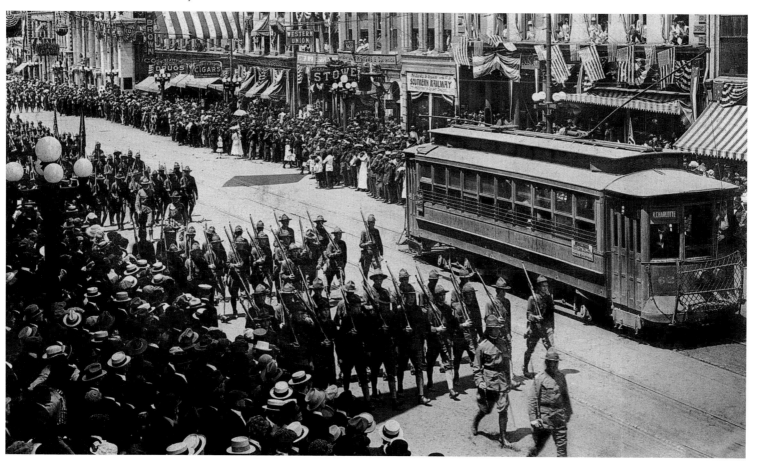

Shortly after the Armistice was signed, the Daughters of the American Revolution erected this monument honoring the soldiers of Camp Greene. It still stands at the corner of Wilkinson Boulevard and Monument Street.

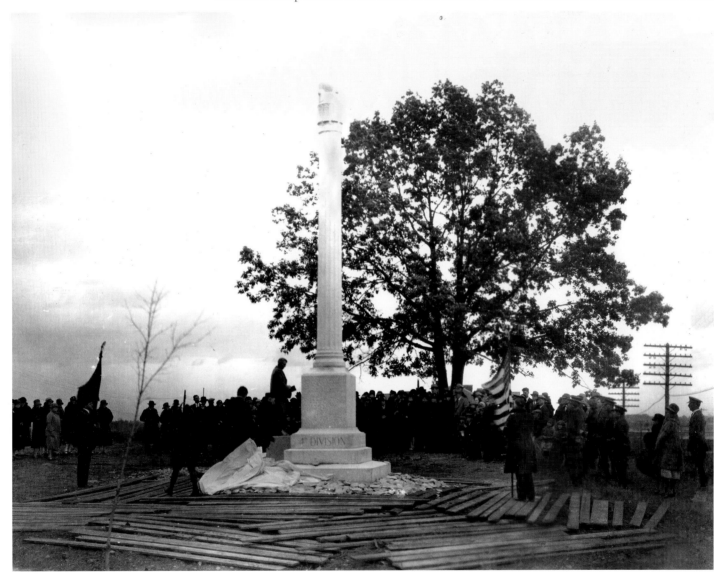

Charlottean Gladys Tillett organized support across the state for passage of the 19th Amendment, which gave women the right to vote in 1920. Here a suffrage parade float rolls down Tryon Street.

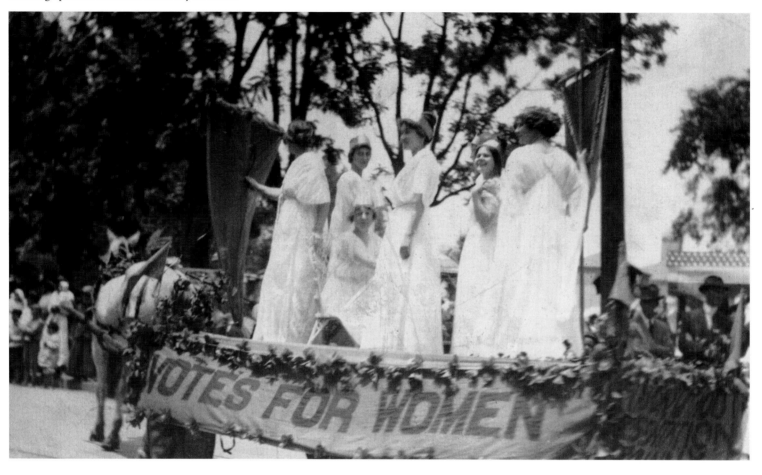

The home of retailer William Henry Belk was designed by architect Charles C. Hook. The 1925 structure stands today at 120 Hawthorne Lane and is used by Presbyterian Hospital.

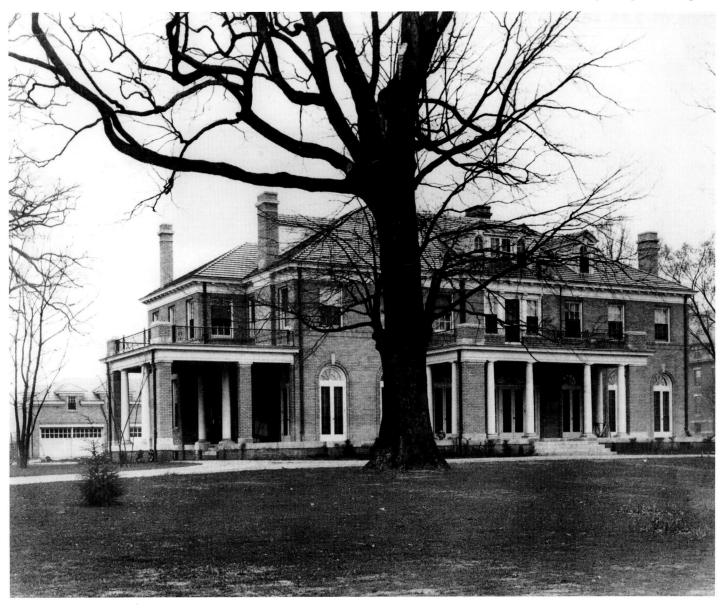

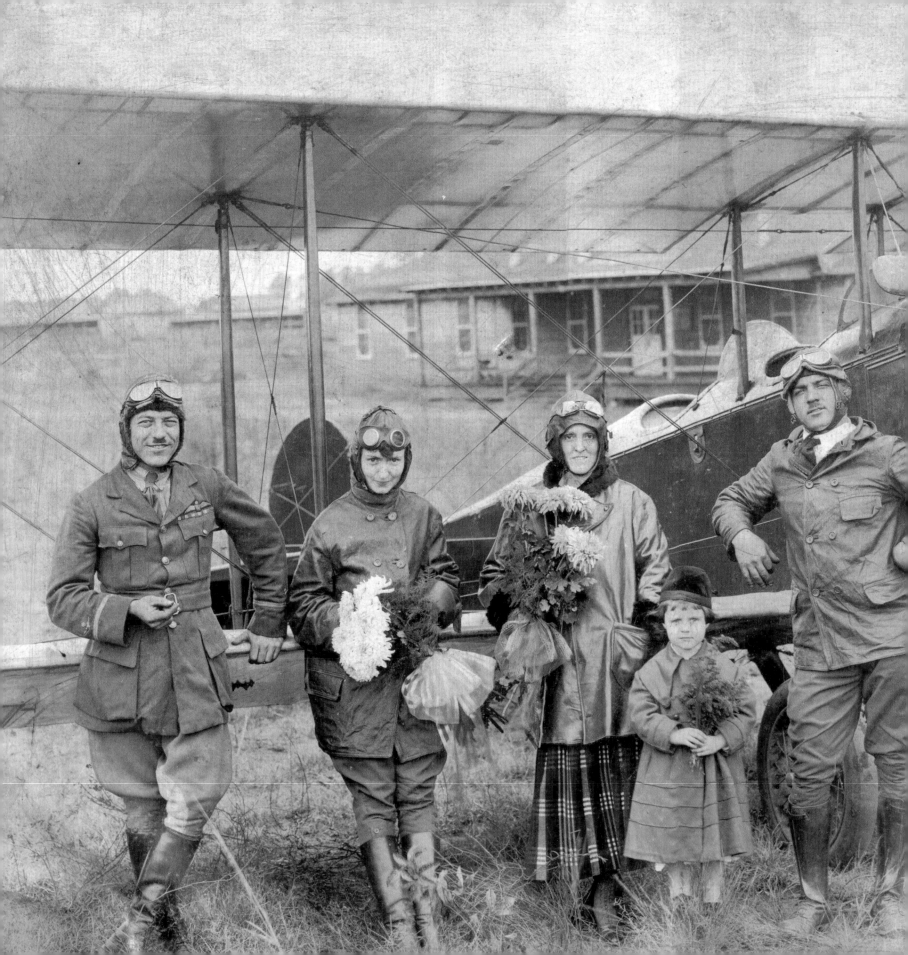

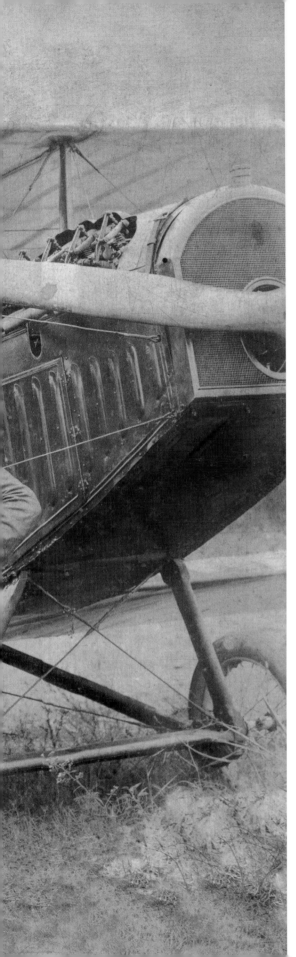

Osmond Barringer loved dreaming up
publicity stunts for Charlotte's newspapers.

This dusty driver and mechanic pause during an open road race in front of the *Charlotte Observer* building on South Church Street in 1919. In the early days of the sport, mechanics often traveled along with the drivers, especially on long-distance races—their skills being needed to make repairs and often to put out fires.

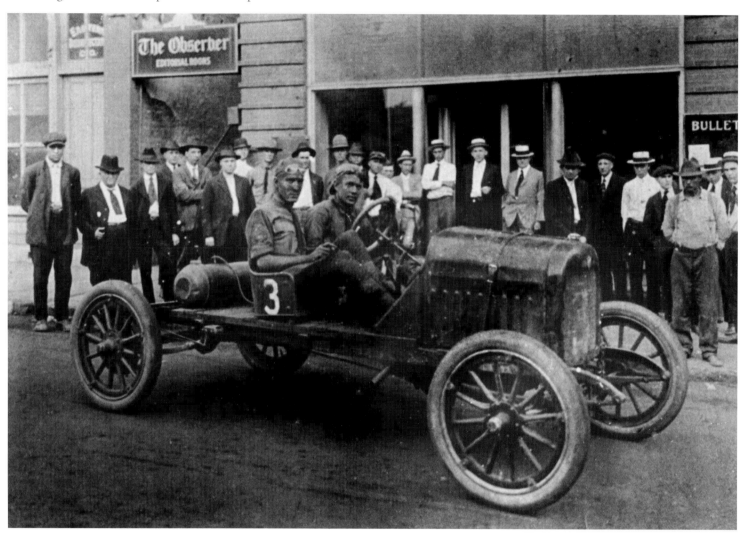

Drivers line up for a photograph prior to the inaugural race, October 25, 1924.

The Charlotte Speedway operated from October 1924 to September 1927. The one-and-a-quarter-mile oval track was constructed of pine and cypress planks and banked 40 degrees in the turns—significantly steeper than modern super speedways. Widely regarded as the fastest speedway in the world at the time, those high-banked turns allowed drivers to easily exceed 140 m.p.h. and set numerous new world speed records.

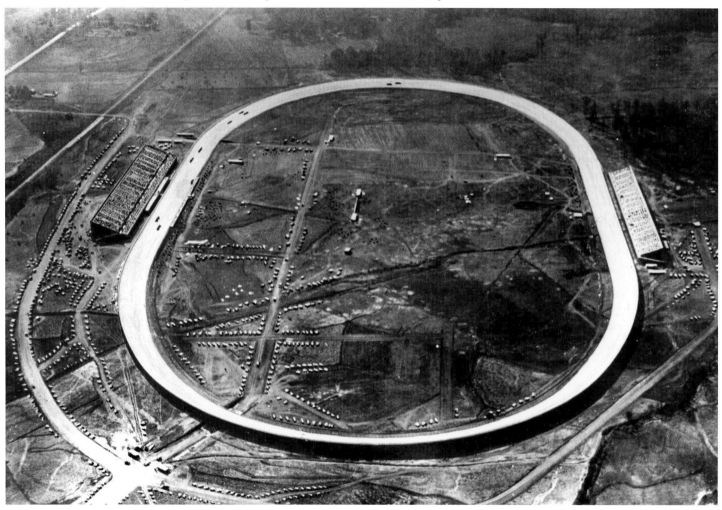

One of many hotels that sprang up during the World War I era, Merton C. Propst's Clayton opened on the northwest corner of Church and Fifth streets. The European-style hotel-seen here ca. 1920-boasted one hundred rooms and fifty baths, which rented at rates of $1 and $1.50. The Clayton was demolished in the mid 1970s.

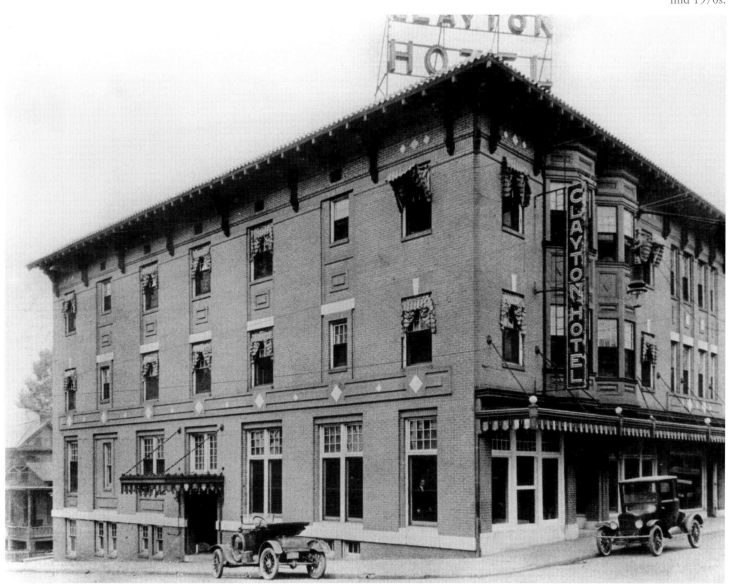

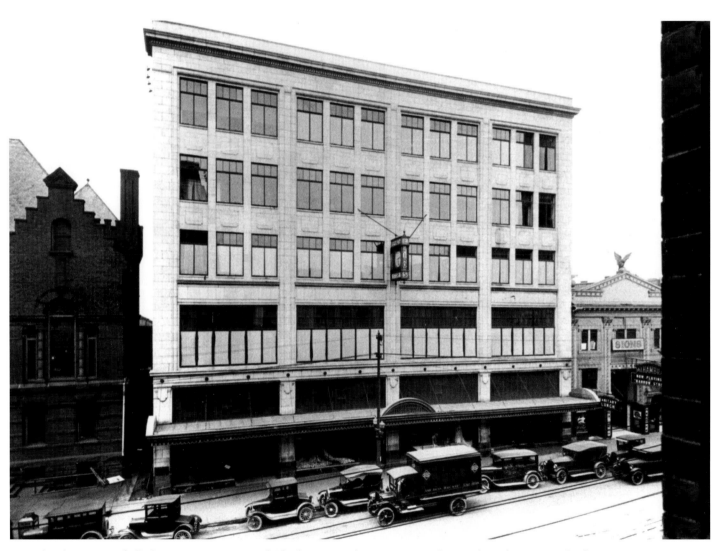

Completed in 1923, Efird's department store wowed Charlotteans with its moving escalator—the only store south of Philadelphia with such a device. Louis Asbury designed the building; the J. A. Jones company erected it.

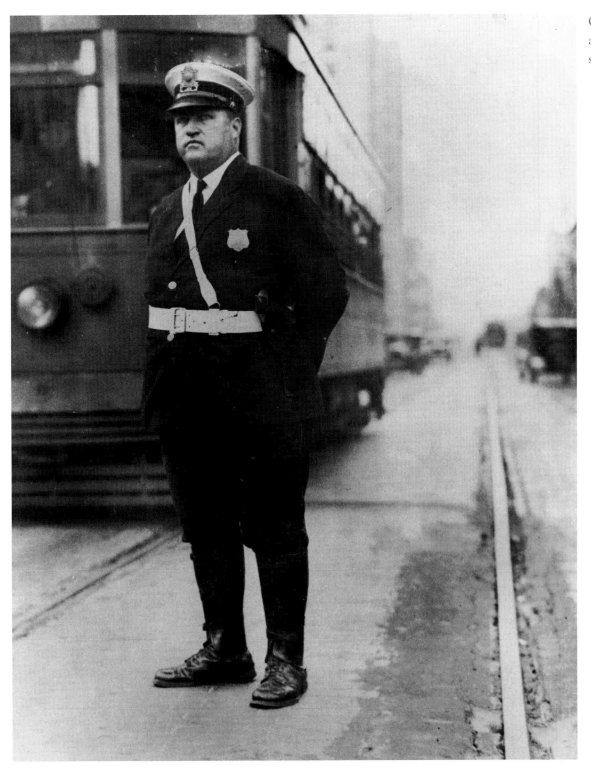

Officer Frank R. Ferguson keeps a dutiful eye on Charlotte's city streets. (1920s)

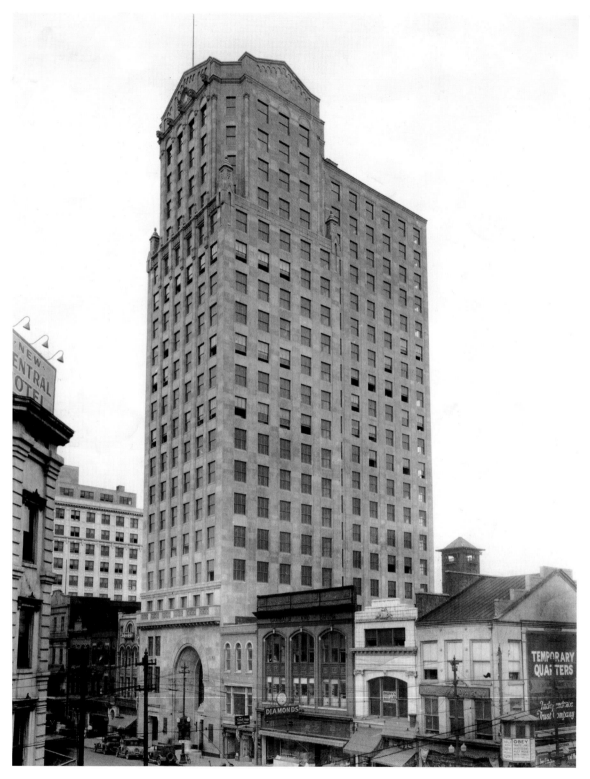

The twenty-story First National Bank building stands in the 100 block of South Tryon Street. Designed by architect Louis Asbury and erected in 1926, it became at the time the tallest building in the Carolinas.

Roland E. Ferguson worked for the Sanitary Steam Laundry, which offered pick-up and delivery service. Here he stands with his truck on North Cecil Street.

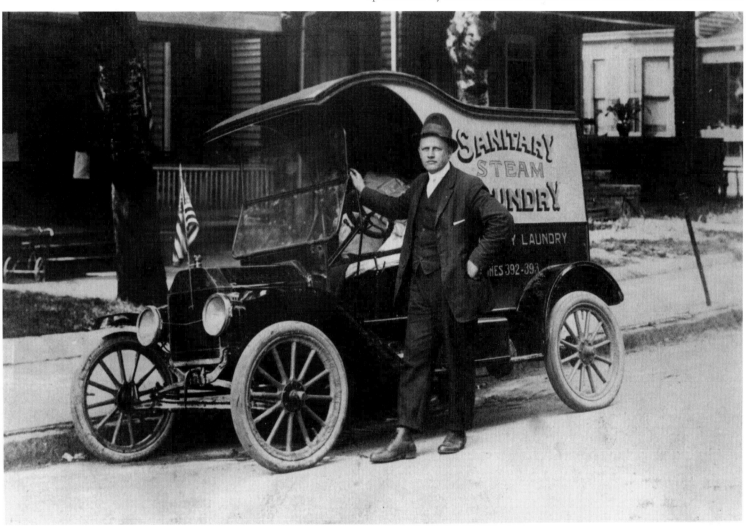

This 1920s parade float advertises a local tire manufacturer.

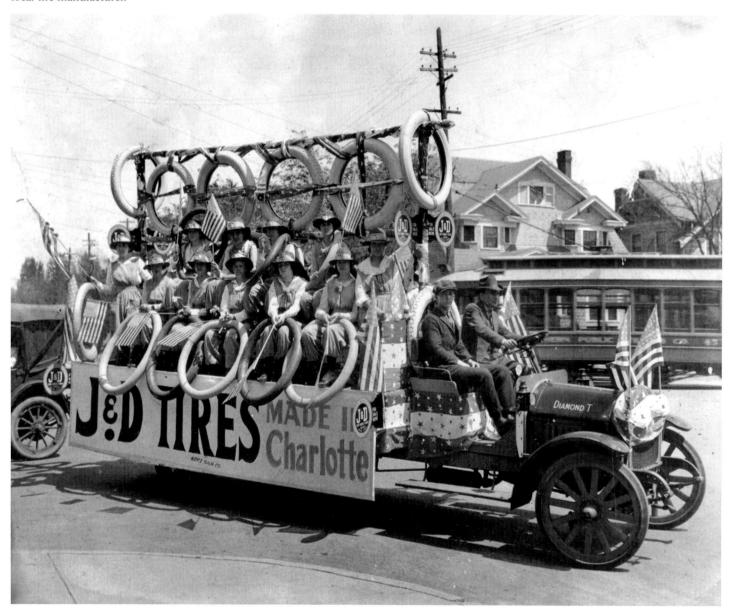

The aptly named Professional Building housed offices for numerous doctors, lawyers, and other small, independent businesses. Completed in 1924 by the J. A. Jones construction firm and designed by Louis Asbury, the building stood at North Tryon and Seventh streets.

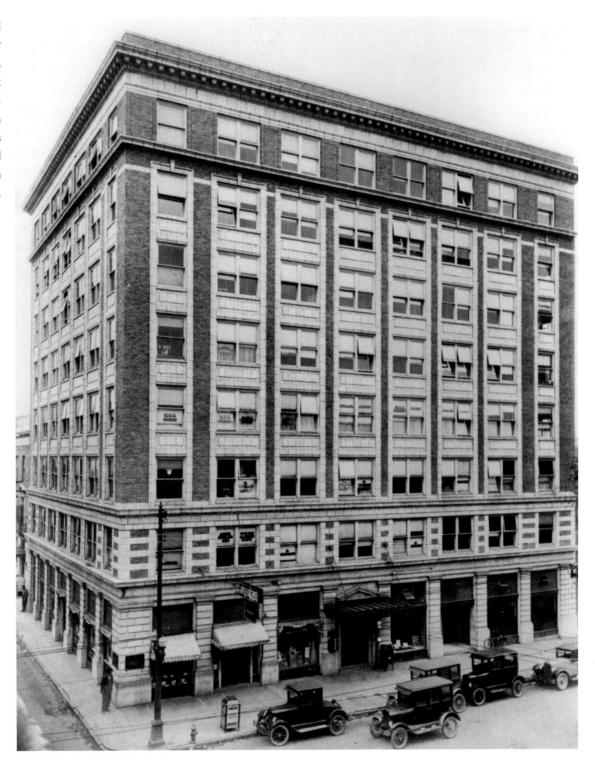

Warehouses and freight cars along the Southern Railway at Park Avenue in 1931. Huttig—a national distributor of building products—actually closed its Charlotte operations two years prior to this photo.

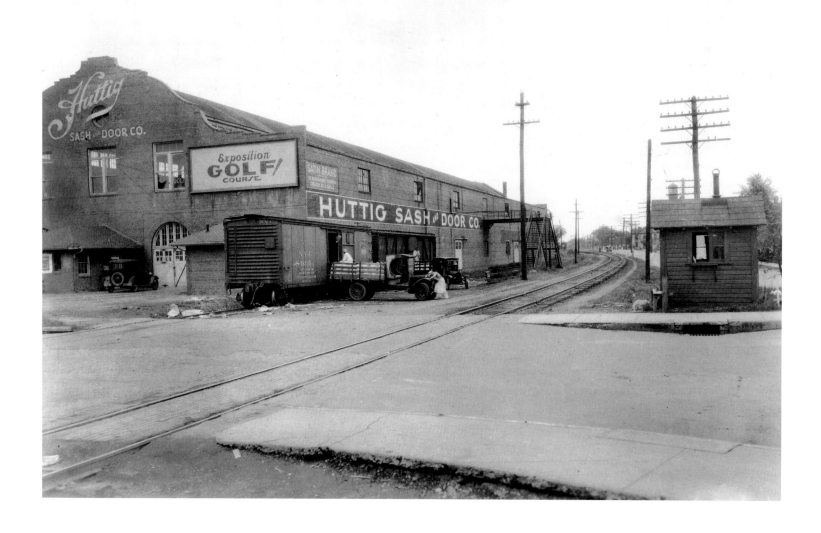

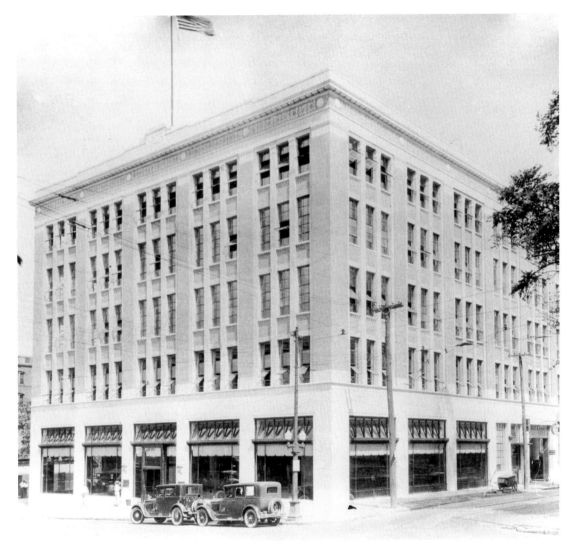

Albert Kahn—the famous industrial architect from Detroit—designed the Coddington Building, which once stood at Graham and Trade streets. C. C. Coddington—the Buick distributor for North and South Carolina in the mid 1920s—headquartered his operations here. For a while the building even housed the WBT Radio Station.

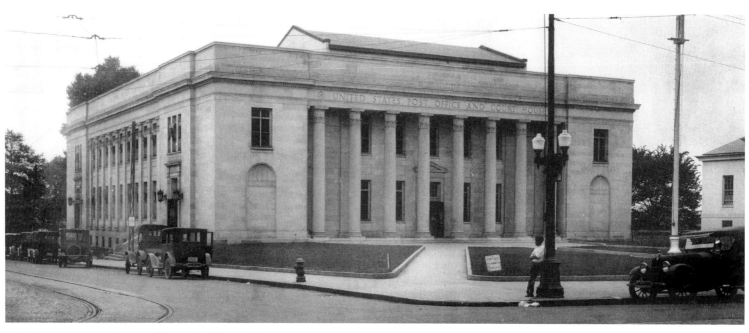

U.S. Court House and Post Office—the fifth Mecklenburg County
Courthouse—is located at 700 East Trade Street. Built at a cost of $1
million, it first opened in 1928.

Charlotte's booming economy was not for everyone. Poverty and institutionalized racism held many in their grip, causing blight and decay in many parts of the city. Shown here is the W. A. Simerson Grocery on North Brevard Street. (ca. 1948)

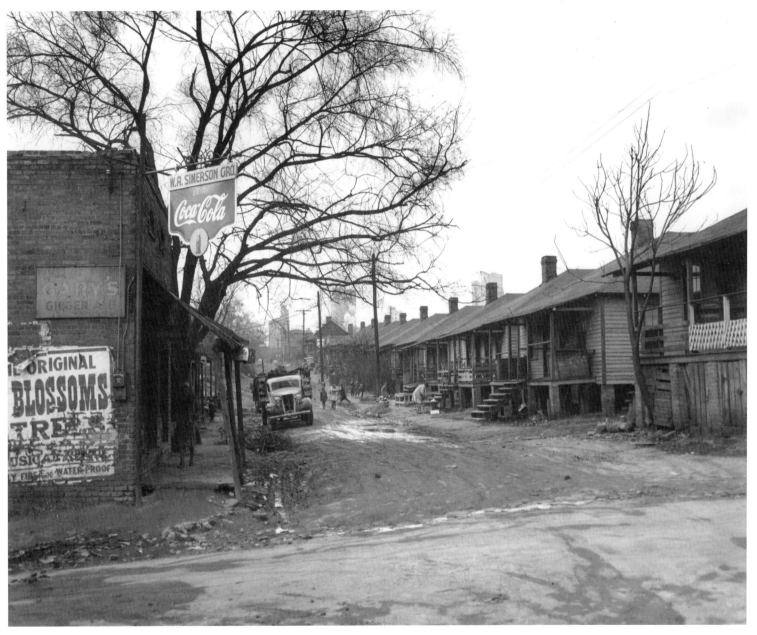

Following Spread: The beginning of the auto age in the South created numerous opportunities for enterprising entrepreneurs to start their own businesses.

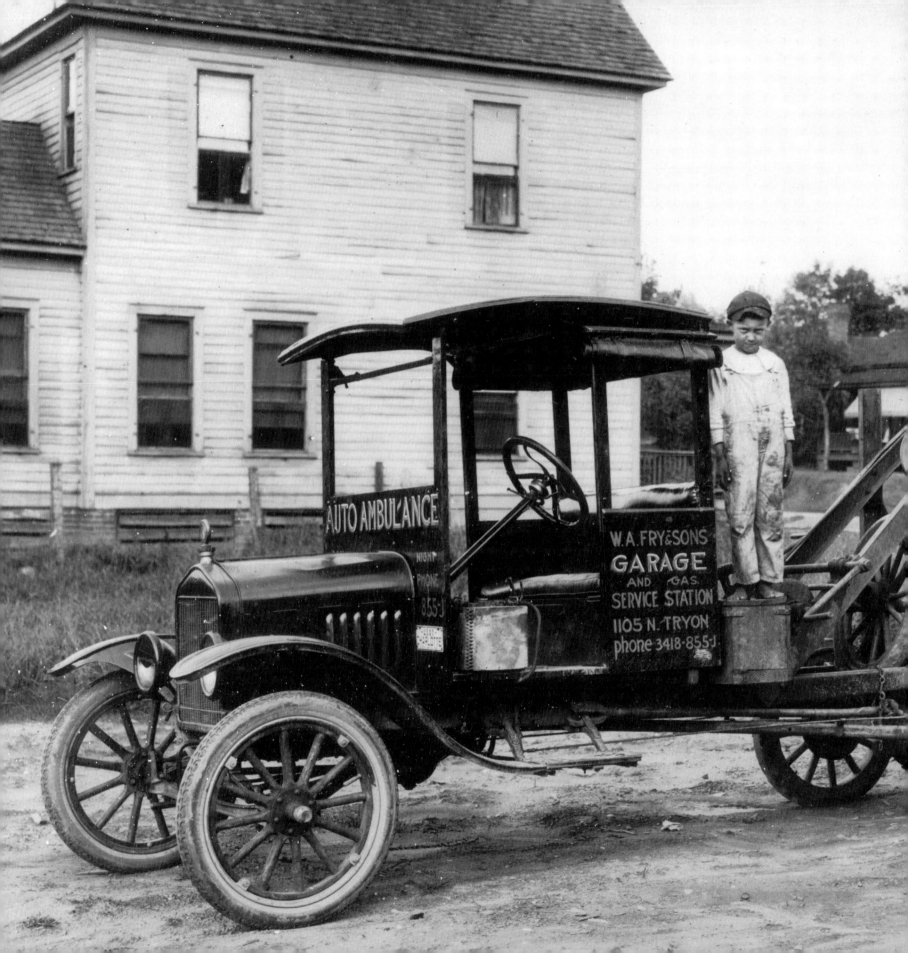

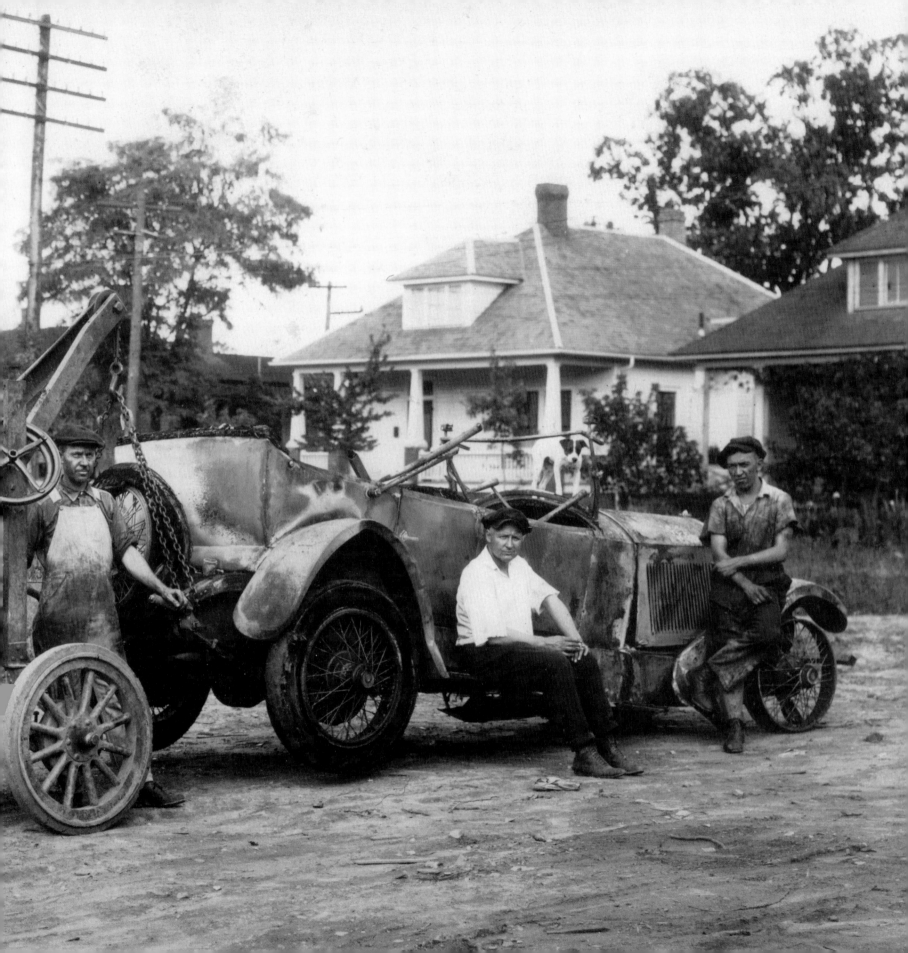

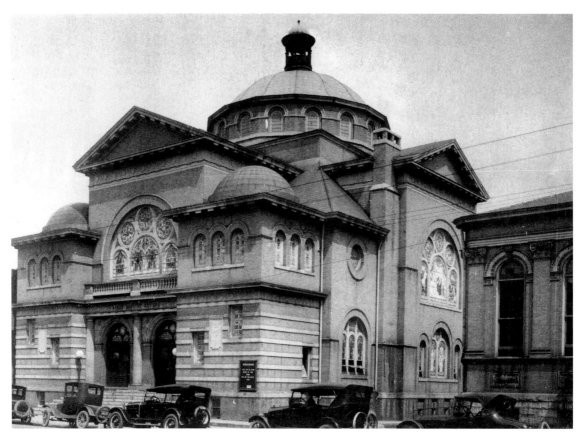

Completed in 1909, First Baptist Church was home to one of the most influential Christian congregations in the city and is one of the most distinctive works of eminent Charlotte architect James M. McMichael—who designed more than one thousand houses of worship. The structure has Romanesque and Gothic elements, but the design is dominated by its central Byzantine dome. The congregation moved on to a new sanctuary, but the structure has been preserved as performing arts space.

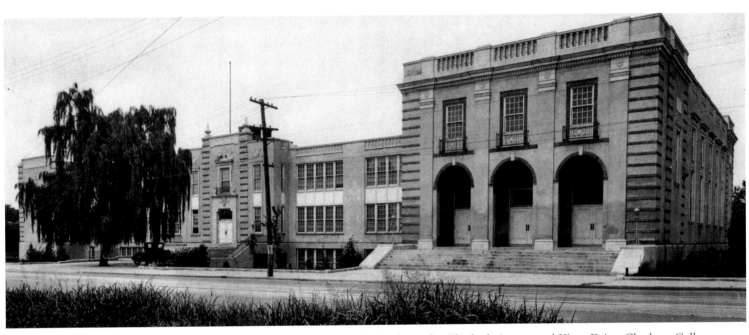

Built in 1923, Central High School is located at Elizabeth Avenue and Kings Drive. Charlotte College—now U.N.C. Charlotte—got its start offering night classes to returning GI's on the campus beginning in 1946. The school is now part of Central Piedmont Community College's central campus.

Charlotte's location along the Southern Railway made it an ideal
location for warehousing and distribution.

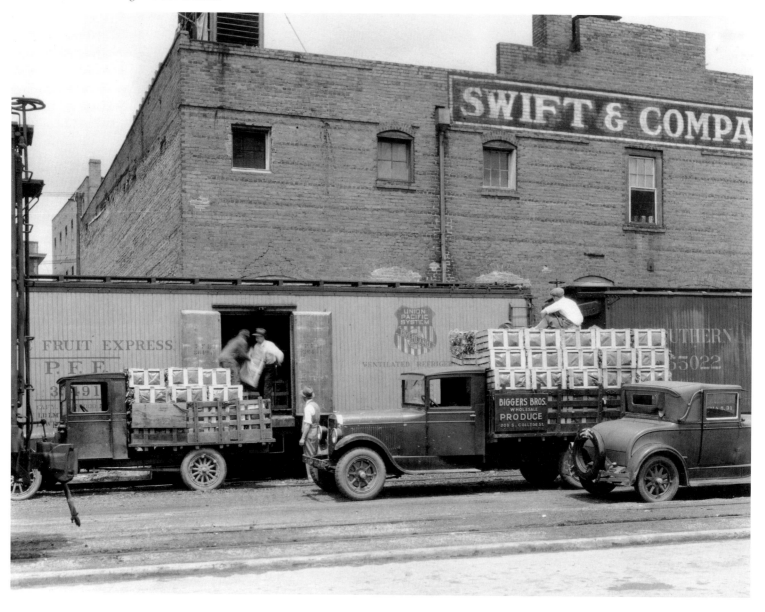

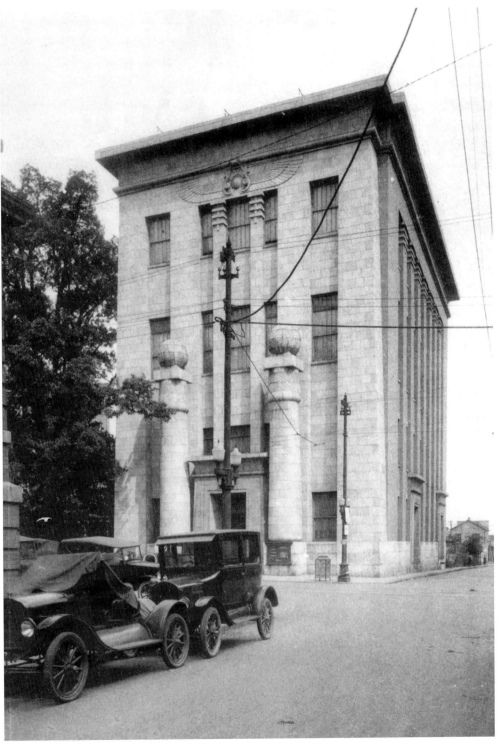

Charlotte's Masonic Lodge enlisted architects Charles Christian Hook and Willard Rogers to design its ornate Egyptian Revival–style temple. The J. A. Jones construction company erected the structure, which opened in 1914. The building—pictured here in the mid 1920s—burned in the late 1930s, but was quickly rebuilt according to the original plans. The temple stood among the canyon of skyscrapers that lined South Tryon Street until it was purchased and demolished by First Union in the late 1980s. It was the last example of Egyptian Revival architecture in North Carolina.

Completed in 1928, this new bridge spanned the Catawba River.

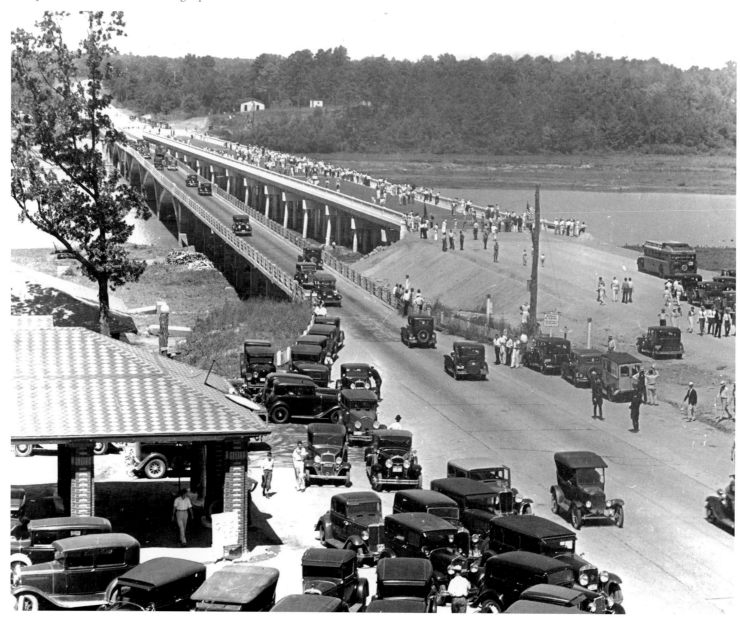

The YMCA moved to this location at 330 South Tryon Street in 1908, seen here in the mid 1920s. This location remained the Y's home until May 1960, when it moved to its present home on Morehead Street—known now as the Dowd Branch.

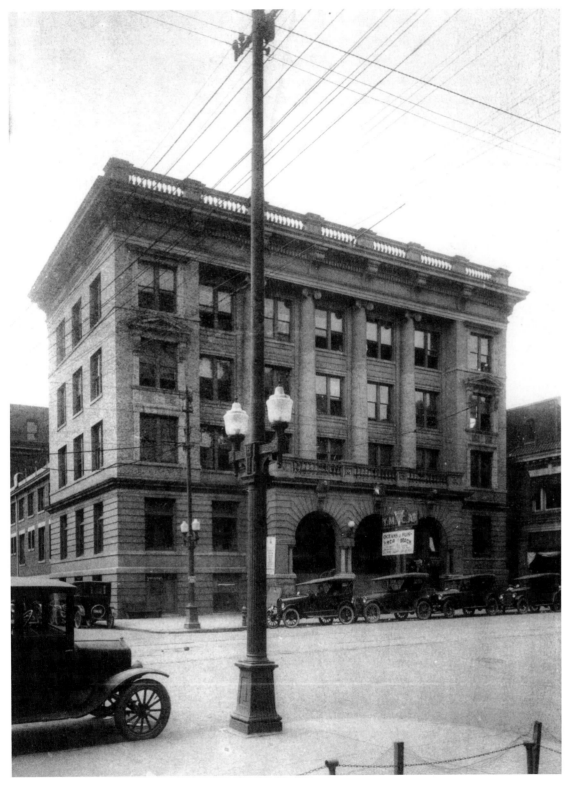

Chartered in 1902 by the Charlotte Woman's Club, the local Young Women's Christian Association (YWCA) provided boarding for young women away from home. The organization moved to this location on East Trade Street in 1914, seen here in the early 1920s. The facility boasted a gymnasium and in 1922 added a swimming pool. The Y later established an employment bureau and here women had the opportunity to learn about law, city government, banking, nursing, and salesmanship. The YWCA opened Charlotte's first childcare center at Highland Park Mill in 1917.

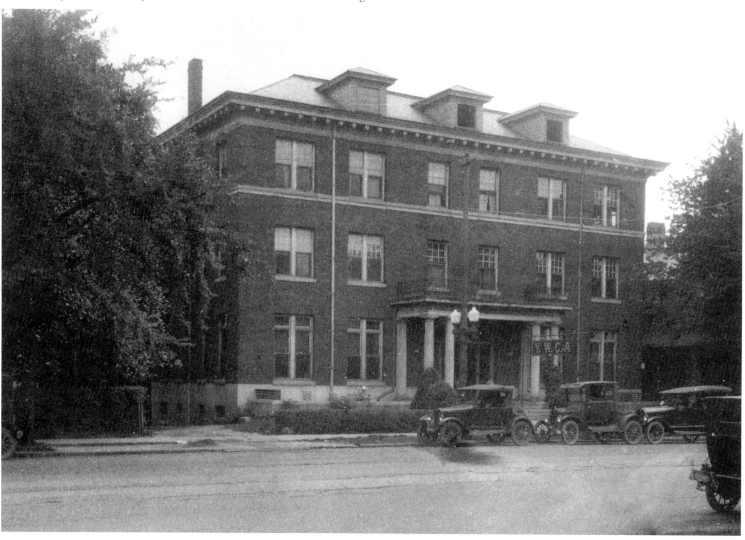

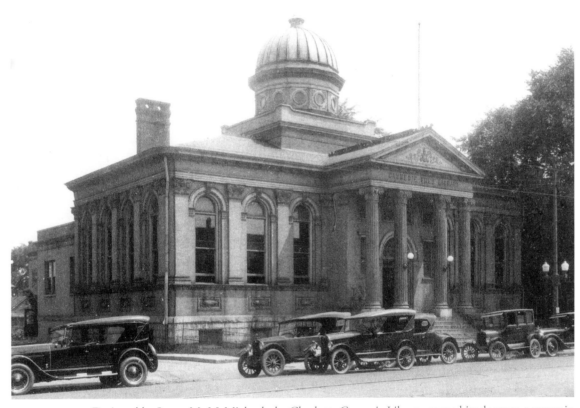

Designed by James M. McMichael, the Charlotte Carnegie Library opened its doors to patrons in 1903. McMichael also designed the complementary First Baptist Church next door. The county demolished this facility at Sixth and Tryon streets in the 1950s. A second, and now third library have been built on the same spot.

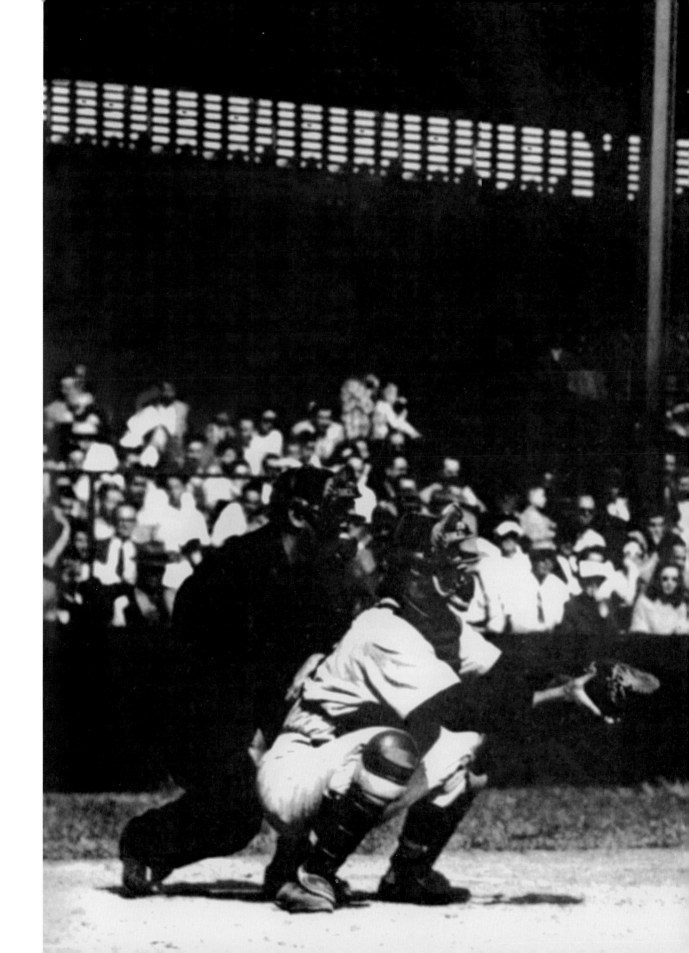

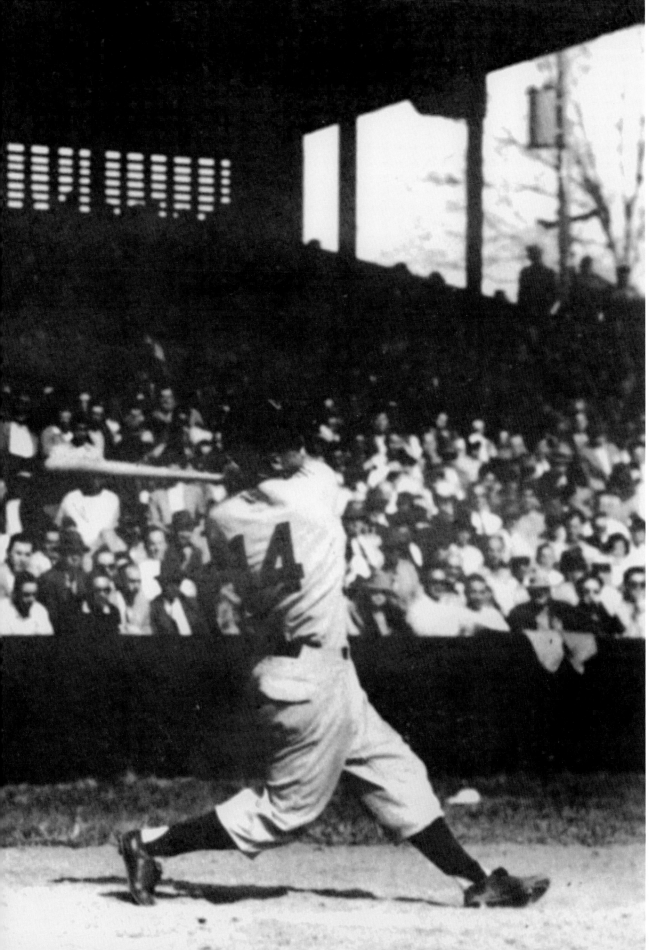

Pro sports in Charlotte began with a minor league baseball team called the Hornets, active from 1901 to 1973. Pictured is Hornets baseball 1920s.

Charlotte Open Air School was an experiment based on the 1920s belief that cold air was beneficial for students. School Superintendent Harry P. Harding stands at the rear of the classroom.

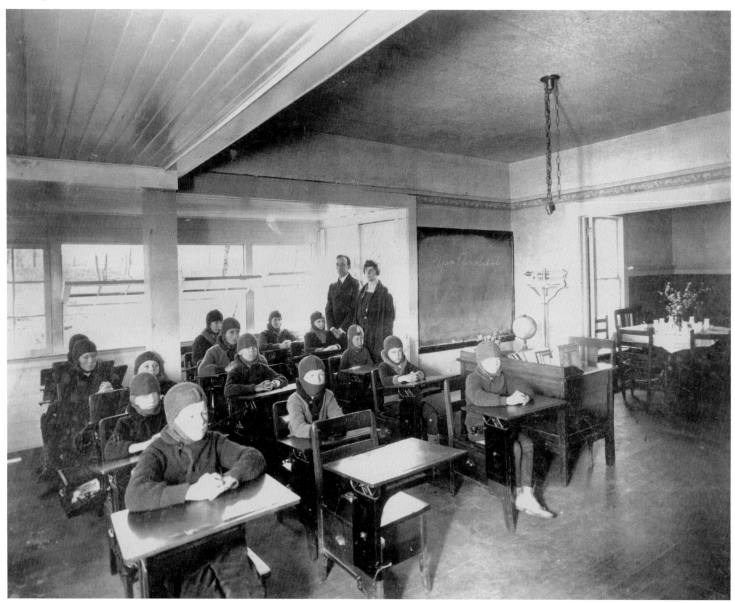

WATCH CHARLOTTE GROW

Folks once commonly said Charlotte was the most church-going town in the world after Edinburg, Scotland—perhaps, but in the late nineteenth and early twentieth centuries the city's boosters fanatically worshiped growth. Still struggling from the loss of the Civil War and beleaguered by persistent poverty, business leaders organized the Charlotte Chamber of Commerce in 1877. They published "booster booklets" and advertised in magazines—anything to attract businesses to the city. "Watch Charlotte Grow" became the chamber's mantra.

New businesses and industries came and their skyscrapers began to dominate the skyline. The 1880s saw William Henry Belk give Charlotte its first grand "Department Store." Efird's and Ivey's too created retail chains headquartered in the Queen City. In 1904, Southern Power (now Duke Energy) began supplying electricity to area textile mills, and, as people embraced electrical appliances, to their homes. Additionally, the company operated Charlotte's electric streetcar system. Phillip Lance invented and began manufacturing the snack cracker as well as other treats. Textile industrialists used the wealth generated by their mills to create Charlotte's first large banks, which were allowed to grow bigger because North Carolina's laws permitted statewide banking—restricted elsewhere to keep financial institutions locally focused. Today's Bank of America and Wachovia can both trace founding roots to this cotton mill capital.

During World War I, city leaders persuaded the army to build the Camp Green military training facility, bringing 60,000 soldiers to Charlotte—effectively doubling the population—and infusing many thousands of dollars into the local economy.

City directories do not record anyone in town owning a car until 1904; nevertheless, within two decades the automobile profoundly affected Charlotte. Speed demons thrilled the masses at Charlotte's first speedway. The workforce at the Ford Motor Company's plant assembled Model T's and Model A's from parts before shipping them all over the Southeast. As these assembly-line-produced cars came within the financial reach of everyday people, increasing sales spawned opportunities for local entrepreneurs to open garages, dealerships, tire stores, and other businesses.

By the 1920s, Charlotte surpassed august Charleston as the largest city in the two Carolinas.

In the mid 1920s, Hayes Bus Lines offered service between Charlotte and Columbia using standard passenger automobiles—one of which is seen here in front of the Firestone Tire and Rubber Company on 5th Street.

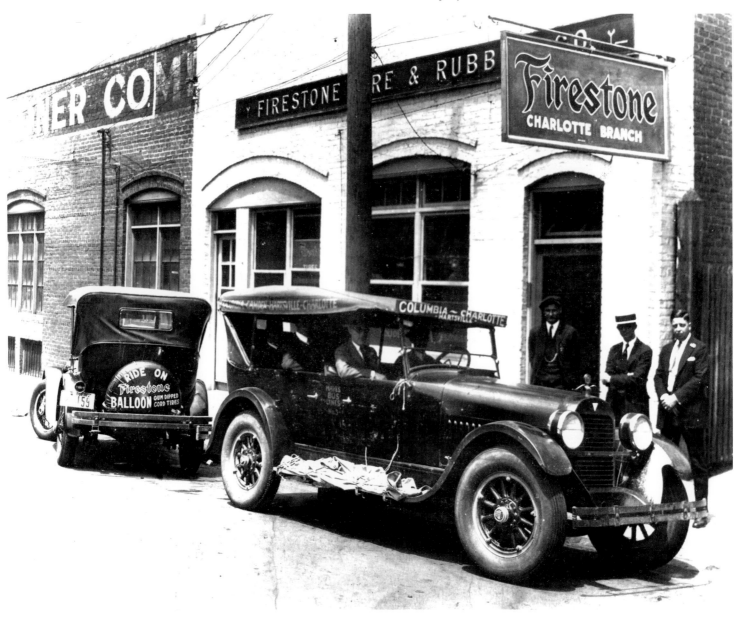

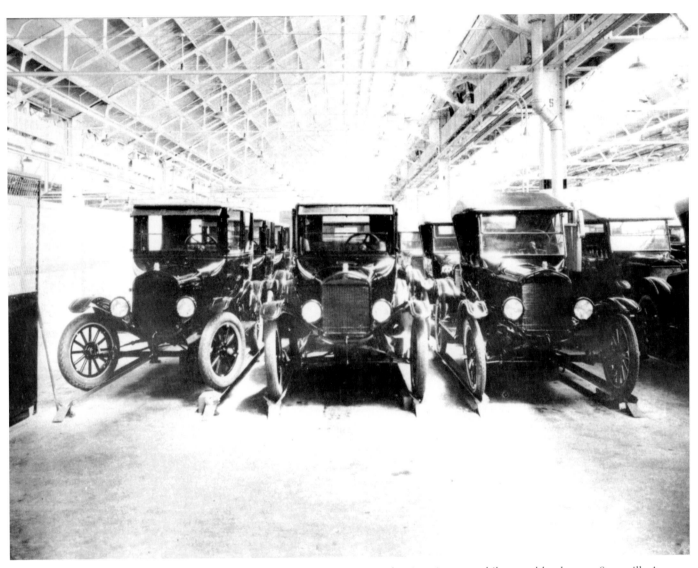

In 1925 the Ford Motor Company opened a gigantic automobile assembly plant on Statesville Avenue. This facility—the third built in the city by the Detroit automobile manufacturer—assembled cars from components shipped down by railroad. Workers at the plant put together 130,000 Model T's and almost 100,000 Model A's for distribution in the Southeast. Production slowed greatly after the October 1929 Stock Market Crash and ceased altogether in 1932.

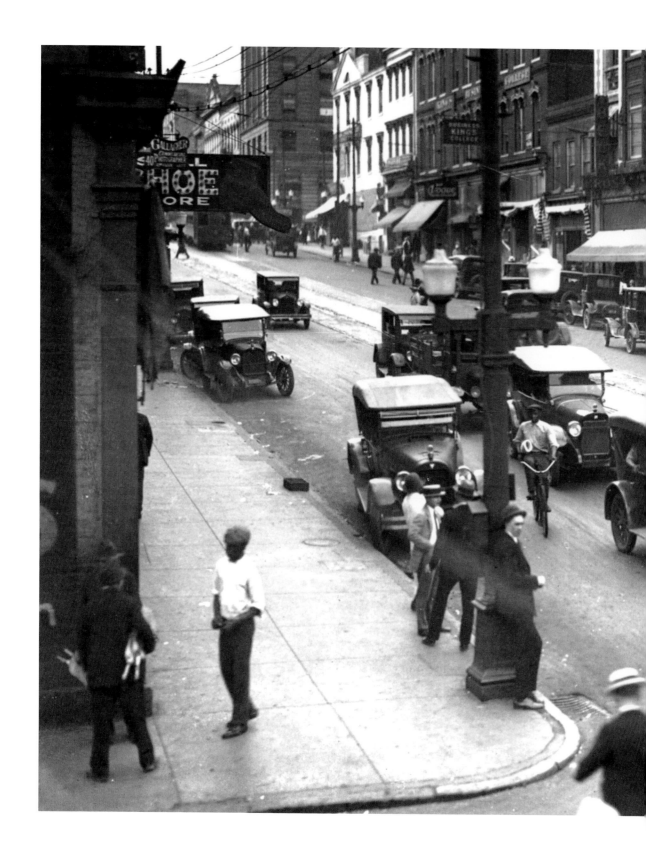

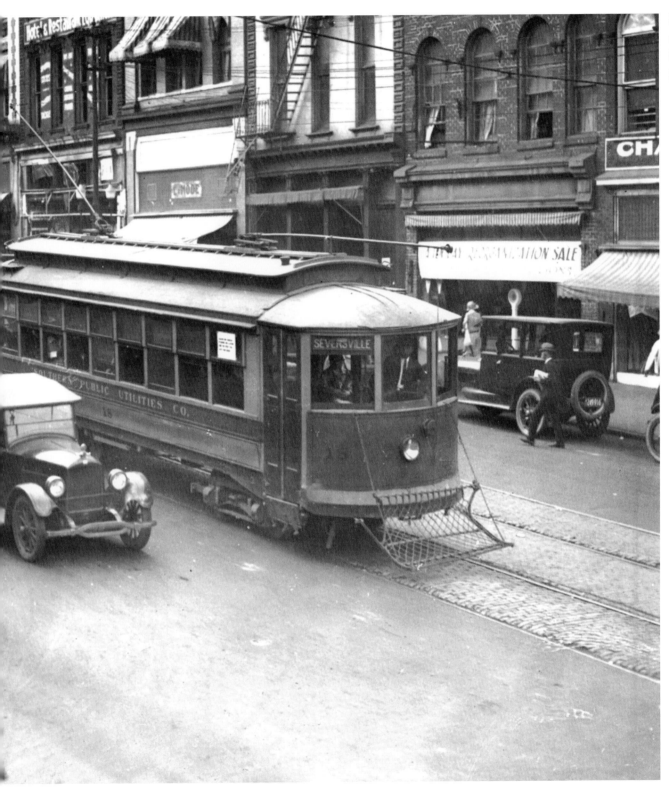

East Trade Street at the corner of College Street, looking toward the Square (1920s)

In the 1930s, President Franklin D. Roosevelt called southern poverty the nation's "number one economic problem." To address that issue and to fight the nationwide Great Depression, Roosevelt (seen here during his 1936 visit to Charlotte) poured federal dollars into building projects here and all over America. This investment stepped up as the nation entered World War II and continued during the Cold War. New military bases, hospitals, schools, and highways remade Charlotte.

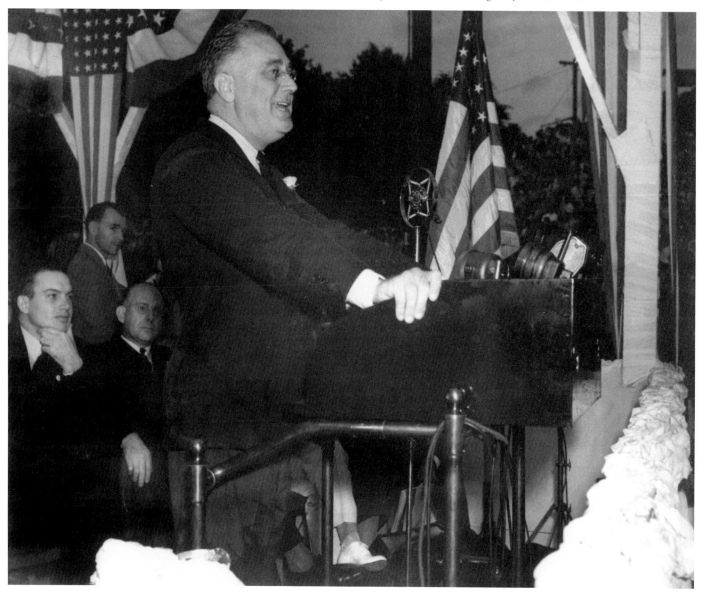

New Deal workers completed Memorial Stadium in September 1936, just in time to host President Roosevelt. The president delivered a stirring speech, entitled "Green Pastures," in which he proclaimed that the South could not prosper so long as the working people, especially the South's cotton farmers, could not make ends meet.

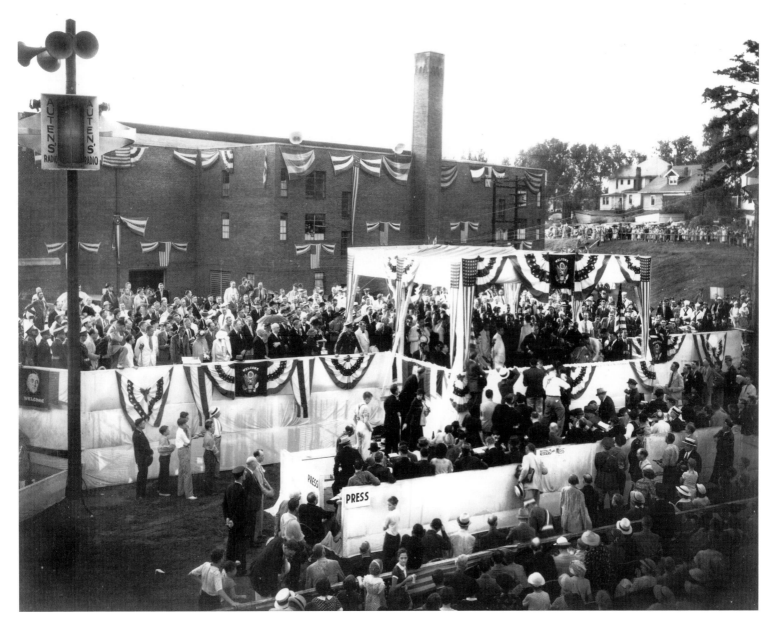

Following Spread: South Tryon, looking north from Fourth Street

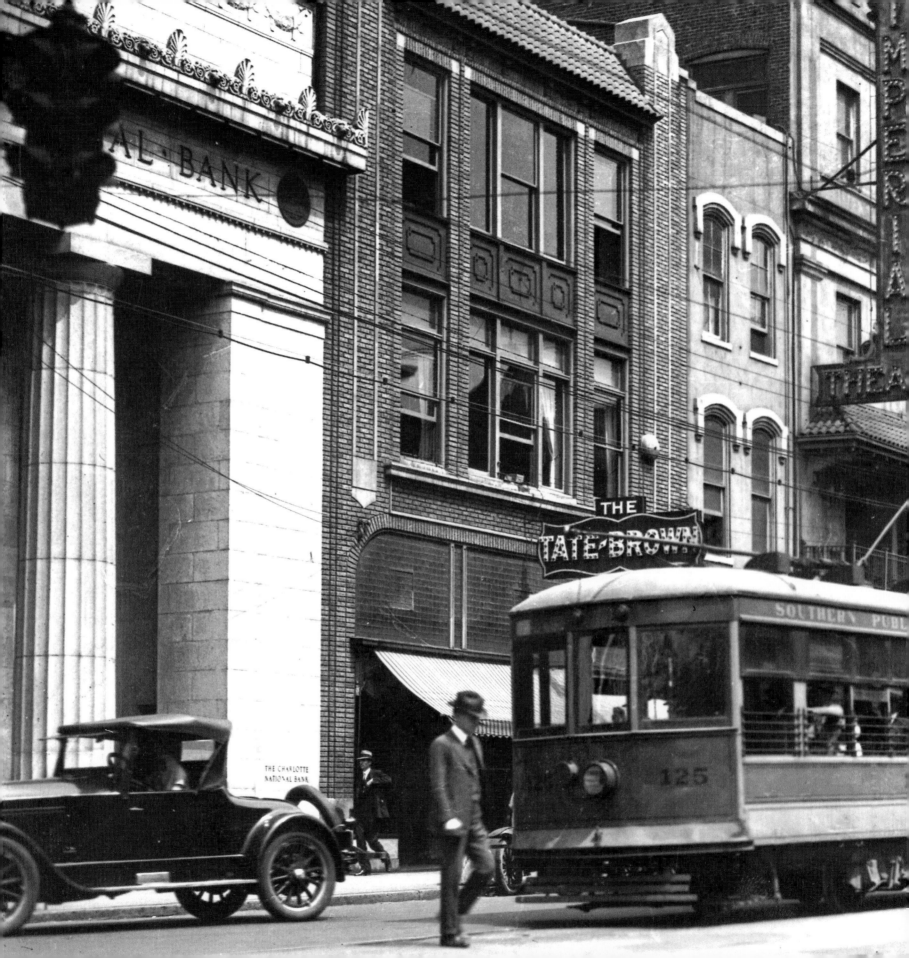

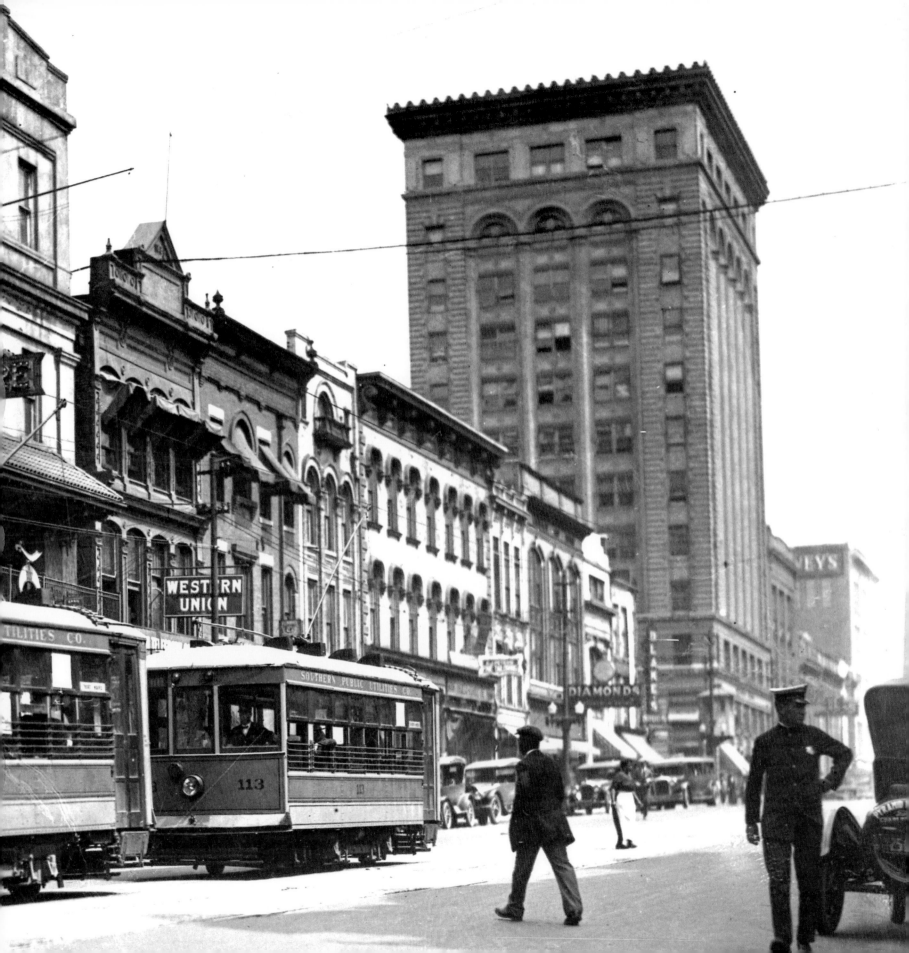

Electricity came early to North Carolina. Starting in the 1880s, engineers began harnessing the power of the rivers around Charlotte to electrify individual cotton mills. Next they devised some of America's first long-distance power lines. James B. Duke and William States Lee created Charlotte-based Southern Power in 1904 (now Duke Energy). By the 1910s—when this photo was taken—cities all around Charlotte were hooked into one of America's first power grids.

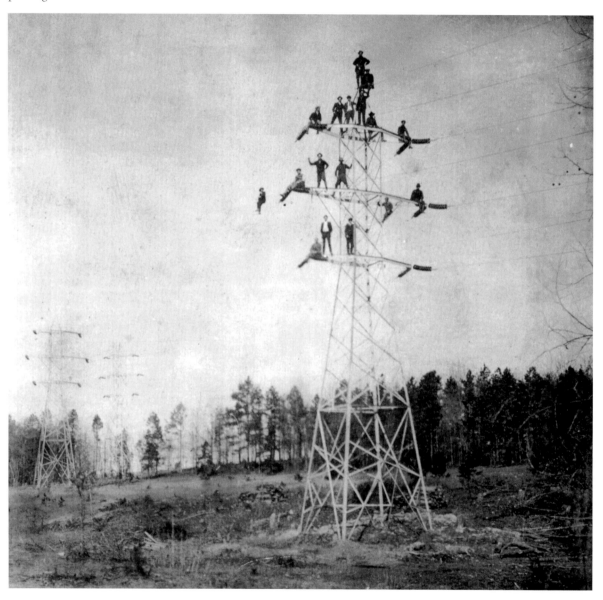

In the mid 1930s, Duke Power began to replace their electric streetcars with buses, arguing that buses were quieter, more flexible, and safer because they could let passengers off at the curb, rather than the middle of the street. The changeover ceremoniously occurred on March 14, 1938, as Streetcar Number 85 left the Square, ending its last journey at the streetcar barn on South Boulevard.

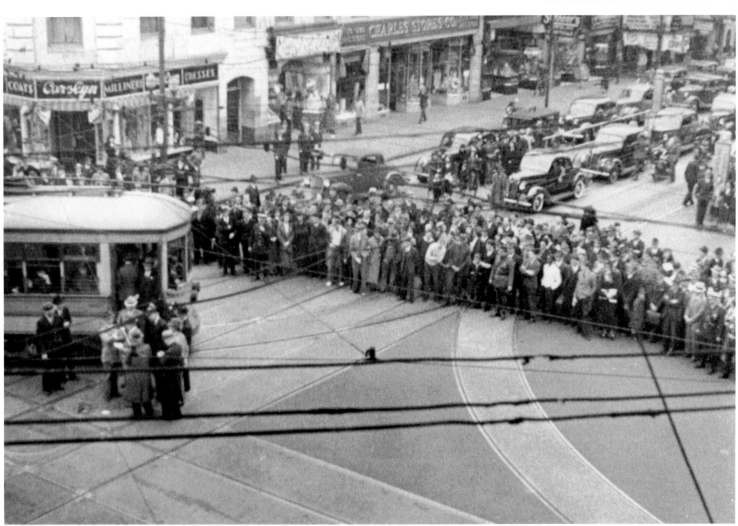

Shortly following Duke's conversion to motorbuses, the streetcar barn at the corner of South Boulevard and Bland Street was converted to meet the needs of the new transportation system. The number of buses operated by Duke Power grew from just 15 in 1937 to approximately 60 at the time of the 1938 changeover. The structure fell victim to Charlotte's hungry bulldozers in the summer of 2006.

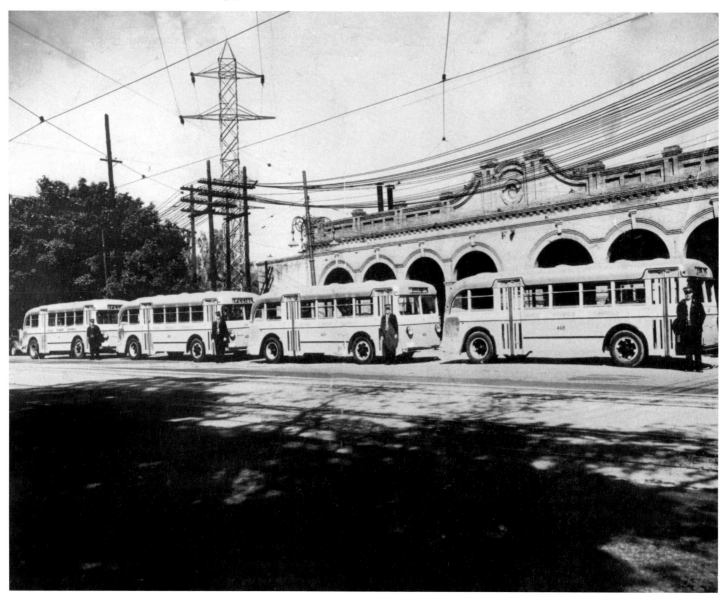

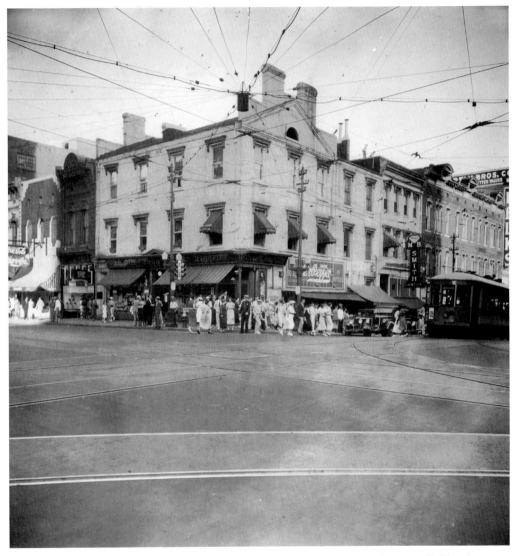

Independence Square, showing the site of British General Cornwallis' headquarters during the American Revolution

In white neighborhoods, barbershops were segregated, but ironically were usually owned and operated by African Americans, such as this uptown shop. White barbers were rare in the South into the twentieth century.

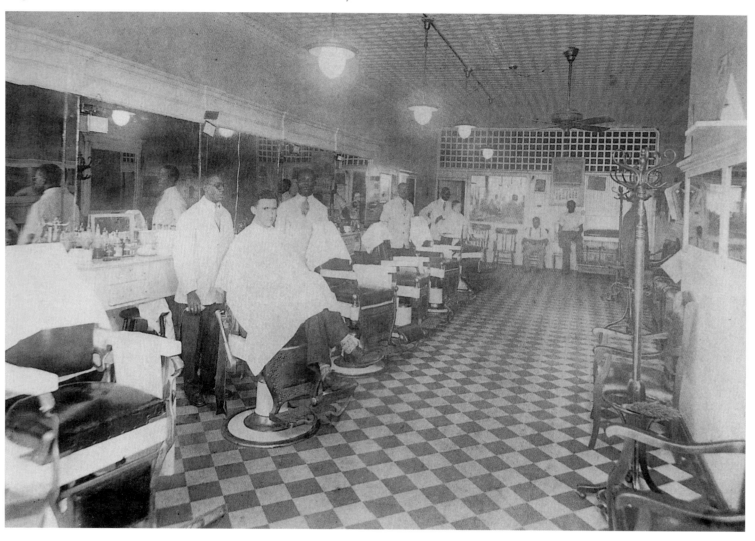

Built in 1924 near the Southern Railway Station, the ten-story Hotel Charlotte once dominated the 200 block of West Trade Street. Its imposing edifice graced with terra cotta caps was designed by New York architect W. L. Stoddard. The hotel was also home to Victor Records, which recorded numerous stars from the golden age of country music—including Bill and Charlie Monroe and the Carter Family.

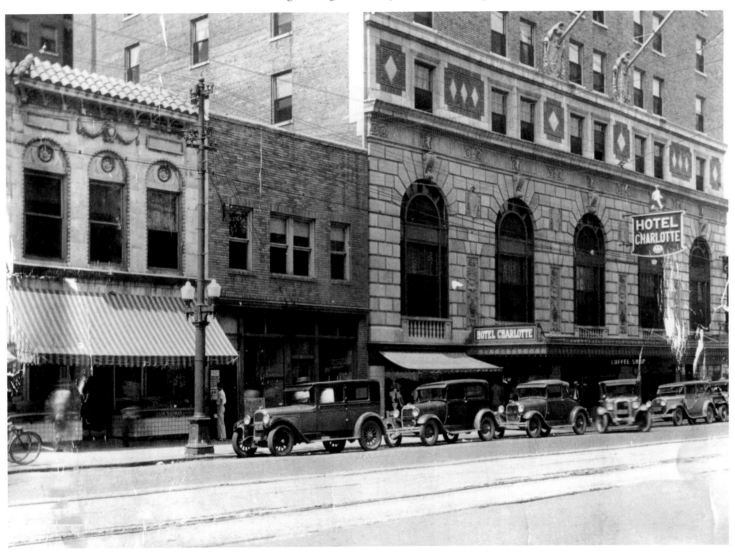

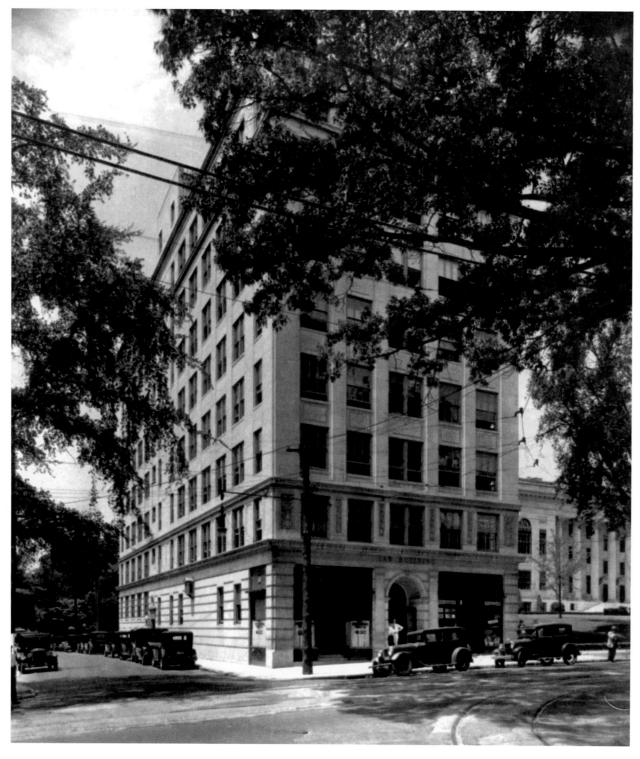

Around 1928 in the middle of a South Tryon skyscraper boom, several area litigators pooled their resources to erect the eight-story Lawyers Building at 307 South Tryon Street. The new structure was situated perfectly to allow its attorney tenants access to the new courthouse on East Trade.

142

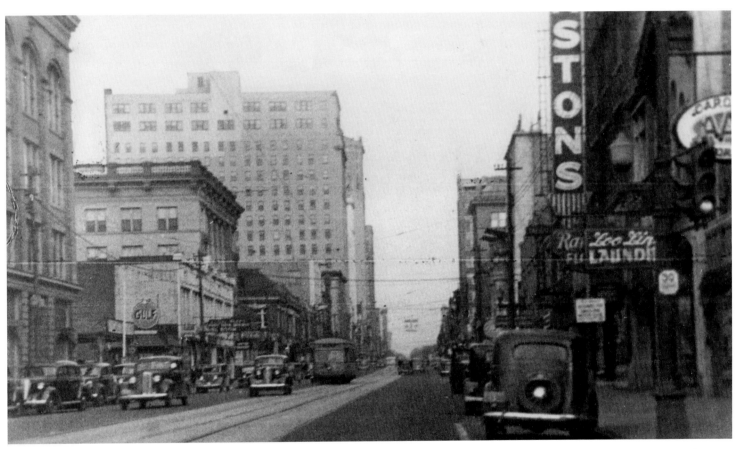

Looking north from South Tryon
and First streets (ca. 1935)

Crowds filled the square for 1929's
reunion of Confederate veterans.

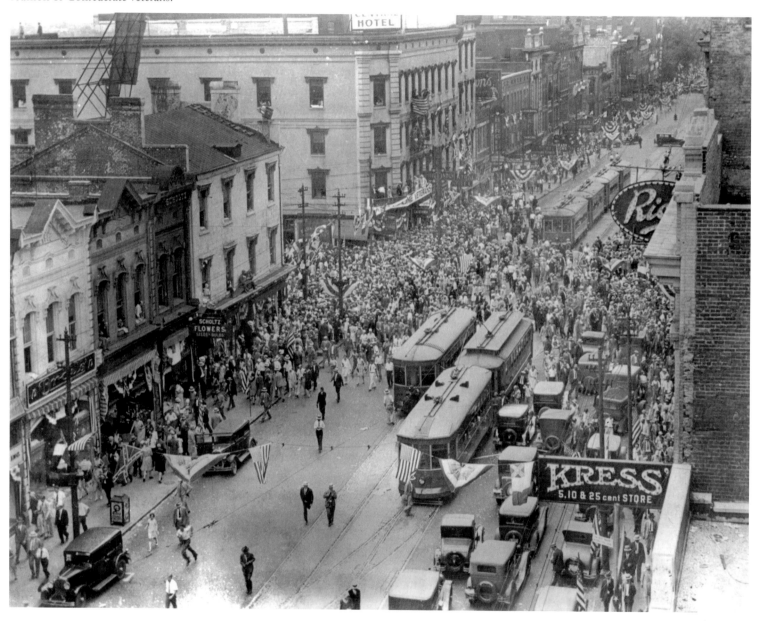

South Tryon Street, facing north from the vicinity of First Street. The old Charlotte Observer building is visible at far-left. The spire of Saint Peter's Catholic Church is clearly visible at right.

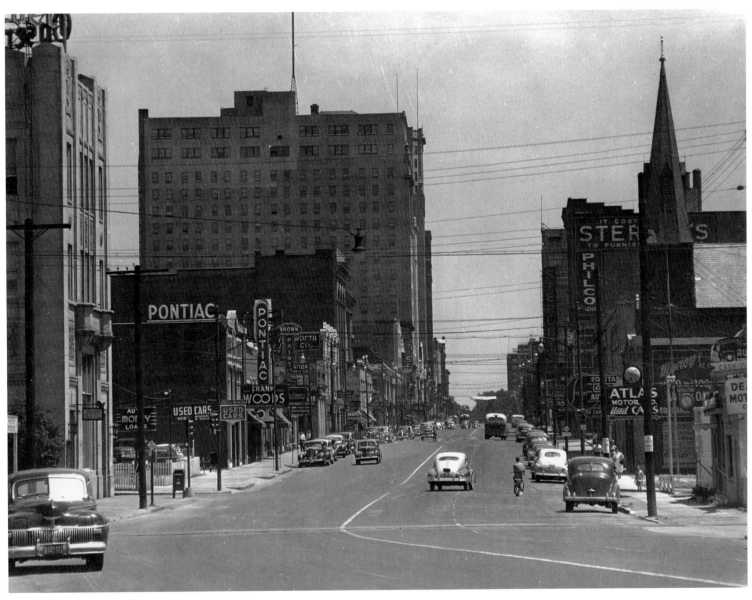

Two women repair a plane at
Charlotte's Morris Field during
World War II.

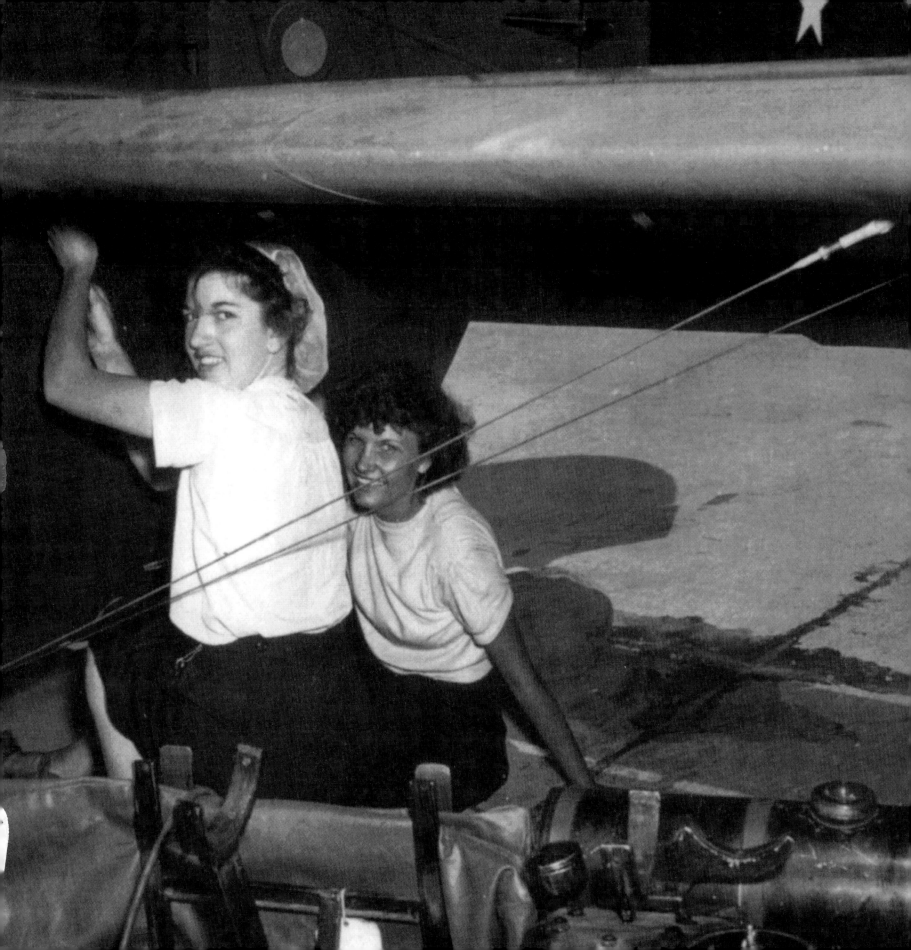

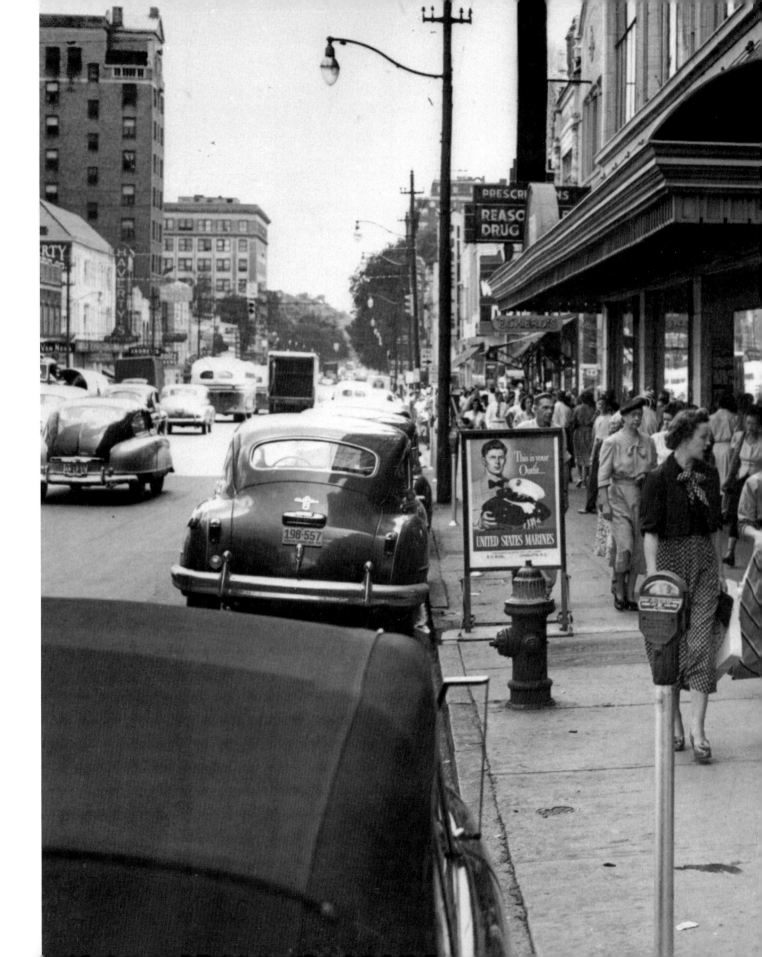

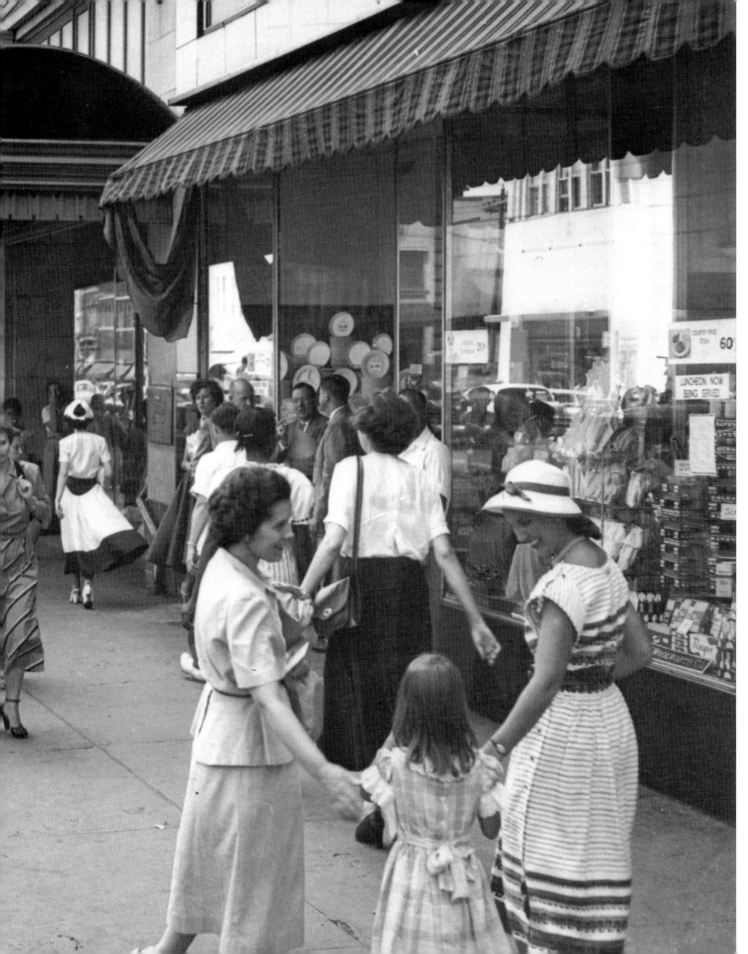

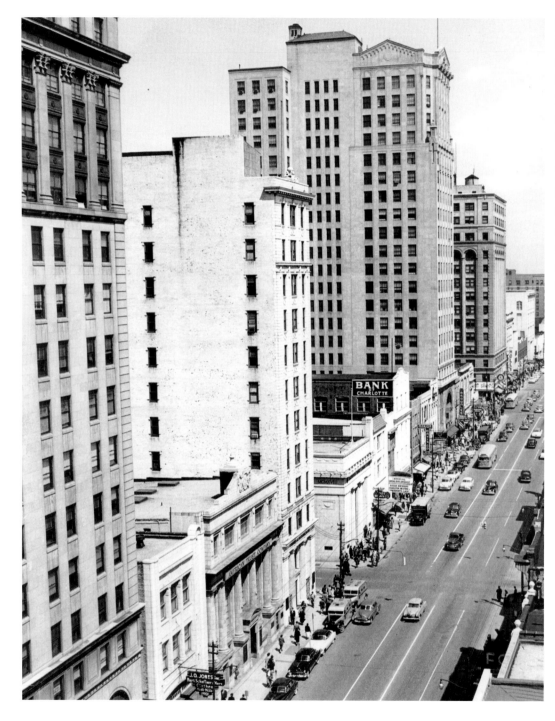

Looking north up South Tryon Street's canyon of skyscrapers. Beginning in the late 1920s, South Tryon came to be seen as the city's financial district—akin to New York's Wall Street. South Tryon Street addresses were highly coveted by businesses who wanted to be symbolically linked to this symbol of the city's power.

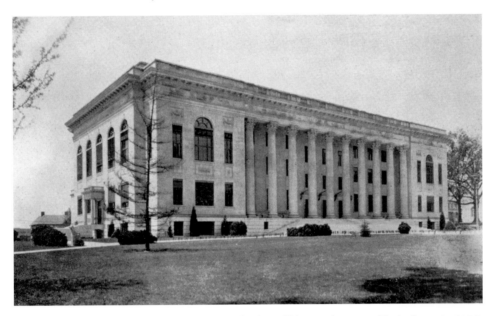

Mecklenburg County built its fifth courthouse on Trade Street in 1928.

Phillip Lance got his start roasting peanuts from a downtown cart in 1913. Three years later his wife, Nancy, and daughter Mary got the idea of spreading peanut butter on crackers—inventing the snack cracker! Today, Charlotte-based Lance is one of the South's biggest snack makers. Pictured are Lance factory workers.

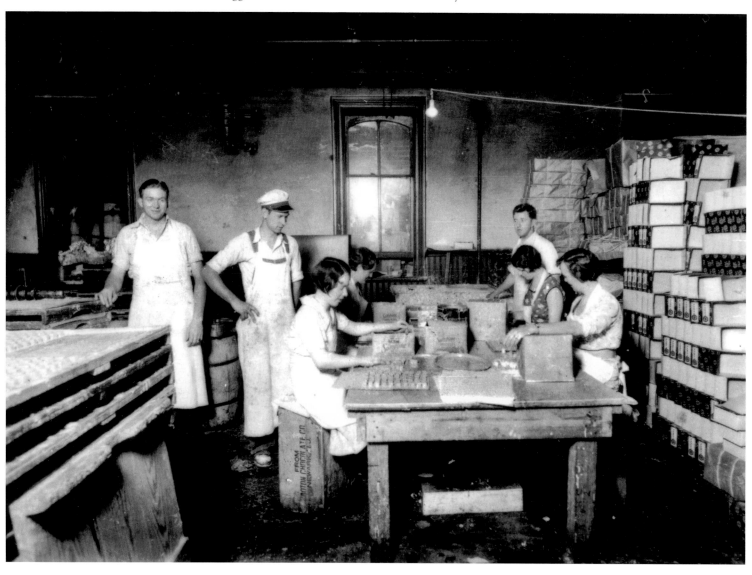

The Lance plant on South Boulevard about 1946

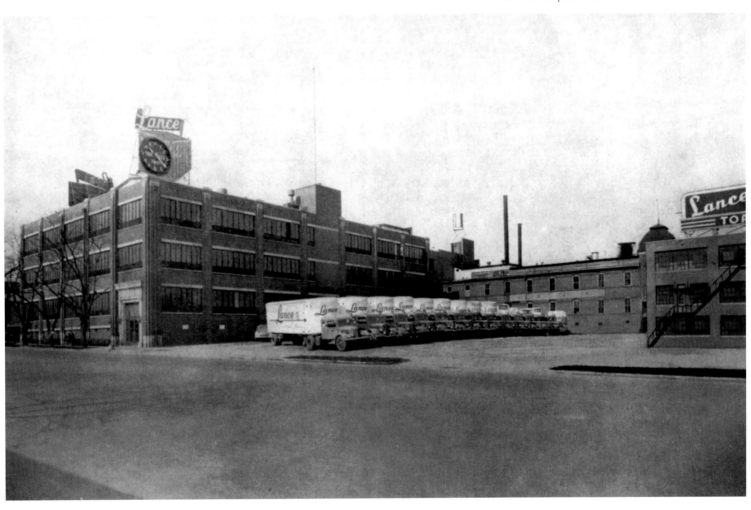

The southwest corner of Tryon and Third streets (ca. 1940)

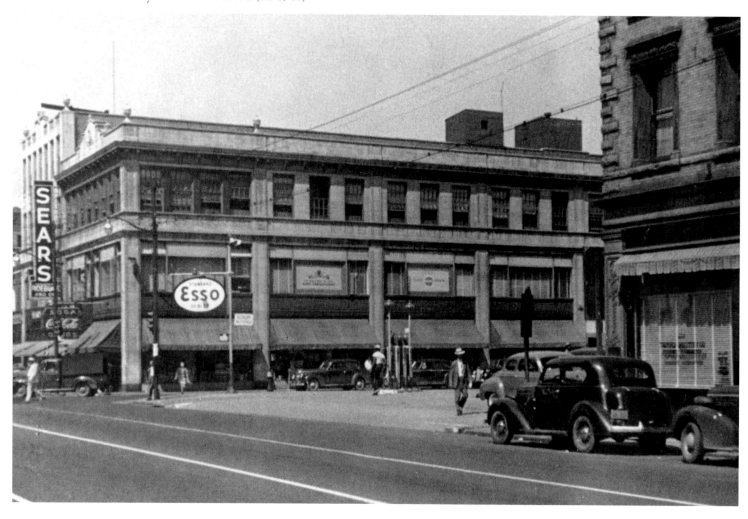

East Seventh Street (ca. 1948)

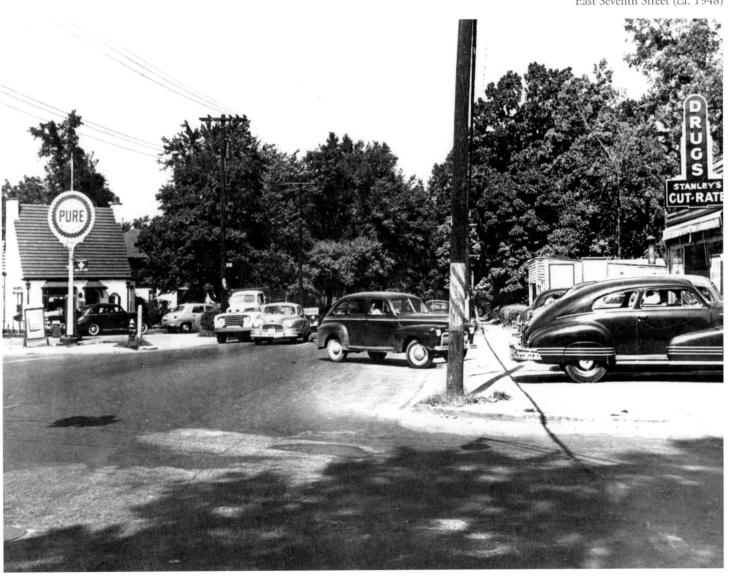

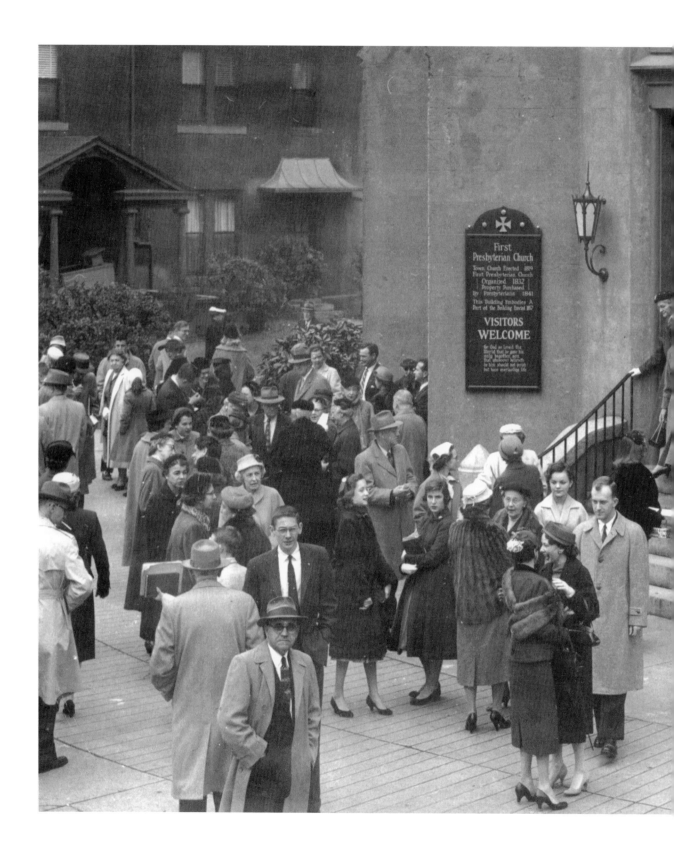

156

Parishioners leave First
Presbyterian Church

Built for students from Alexander Graham Junior High to safely cross the street, this tunnel once connected South Boulevard to East Morehead Street. The Dowd Flats are visible in the background. (ca. 1950)

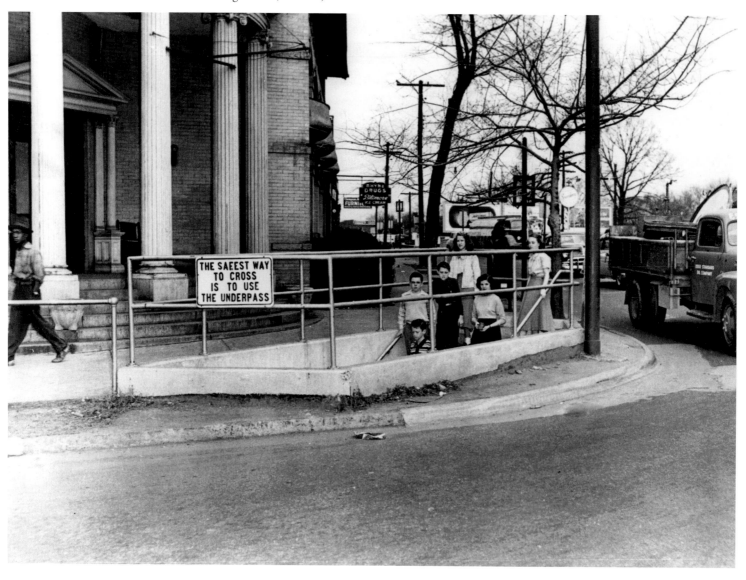

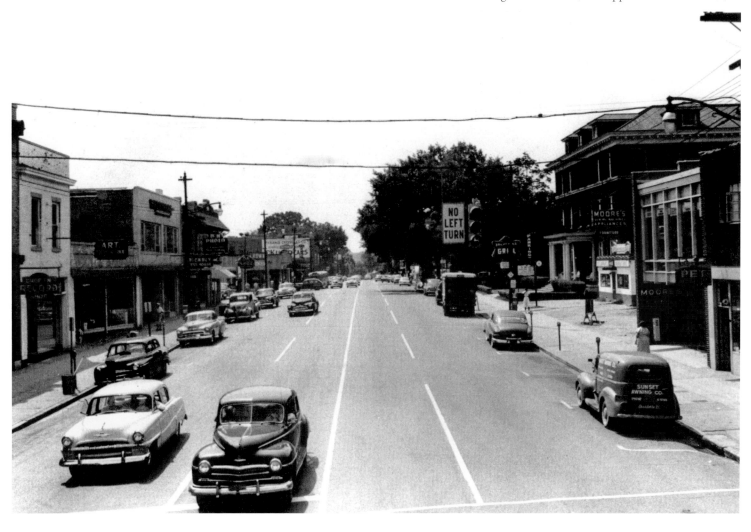

Trade Street from Brevard facing Caldwell Ave., as it appeared in the mid 1950s

These businesses lined West First Street between Church and Mint in the early 1950s.

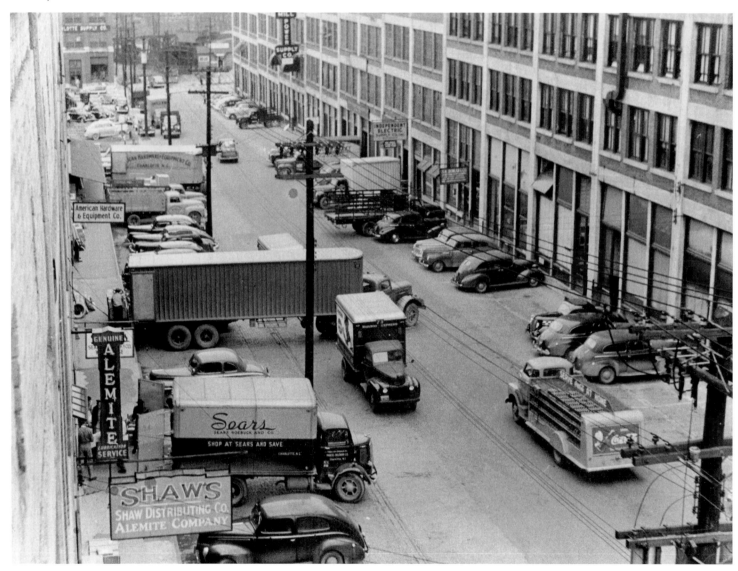

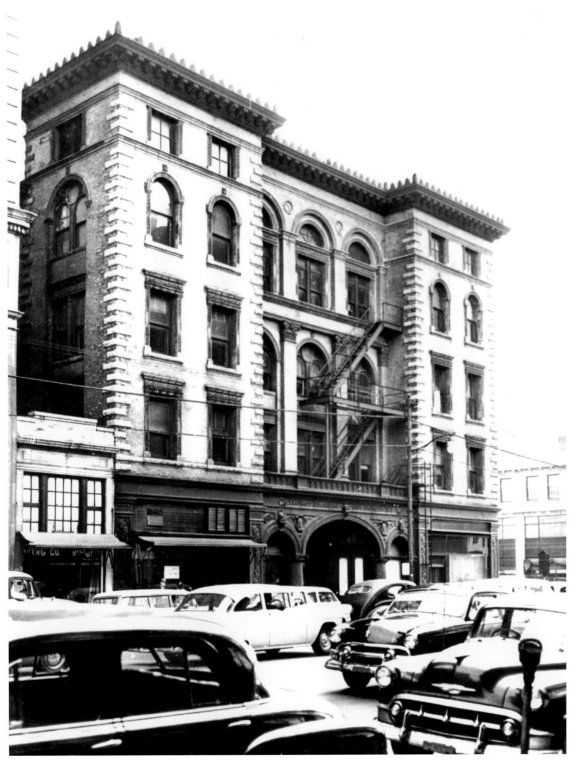

Designed by Frank P. Milburn and considered the finest office building in North Carolina at the time of its completion around 1898, the Piedmont Building stood as part of the canyon of skyscrapers that lined South Tryon Street until its demolition in 1956.

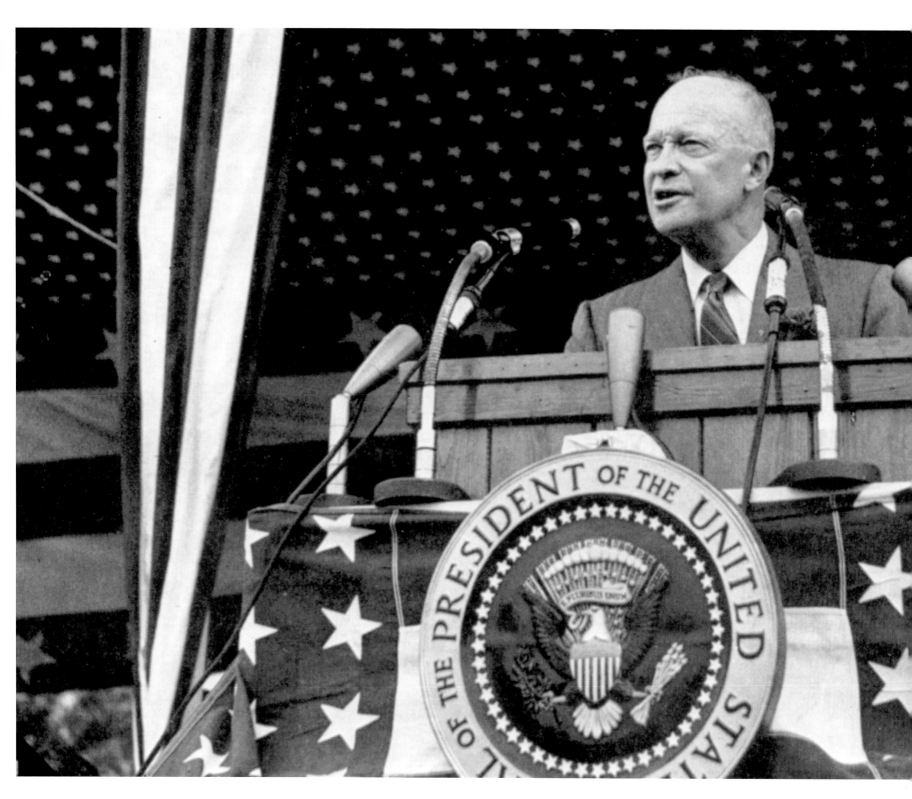

162

A crowd of more than 60,000 filled Freedom Park on May 20, 1954, to hear an address by President Dwight D. Eisenhower. The event was one of the grandest annual celebrations honoring the Mecklenburg Declaration of Independence. Earlier guests of honor had included Woodrow Wilson (1916), and William Howard Taft (1909). The last large celebration took place in 1975, when President Gerald Ford appeared.

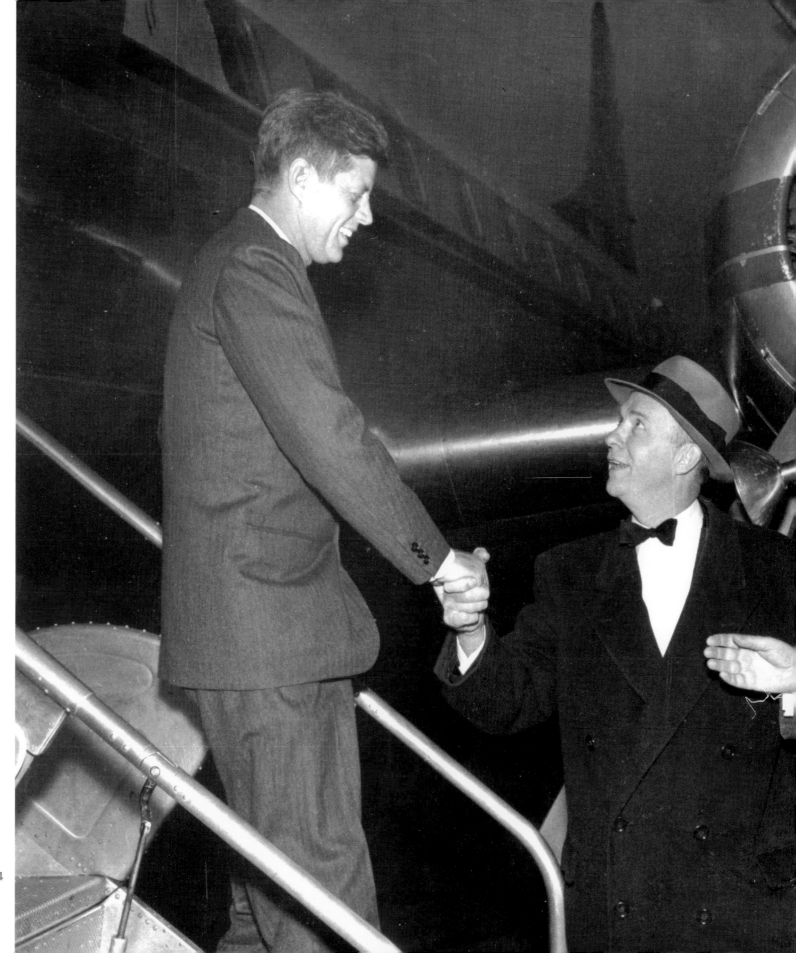

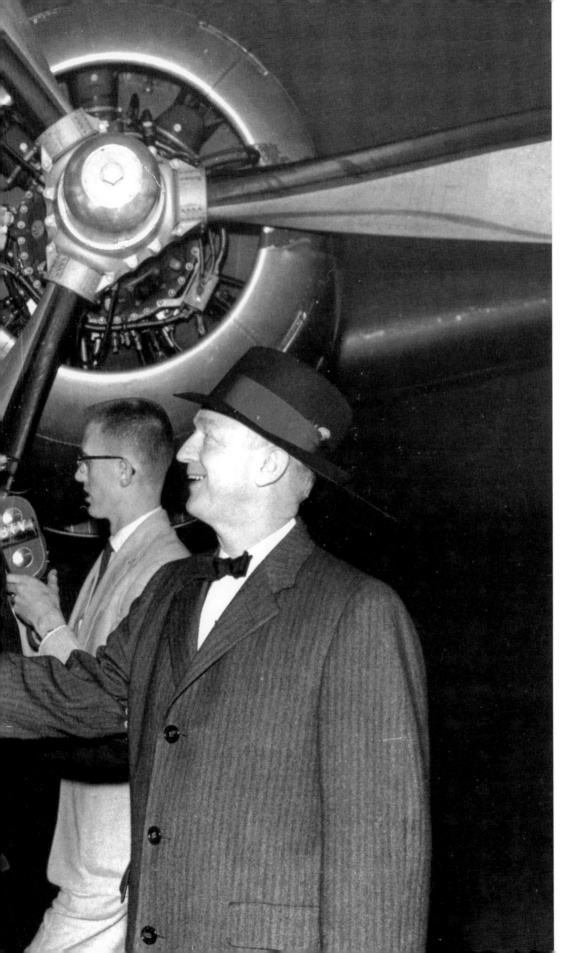

Then Senator John F. Kennedy
arriving at Douglas Airport in mid
January 1959

People at the Square (ca. 1950)

People at the Square (ca. 1955)

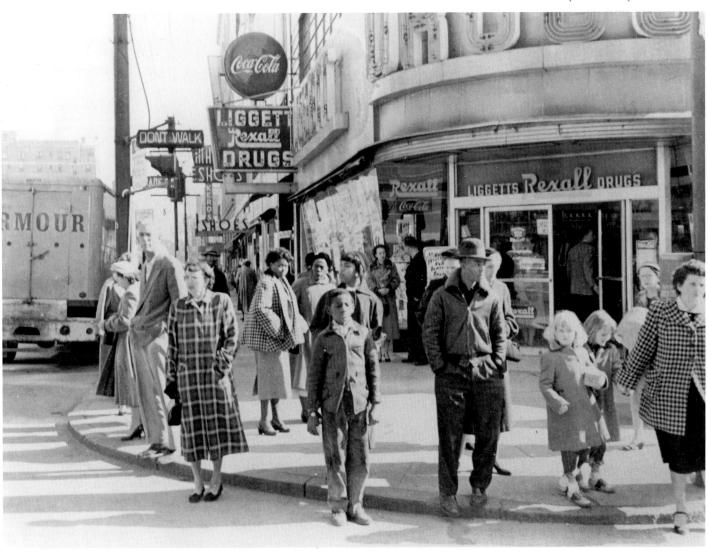

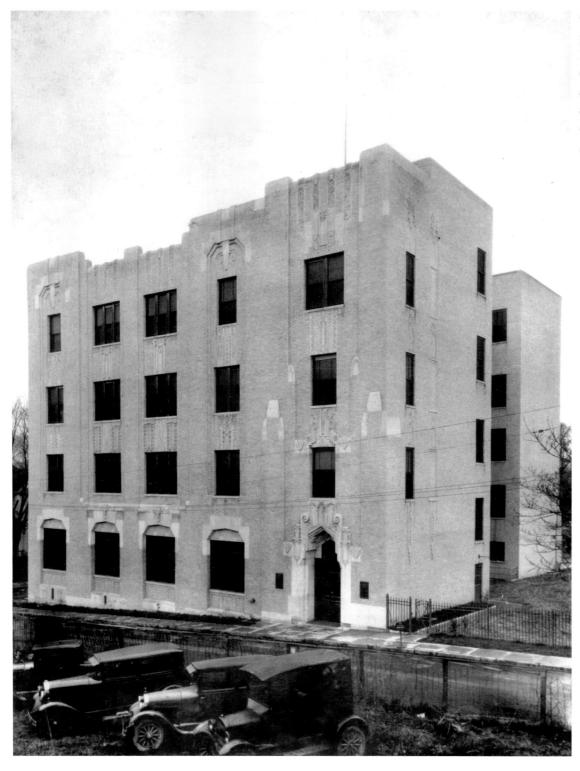

Only 968 Charlotteans had phone service when the Southern Bell Telephone and Telegraph Company purchased the Charlotte exchange in 1904. Bell moved operations to this building on Caldwell Street when the dial system came to Charlotte in 1929.

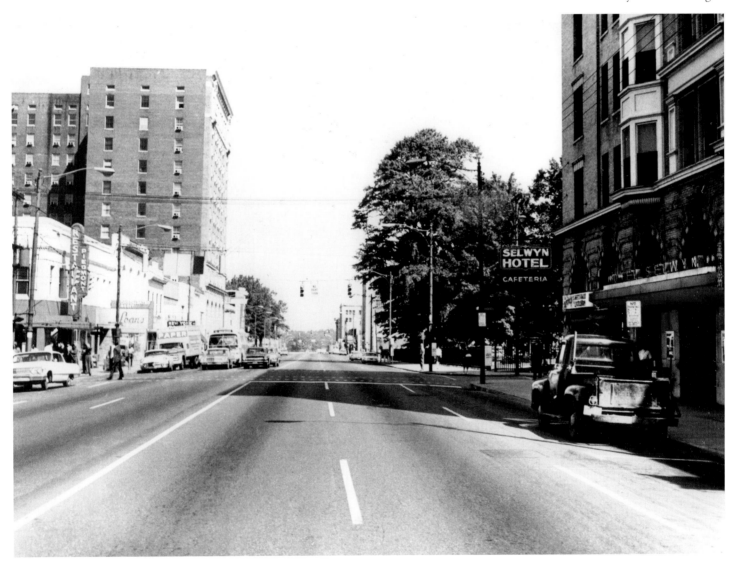

West on Trade Street, just past its intersection with Church (ca. 1950).
The Selwyn Hotel is at right.

National Welders Supply Company (1941–2006)
Founder, Jim Turner (1910–1998)

With five hundred dollars, a car, confidence, and personality, Jim Turner acted as a manufacturer's agent for some product lines, while carrying a small stock of welding items he could obtain on consignment from different suppliers. Soon he located the business in a leased storefront on South Tryon Street in Charlotte.

As the years and decades passed, the visions and goals set by the founder blossomed into reality. Turner and National Welders rose from being an entrepreneur with a small company to a corporation, with Turner at the helm. Today there are 55 National Welder service centers in four states, three air separation plants, two acetylene plants, and one specialty gas plant. Turner built the first air separation plant in North Carolina.

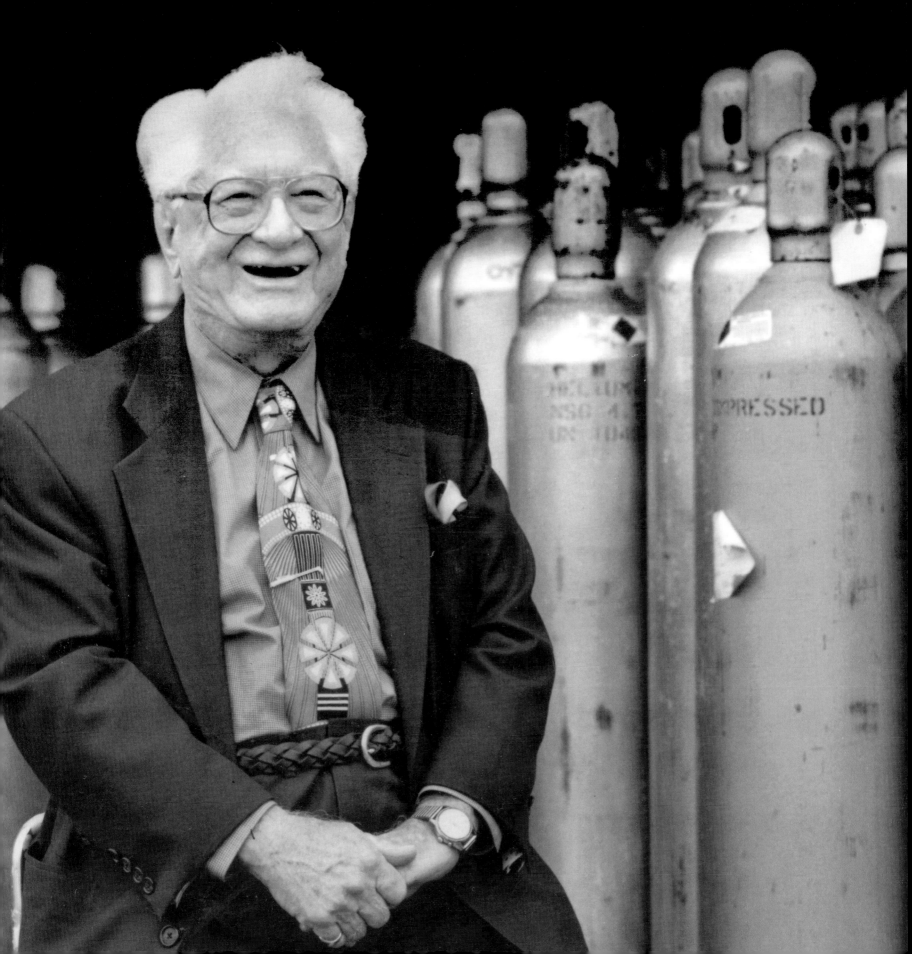

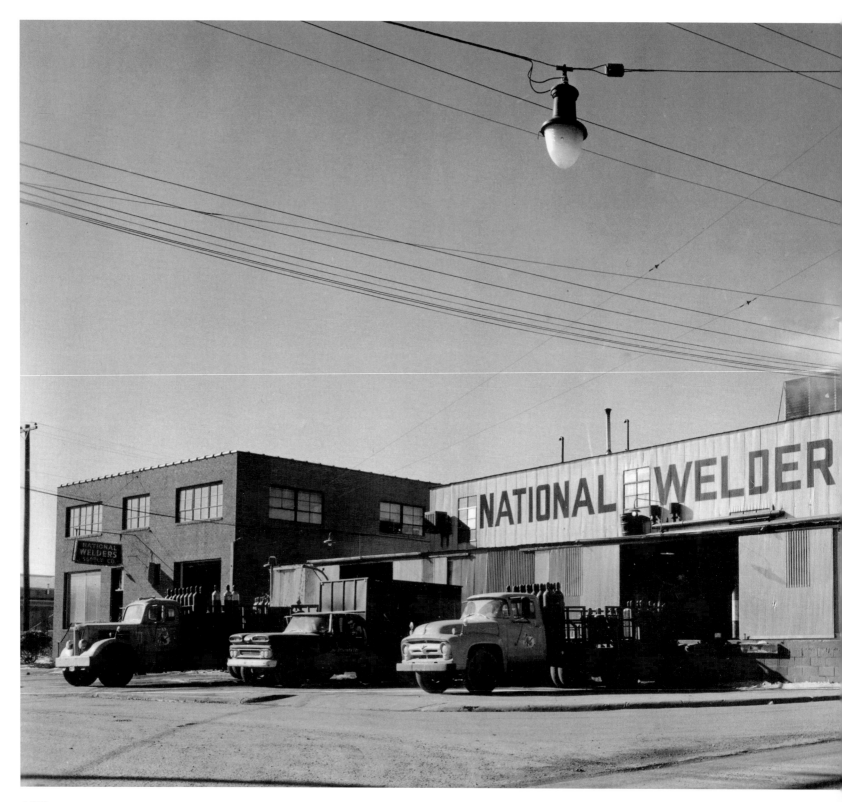

Money was tight, but Jim Turner, as a natural entrepreneur, used other people's money to his advantage, whether buying on consignment or arranging extended payment terms. As money came in, he always reinvested, either back into National Welders, or in over-the-counter stocks of competitors (to gain relationships, ideas, and financial statements), or often in what would today be called IPO's.

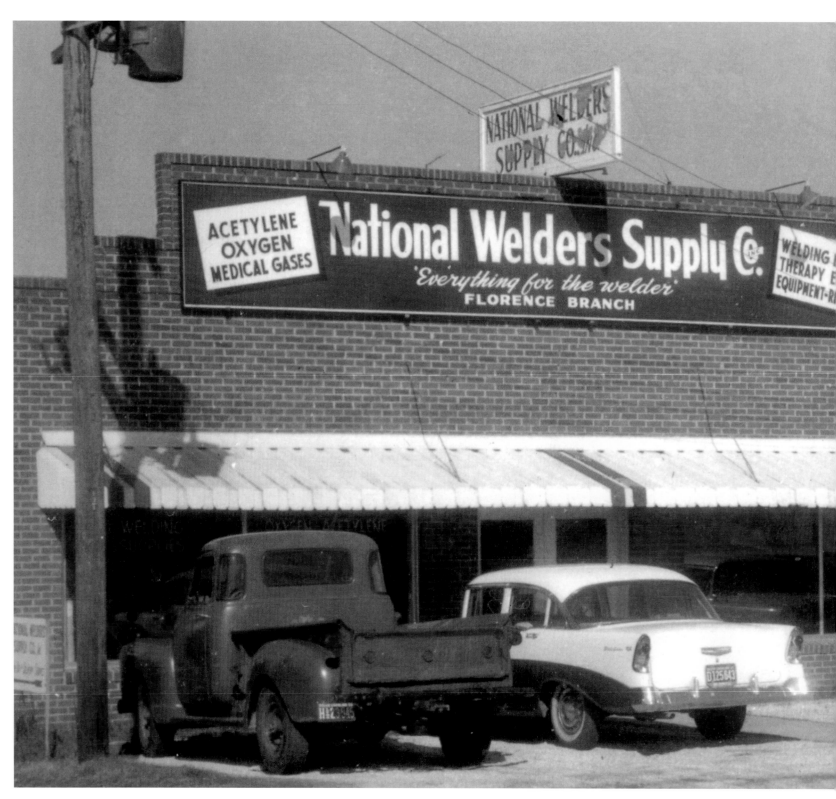

Turner's Welders Supply store openings headed south, as illustrated by this photo of the Florence, South Carolina, branch.

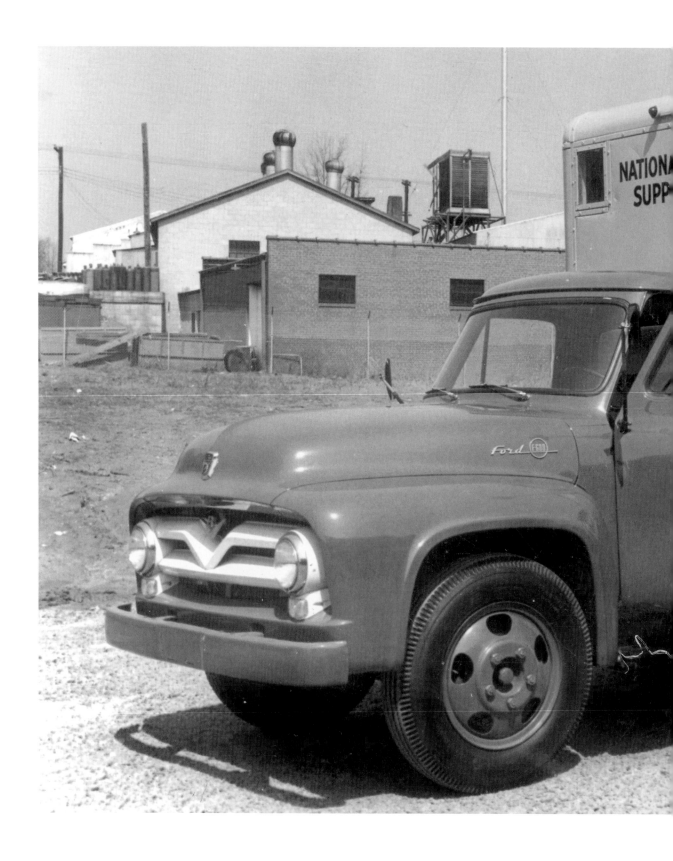

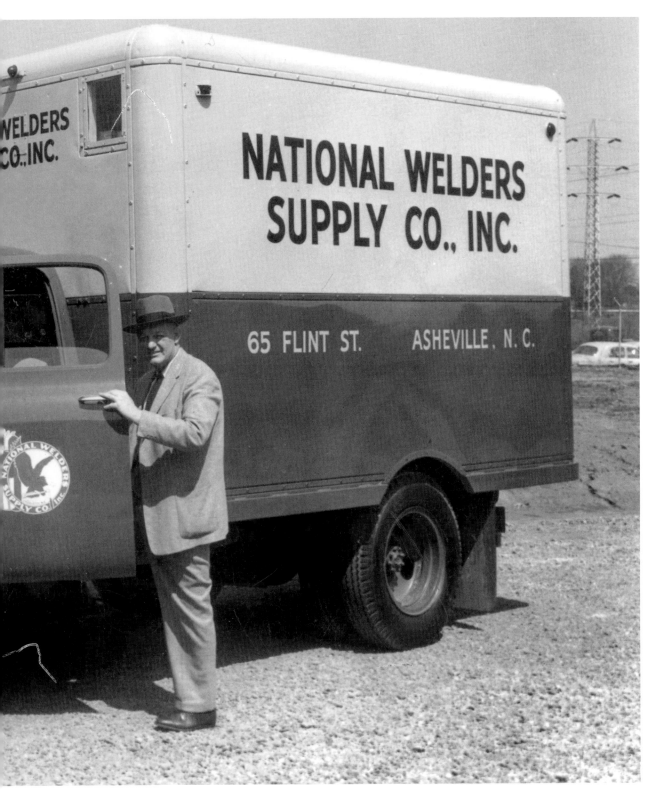

World War II presented opportunities to anyone supplying material for manufacturing. Labor was in short supply, so Jim Turner set up a school to train welders to work in shipyards on the East Coast, advertising for students to "help win the war and earn big wages." He marketed opportunity, offering low tuition and terms, no deposit, and a pay-after-graduation plan, assuring students they could keep their present jobs while learning electric arc welding.

A parking lot behind City Hall (late 1950s)

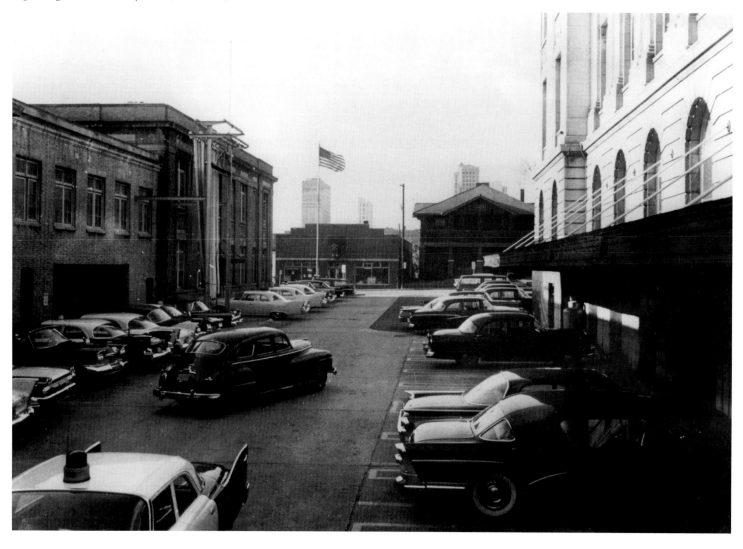

STRENGTH AND RESOLVE

On October 29, 1929, everything changed. Many of the businesses that boosters worked so hard to attract to the city failed after the Stock Market Crash. Especially hard hit were the financial institutions. The Industrial Bank of Mecklenburg, Merchants and Farmers National Bank, the Independence Trust Company, and First National Bank all closed their doors—never to re-open and begging the question of whether recovery was possible.

In the 1930s, President Franklin D. Roosevelt declared that the poverty holding the South in its grip constituted the nation's "number one economic problem." To combat that destitution as well as to fight the nationwide Great Depression, the president funneled millions of dollars into New Deal work programs such as the Federal Emergency Relief Administration, Civil Works Administration, Civilian Conservation Corps, the Works Progress Administration, and many others.

Under the direction of these federal programs, jobless Charlotteans found employment and in effect reinvented their city. The work done in Mecklenburg was often physically arduous—consisting of clearing land and chopping firewood for the needy, erecting sanitary outhouses to combat disease, grading and paving new roads and highways, as well as improving dilapidated thoroughfares. Piece by piece, New Deal workers dismantled the old U.S. Mint building downtown and reassembled it in Eastover as the Mint Museum. In addition to numerous other projects, they also erected Memorial Stadium, Memorial Hospital, Charlotte's Municipal Airport, and a military training airbase.

As the nation entered World War II and subsequent Cold War, Charlotteans participated in military programs, and new wartime industries centered themselves in Charlotte. Local healthcare professionals formed a frontline emergency medical unit and left for service overseas. Area cotton farmers and textile mill workers stepped up production of goods needed by the military. Women and men too old or unfit for service took jobs working at the Morris Field airbase adjacent the airport, the Army Quarter Masters Depot, or in a munitions factory that manufactured shells for the Navy. After the war the nation turned a watchful eye toward the Soviet Union, and the Douglas Aircraft Company began the development of new weapons and the manufacture of missiles in Charlotte as part of the Nike missile defense program.

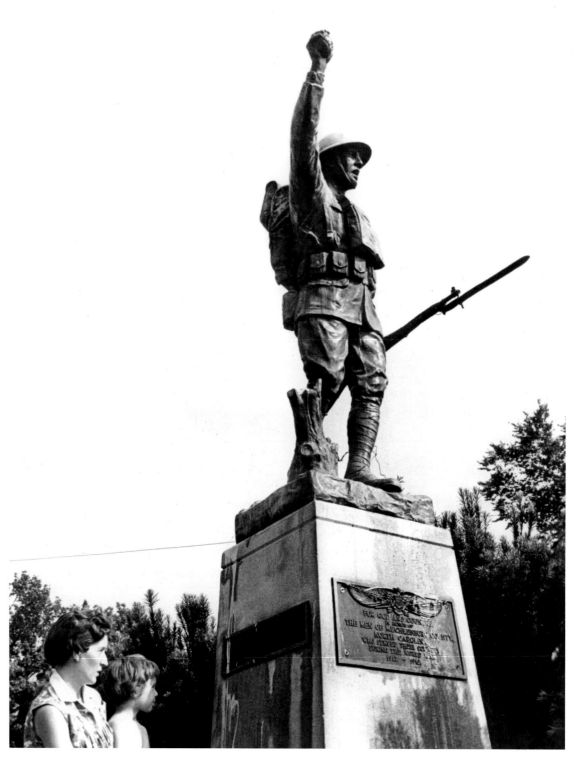

Sculptured by Georgian artist E. M. Viquesney, *Spirit of the American Doughboy* originally stood on the grounds of the old courthouse and was given in honor of the men from Mecklenburg County who valiantly served in World War I. Today the statue is seen on the northeast corner of Trade and Davidson streets.

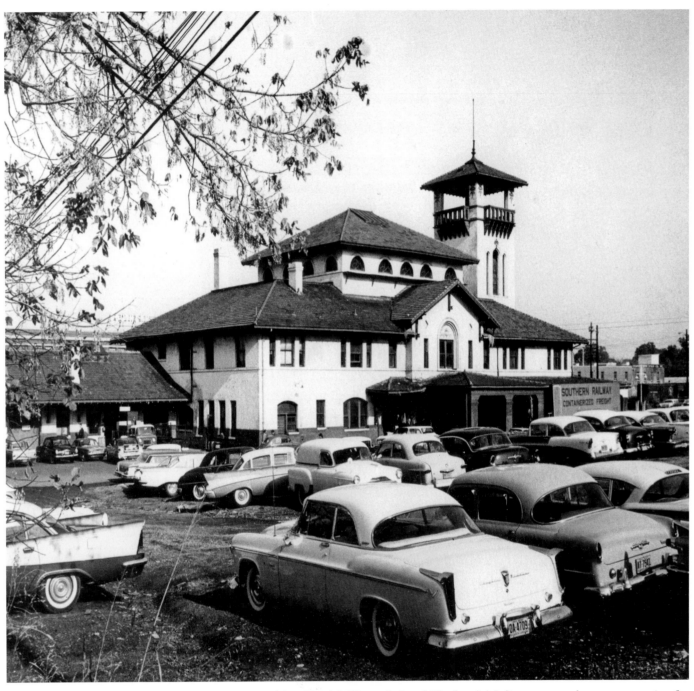

Architect Frank Milburn designed Charlotte's Mediterranean-style passenger station for the Southern Railway, seen here from Depot Street in 1964. The building graced West Trade Street downtown and welcomed travelers to the city from 1905, until it was razed in the 1960s.

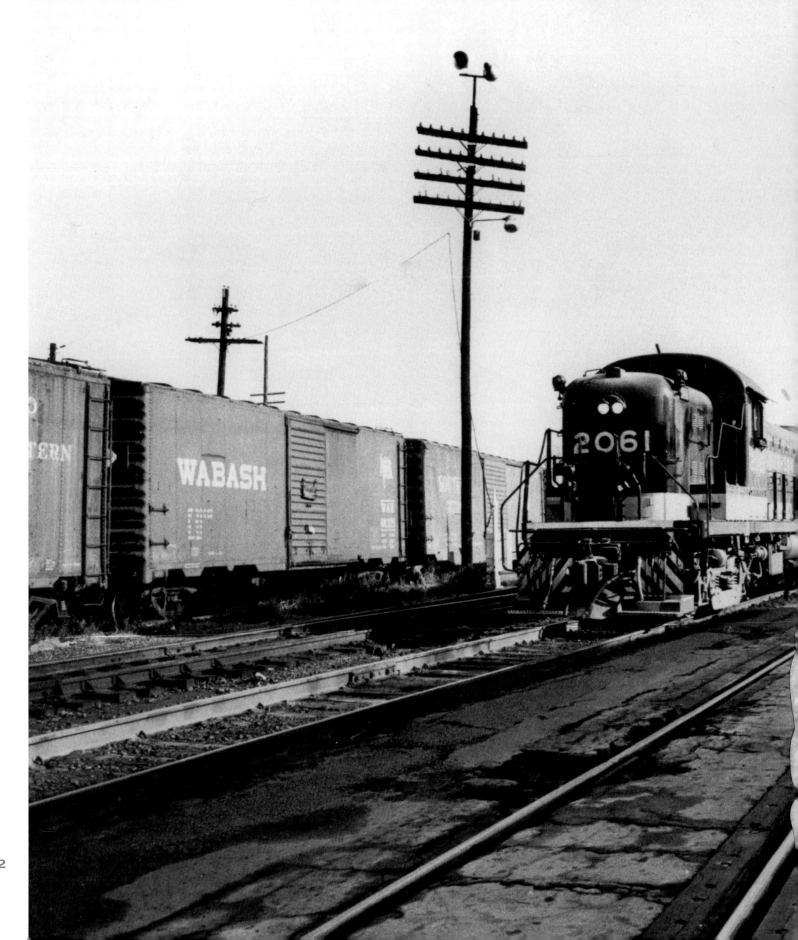

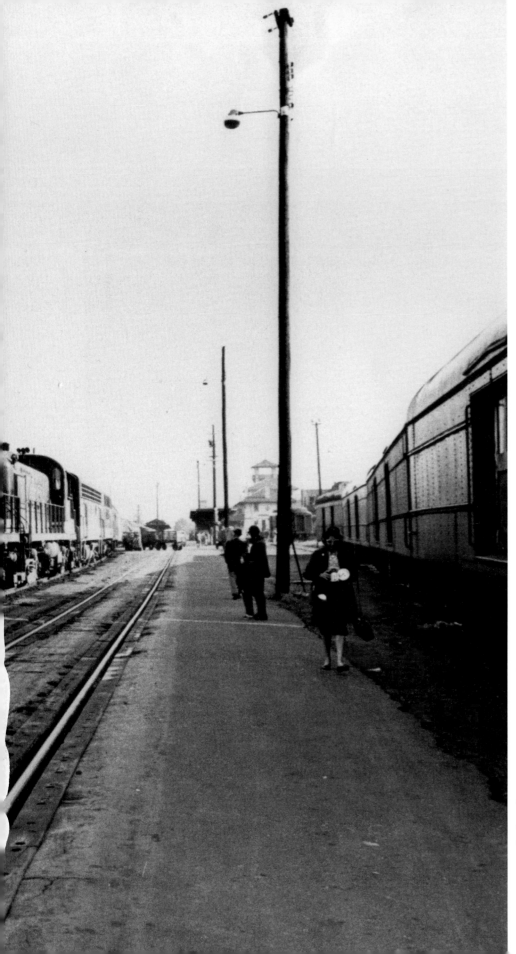

The last passenger train departed the Southern Railway Station in November 1962, seen here leaving the area north of the rail yard.

Another minor league baseball franchise, the Charlotte O's, played during the late 1970s and early 1980s in Crockett Park on Dilworth's Magnolia Avenue. Renamed the Charlotte Knights, the team moved to a new stadium in Fort Mill, South Carolina, in 1987.

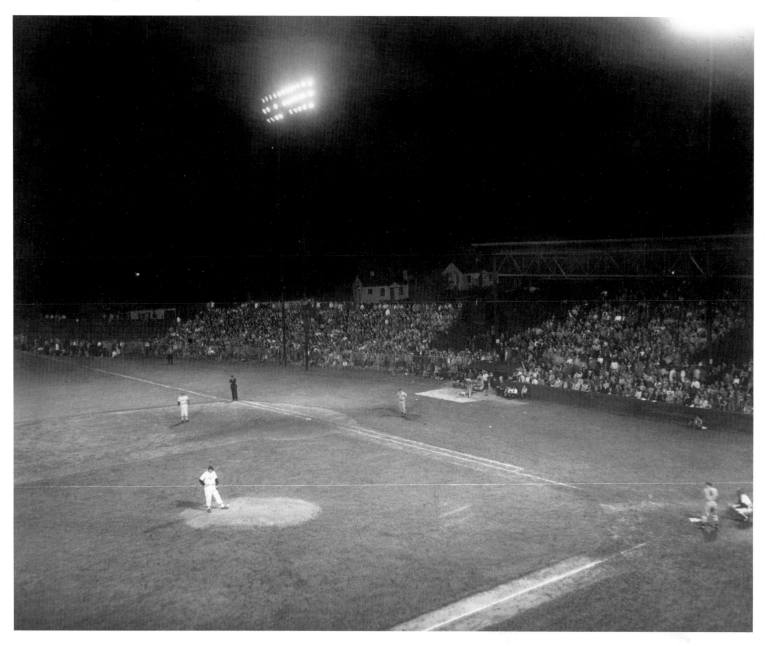

Built between 1938 and 1940 with federal money as part of Roosevelt's New Deal, Charlotte Memorial Hospital was originally four stories tall with just 300 beds. The hospital was instrumental in dealing with the polio epidemic that swept through the Carolinas in 1948. The complex—seen here in 1961—has expanded several times over the years and now serves the community as a Medical Center.

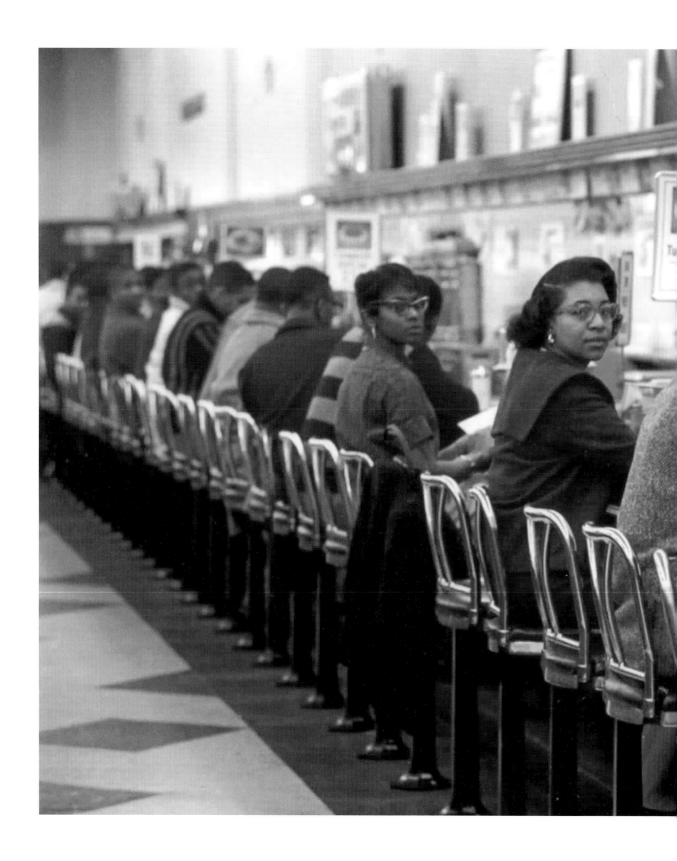

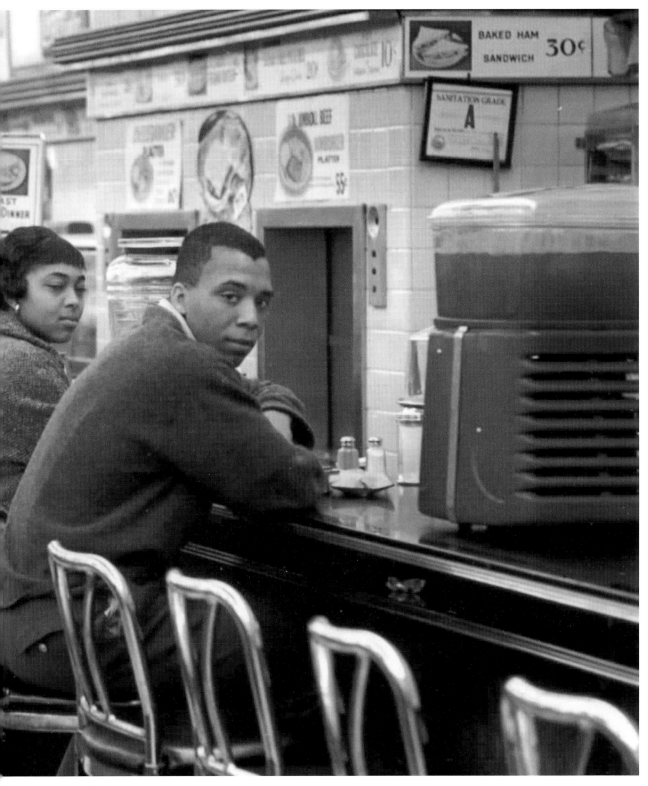

The sit-in movement began in Greensboro, North Carolina, in February 1960, when four well-dressed black students sat down at a whites-only lunch counter and refused to leave until they were served. Nine days later, students from Charlotte's Johnson C. Smith school picked up the idea. Led by J. Charles Jones, 200 students marched uptown and took over the Woolworth's as well as all the other lunch counters. After more than five months, the students prevailed and lunch counters began serving African Americans.

Following Spread: Charlotte dentist and Presbyterian minister Reginald Hawkins (right) with Martin Luther King, Jr., at Johnson C. Smith school in 1966. Throughout the 1960s, Hawkins led protests and filed lawsuits that resulted in the desegregation of Charlotte Memorial Hospital, Mercy Hospital, the North Carolina Dental Society, and the Charlotte YMCA.

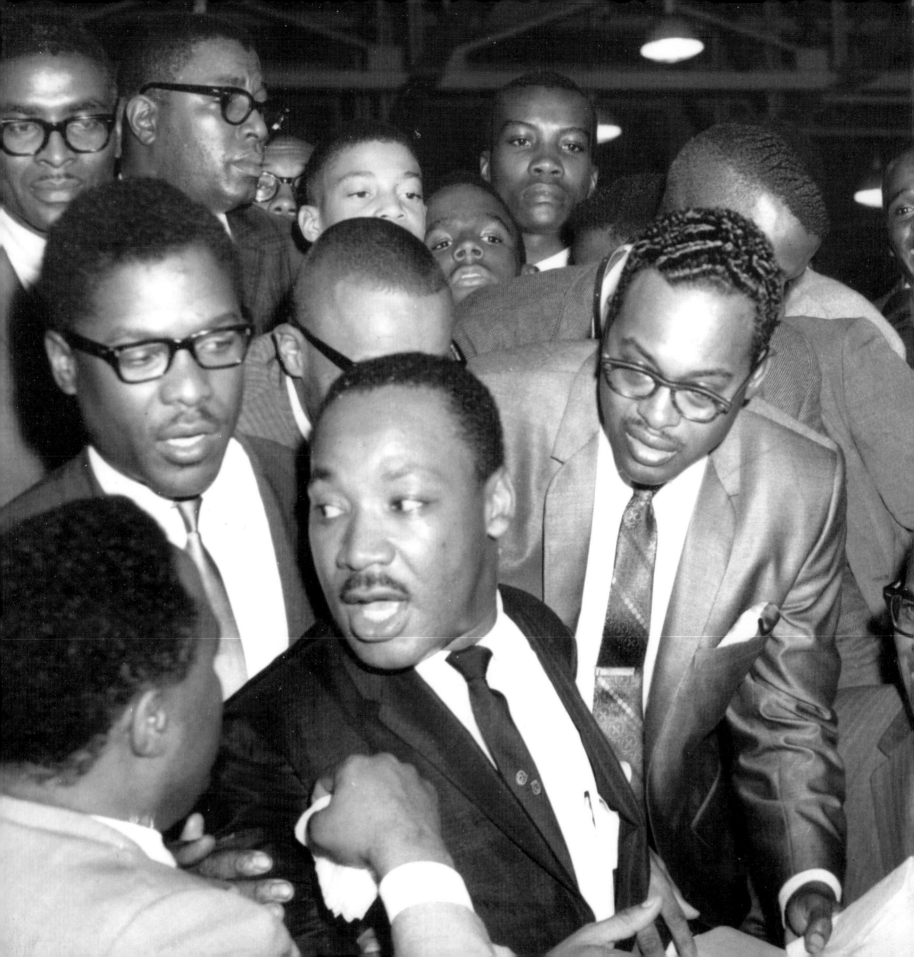

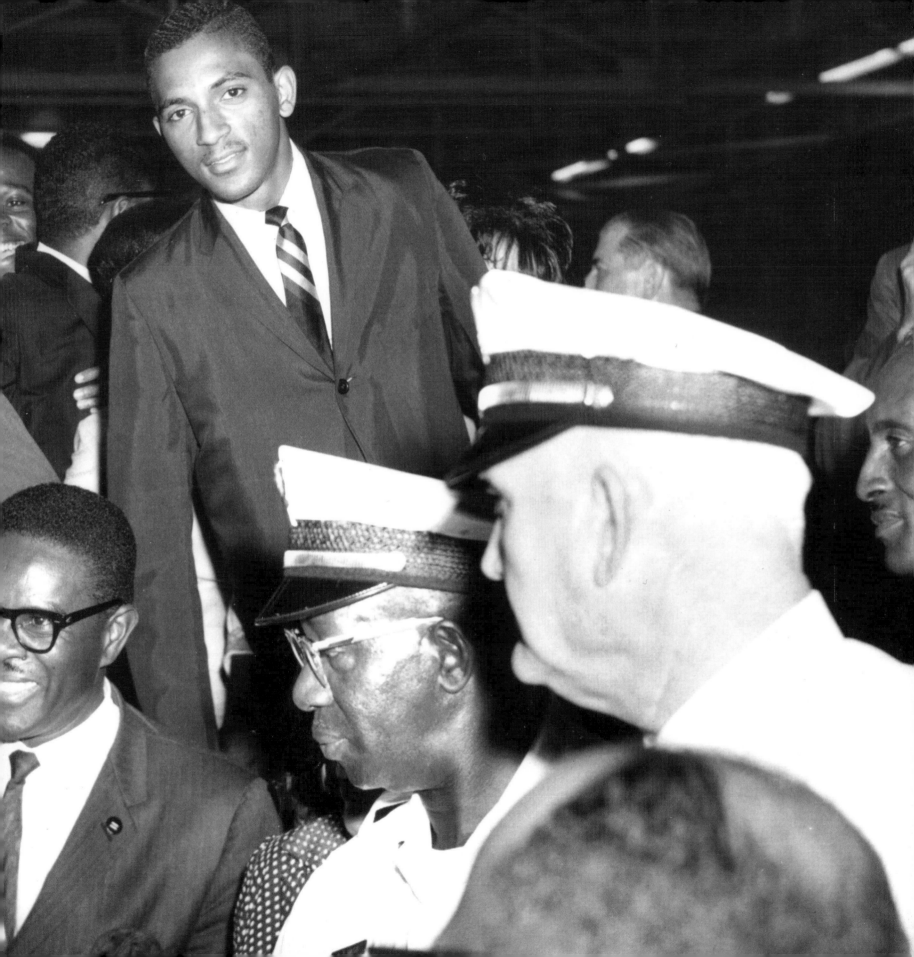

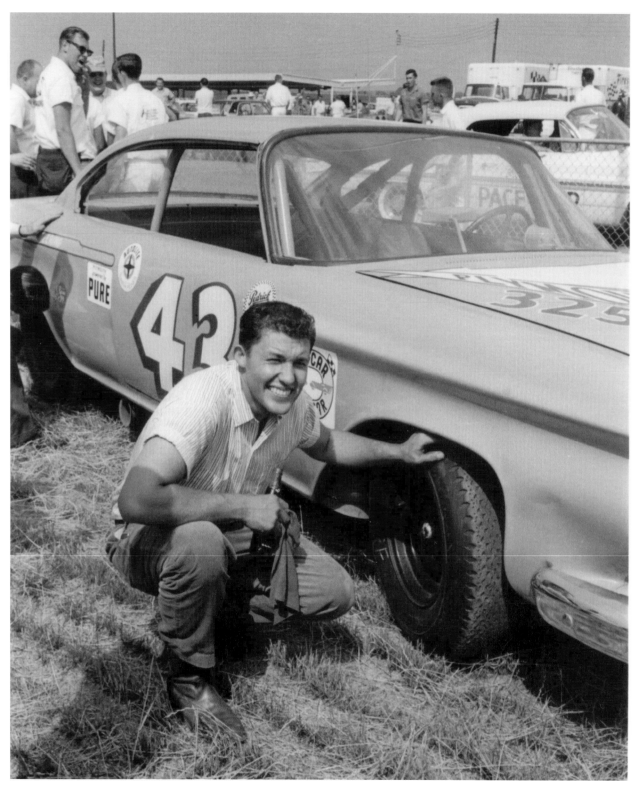

Seen here after winning the pole for the 1961 World 600 in Charlotte, Richard Petty dominated the sport of auto-racing in the 1960s. His best year was 1967, when he won 27 of 48 races—including a record 10 in a row—finished second place seven times, and easily cruised to the championship.

Beginning in 1953, WBTV aired a popular noontime show for women starring Betty Feezor. Feezor hosted her own show at a time when very few women held such roles.

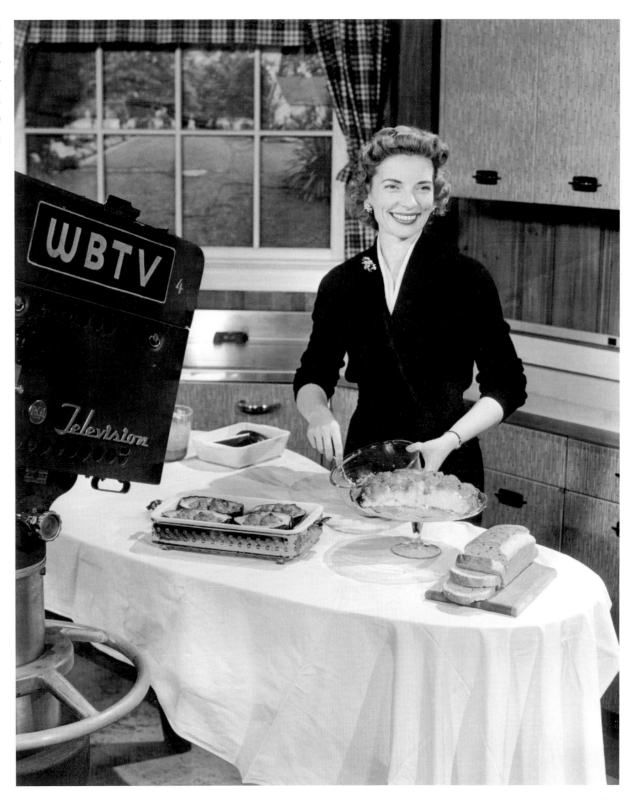

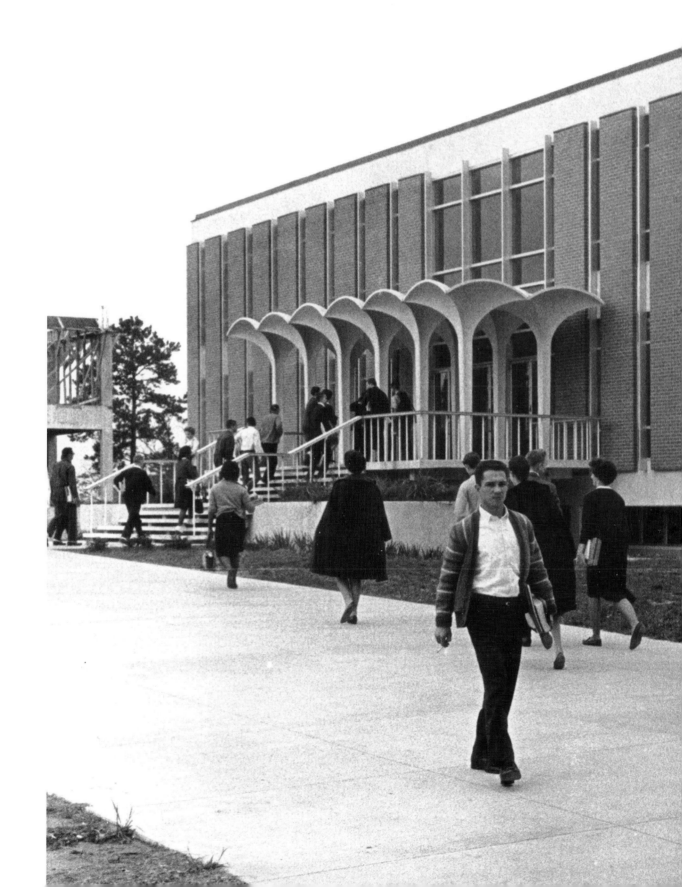

The first structure erected on the University of North Carolina's new suburban campus was the Kennedy Building, which housed everything from the chancellor's office to the library.

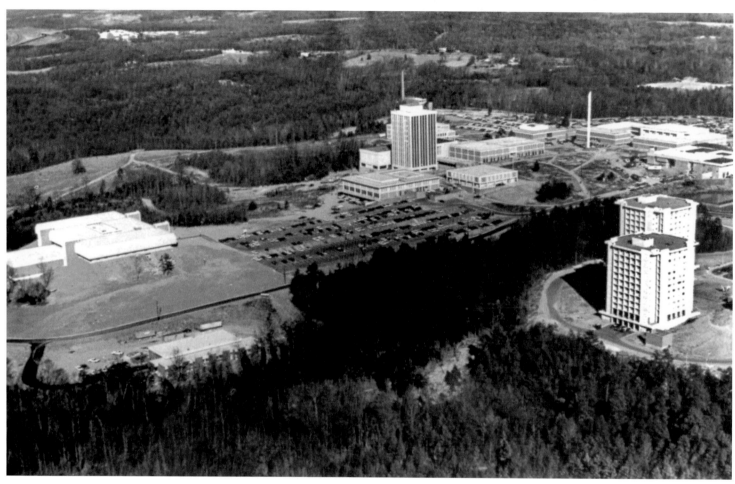

Pushed to success under the leadership of Bonnie Cone, Charlotte College soon outgrew its home in Central High School, as well as a building they erected on Cecil Street. In 1959, the school began to acquire land for its current site on Highway 49, becoming a four-year institution in 1963. Two years later the school became the fourth campus of the University of North Carolina, known since as U.N.C. Charlotte.

The Wachovia building on South Tryon Street (ca. 1961). Charlotte-based First Union acquired its Winston-Salem-based rival in 2001. The corporation—now the fifth largest bank in the United States—took the Wachovia name and kept its headquarters in Charlotte.

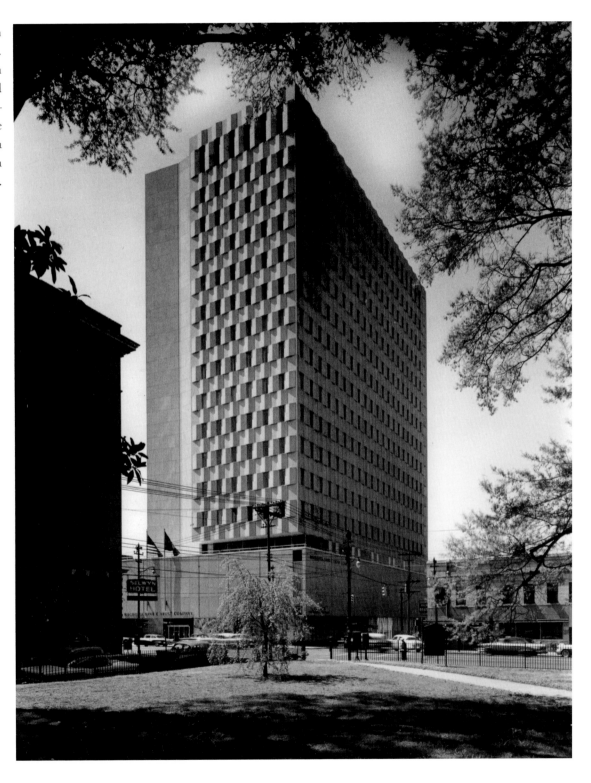

In 1927, the U.S. Federal Reserve chose Charlotte as the site for its branch serving the Carolinas. The Federal Reserve bridges banks with the federal government—putting new dollar bills in circulation and shredding old ones. It also "clears" checks—returns a check written anywhere in the Carolinas back to its home bank. Fast access to "the Fed" gave Charlotte banks advantages over banks farther away. Shown here is an employee clearing checks in the 1970s.

Professional hockey came to Charlotte after a 1956 fire displaced the Baltimore Clippers. Expecting a lackluster response in the South, the team drew an initial crowd of over 10,000—3,000 had to be turned away. Charlotteans discovered a love for this violent "northern" sport. Rechristened the Charlotte Checkers, the team won the 1974 Southern Hockey League championship and played until 1977. The current Charlotte Checkers team was established in 1993 as an affiliate of the NHL's New York Rangers.

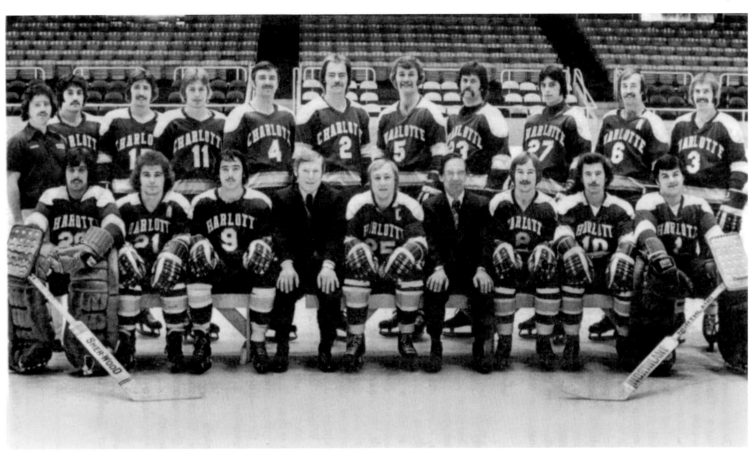

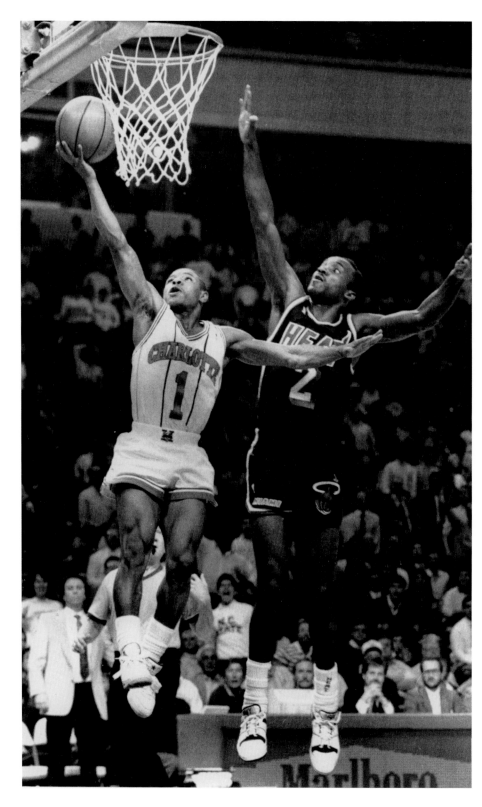

The Carolina piedmont
has been basketball-mad
dating back to textile
mill teams and such
fierce college rivalries as
Winston-Salem State
versus Johnson C. Smith
and Chapel Hill versus
Duke. In 1988, pro
ball arrived. The NBA
Charlotte Hornets played
to sell-out crowds. The
Sting, of the new Women's
National Basketball
Association, soon joined
them. A new NBA team,
the Bobcats, began
playing in 2004 after the
Hornets moved to New
Orleans. The Bobcats
are owned by Robert
Johnson, billionaire
founder of BET, the Black
Entertainment Television
channel.

Here, Tyrone "Muggsy"
Bogues scores against the
Miami Heat in 1988.

In 1973, activists in the Charlotte Women's Movement established a chapter of the National Organization for Women (NOW). Despite being a small group, when compared with bigger cities, Charlotte NOW effected a great deal of change. Shown here are NOW volunteers in Latta Park in 1975.

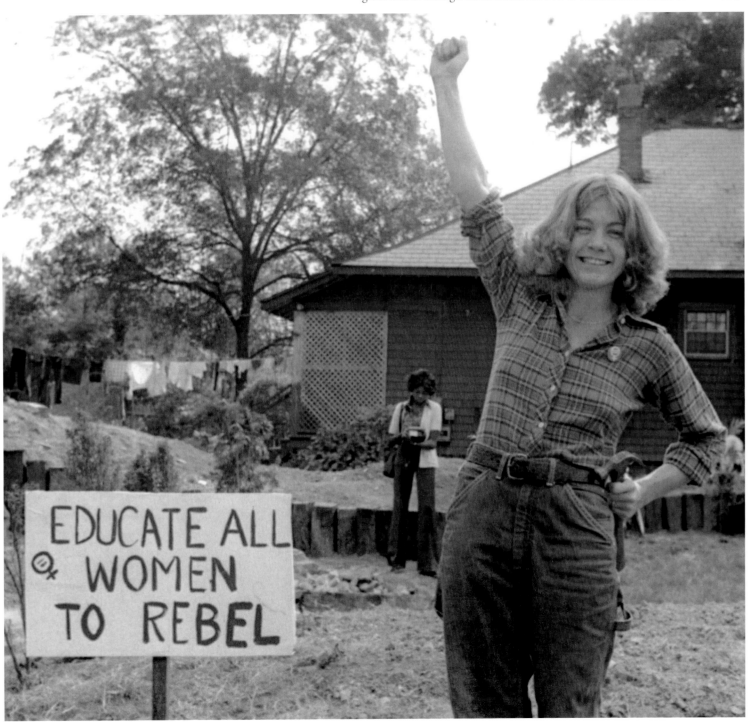

Notes on the Photographs

These notes, listed by page number, attempt to include all aspects known of the photographs. Each of the photographs is identified by the page number, photograph's title or description, photographer and collection, archive, and call or box number when applicable. Although every attempt was made to collect all available data, in some cases complete data was unavailable due to the age and condition of some of the photographs and records.

Black ex-slaves had no money at the Civil War's end. Farming was the only life most had known, so they made rental agreements to borrow land, seed, tools, and mules for plowing. The owners of the land insisted that cotton be grown as a cash crop. By 1890, three-quarters of the area's African American farmers were tenants farming someone else's land. Shown here are Mecklenburg County tenant farmers. (ca. 1900)

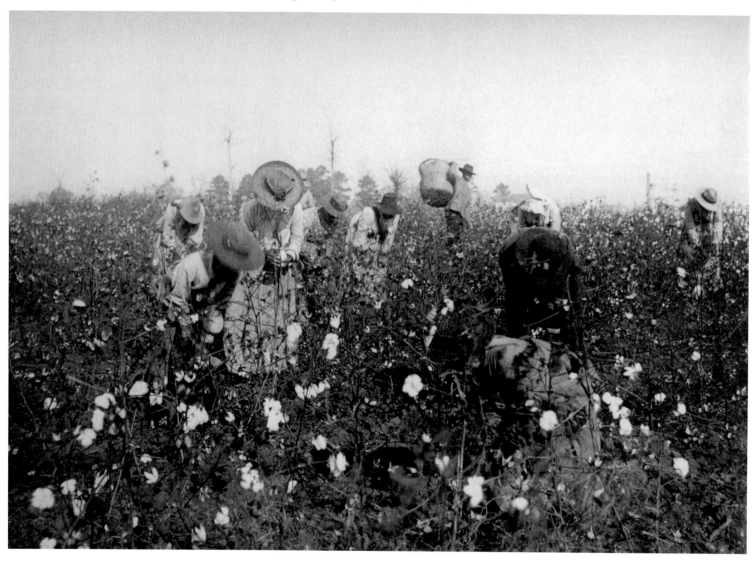

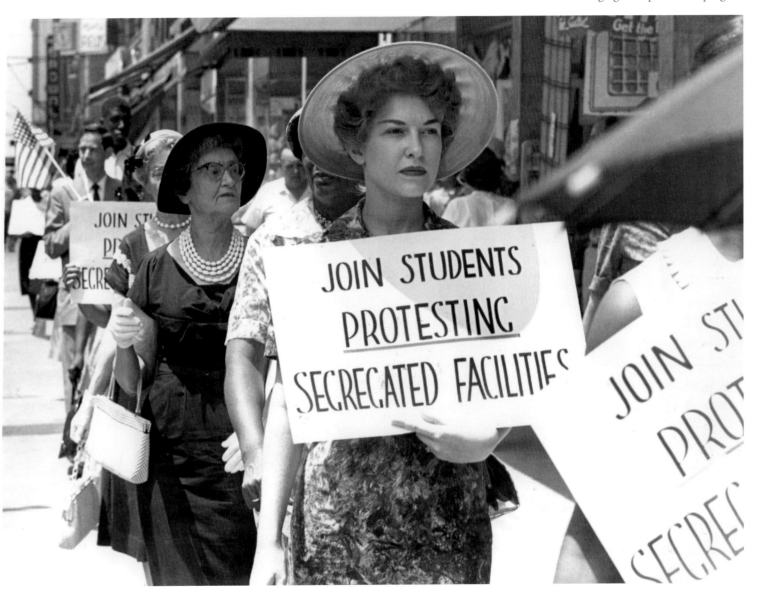